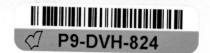

The Arts of
BLACK AFRICA

The Arts of BLACK AFRICA

by Jean Laude

Translated by Jean Decock

University of California Press
Berkeley Los Angeles London 1971

University of California Press
Berkeley and Los Angeles, California
University of California Press, Ltd.
London, England
© Librairie Générale Française, 1966
This translation © 1971
by The Regents of the University of California
ISBN: 0-520-01797-8
Library of Congress Catalog Card Number: 71-125165
Designed by Sandy Greenberg and Dave Comstock
Printed in the United States of America

Translator's PREFACE

Jean Laude's work is not just another broad, generalized, vulgarized survey of the artistic and cultural heritage of black Africa, not just another civilized look at exotic and mysterious art in museums and private collections. African art objects had been mere data, documents, and curiosities when, a little more than half a century ago, we "discovered" African art; that is, we reacted aesthetically to it and exhaustively studied the African heritage in our museums in order to classify and record our impressions. We later realized that all we could possibly record was the history of our reaction to an art that we could apprehend only from the outside and will never be able to understand otherwise. The well-known poet, Jean Laude, was aware of this fact from the start.

Thus, Laude began to study specific relations between French painting and Negro art, which began early in the twentieth century. He has recently published a two-volume thesis on the subject. His work stems from Western experience, echoing and reflecting the newfound interest in so-called primitive arts and civilizations and their subsequent influence on Western art. He denounces as preposterous the idea of "discovering" art and civilizations that were in existence when Europe was still a battlefield of savage tribal rivalries (see the comparative survey of world history and art at the end of the text). An opening of perspective, or possibly a return to the origins, would be an appropriate description of the century's new awareness, since people's attention was directed not only toward "primitive" civilizations but also toward Romanesque art in the West and the painting of early Italian and Flemish artists. The first exhibit of primitive Flemish painters, for instance, was held in Bruges in 1902.

In the first stage of reaction to black art, after the "dark ages" of the realistic, naturalistic, and positivistic decades of the late nineteenth century, artists such as Picasso, Braque, and the German expressionists first saw in African masks what they wanted to see: pure force and intensity. They stressed primitivism in its favorable meaning of both the vital and the essential; there it was, this black art, ex nihilo, almost abstract, cut from any frame of reference. Only later, after Modigliani or Brancusi, did the West become aware of the diversity of Negro art, which grew more explicit when the experience of discovery gave way to more technical concerns, such as the relationship between the artist and his material, whether wood or metal.

As appreciation and knowledge followed a purely aesthetic view of African arts, Westerners learned to discern the mark of the artist and to identify the individual creator. They began to classify, label, and study art objects. African art was exhibited in museum showcases or piled up in European museum vaults and warehouses. Art was once more in the hands of scholars, stifled to death, assigned to geographical, historical, or national categories, placed in grammars and alphabets of symbols, de-

signs, and decoration. Fortunately, with the emergence of the new social sciences (*sciences humaines*) shortly after World War II, anthropology and ethnic studies encouraged a new field-trip approach to art which meant the studying of objects in their vital and live context, setting the trend pursued in the more recent approach to African arts. Michel Leiris, who traveled extensively in Africa, substantiated his careful, honest evaluation by his experience of reality. The old sweeping generalities on the unity of black art have given way to the regional gathering of elements for a future history by art historians turned into travelers, who live and learn on the premises where the art is born.

The public knows little about these societies without history (to use Lévi-Strauss's terminology). When people speak of Renaissance or even Mexican art, there is little danger that they will confuse Brueghel and Michelangelo, Dürer and El Greco, or Aztec and Spanish elements. Yet in dealing with African arts they are still tempted by generalizations, as André Breton was in the 1920's. Those who ask whether African art is sacred or merely functional, and whether it allows the notion of beauty, should always be aware—and Jean Laude never lets them forget it—that their changing point of view reflects the evolution of their own concept of art.

Laude's work is valuable because, far from ignoring the ambiguities of a particular approach, the paralyzing absence of criteria, and the limitations of the data, he takes them all into account and integrates them into a synthesis which is thereby the best possible introduction to African arts. His triple preoccupation is to describe the diversified expression of creative artists, to define their specificity by relating it to societies and cultural environment, and to evaluate the personal techniques of the artist. Laude's work grows toward a totalization because it relates metaphysical implications, spatial dimension, and historical perspective.

When Africa called the first World Festival of Black Arts, held in Dakar in 1966, with the purpose of defining the "function and significance of black art in the life of a people and for the

CONTENTS

ILLUSTRATIONS

1

Africa Lost and Regained

The course of black art has been a singular one. African sculpture, admired first out of mere curiosity, then held in contempt, disdained, and scorned, soon became ethnographic data; then suddenly, through the interest of several modern painters, it was promoted to the dignity of an inspirational source. Today it is an object of trade and research for an ever-increasing number of connoisseurs. For more than five centuries before entering the contemporary aesthetic hall of fame, African sculpture was regarded from very distinct and contrasting points of view. The history of these differences in perspective is instructive and must play its part in a study of the arts of black Africa.

Twice, in the last quarter of the fifteenth century and in the second half of the nineteenth, the Western world turned toward Africa, and twice this tentative communication broke down, ending in bloodbaths or in profound silence. Total misunderstanding inevitably produced tragic repercussions. Perhaps these attempts were so ruinous because of the circumstances that brought the two worlds together: lust for gold, the European desire for power, the

discovery of another civilization, economic crises, the clash of two peoples stubbornly opposed in their characteristics. These are the reasons that come to mind when we attempt to understand the lasting and growing contempt directed, until recent times, toward Africa by the West, when we search for an explanation of conquest, enslavement, and colonization. Considered separately, however, these causes seem insufficient; it is only their union that made them so powerful, thrusting Europe out of its boundaries into deserts or upon uncharted seas.

The wind blew toward adventure! How full of wonders was the world! Reason as well as dream took hold of the undiscovered, to reshape and mold it to the demands of fear and desire. Ponce de León, who set sail in search of the Isle of Youth, discovered Florida. All the fantastic science of the Middle Ages was still present in the imaginations of navigators and traders: fabulous books of beasts and herbs, strange customs, supernatural phenomena, and the infinite variety of monsters described in the twelfth century by Honorius of Autun in his treatise *On the Image of the World*. It was through Islam that the crusaders discovered the Sudan, land of the black people, whence came the most powerful magicians of the Arabian tales.

The image of African civilization which Europe constructed was shaped by an ideology. Rooted in myths born in the Middle Ages, it saw in the black continent the land of the idolators, the forgotten kingdom of God. Africa was indeed a world to convert, even more so since the mysterious Christian kingdom of Prester John, whose alliance was sought for the fight against the infidel, was presumed to be there. Upon discovering Ethiopia at the beginning of the sixteenth century, the Portuguese believed they had reached the land of Prester John. Yet the yearning for travel and the wonders of discovery combined with apostolic zeal are not enough to explain the fascinating influence of Africa upon European imagination and curiosity as early as the time of the Crusades. Even before the inception of the slave trade, the sense of adventure was rooted in economic necessities. In the thirteenth century Europe started to use spices, especially pepper to season

food, and wanted ivory for tableware. The first articles the Portuguese ordered from Benin in the fifteenth cetury were ivory cups and salt and pepper shakers. Through the medium of the Arabs and the Jews of the Rhone Valley, ivory from which the masterpieces of Mosan art were carved was likewise brought up from the land of the Zandj in eastern Africa.

More than anything else, Europe needed gold. Merchants knew that the gold they purchased from the infidels in the trading posts, the fonduks of North Africa, came from the interior, from the Sudan. The decline of Hungarian mines provoked the worst economic crisis of the thirteenth century. The desire to find the source of the precious metal, to eliminate the intermediaries who controlled the commerce in exotic goods and commodities on the Barbary shores, to compete with Arab markets, and to awaken the European economy to a life of trade was the essential motivation behind the first encounter between Africa and Europe.

The Birth of Exoticism

"It is well known that Africa always provides something new," wrote Rabelais, probably quoting Pliny the Elder. When Rabelais wrote these words, there already were tangible signs of novelties all over Europe. The earliest known mention dates from April 1470, when Charles the Bold signed an order to pay to "Alvarre de Verre, servant to Jehan d'Aulvekerque, Esq., Portuguese lord, . . . 21 pounds . . . who lately presented him with a sword and some wooden figures used as idols." Beginning in the first third of the fifteenth century, princes and merchants acquired natural as well as man-made treasures for their private collection rooms.

Near Fontenay-le-Comte, in Bel-Esbat, the son of André Tiraqueau (1480–1558), Rabelais's protector, had assembled several exotic objects described in verse by his nephew, André Rivaudeau, who wrote to his uncle in praise of

> . . . the clothes of the savages
> Cleverly made of small cartilages,
> Roots, and bark, and their furry hats,

> Their tights, their carpets, and their beautiful plumes
> Which you have displayed in this ornate room
> Where you, Tiraqueau, hold in your possession
> Peru and Guinea.

Invited by the Ango brothers, well-known shippers of Dieppe, to their villa "La Pensée," Francis I wondered at the fabrics, the wrought gold, the Indian crockery, and the curious objects from Brazil, Land of the Parrots, as well as ivory spears, idols, and skins of wild animals from African shores.

It is doubtful that an inventory of what the Renaissance knew of the products and goods of Africa could be compiled. The amplitude of the trend, the exact nature of the interest in exotic objects, the importance attributed to overseas curiosities in daily or artistic life, are indeed difficult to assess. The interest was probably only a fad, but it lasted until the seventeenth century and was strong enough to create a market in Africa itself. Black craftsmen, working under Portuguese merchants, fashioned ivory pieces eagerly sought by the royal courts of Europe. Ivory spoons, forks, and horns were among the possessions of Ferdinand I, archduke of Tyrol, in his castle at Ambra. Carved horns, covered cups, salt cellars, forks, and spoons ordered directly from artists in Africa were collected by museums in Madrid, Brunswick, Leyden, and the Vatican. Michael Praetorius illustrated his *Theatrum Instrumentorum* (1619) with several ivory horns from Benin or the Congo.

The curiosity rooms contained principally African works of European inspiration. Traditional art was far more scarce, since the sacred qualities attributed to such pieces by indigenous peoples made them difficult to purchase. The wooden figures of native art were fragile; their bizarre appearance might also have discouraged collectors or their heirs who would eventually dispose of them. Many must have been lost in the Lisbon earthquake of 1755. Only a few works not inspired by Europe remain: Mangbetu copper spears, velvets from Kasai, sculptures in ivory or wood from the kingdom of San Salvador and the Nigerian coast are preserved in the ancient Weydmann Collection in Ulm and in

1. Saltshaker. Ivory. 16th or 17th century.
Benin, Nigeria. British Museum, London.
Photo by the museum.

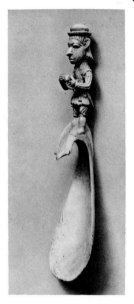

2. Spoon. Ivory. 16th or 17th century. West
Coast of Africa. British Museum, London.
Photo by the museum.

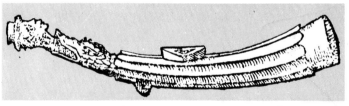

3. Horn. Ivory. 17th century. West Coast of Africa. Illustration in
Theatrum Instrumentorum (1619), by Michael Praetorius.

4. Horn. Ivory. Benin, Nigeria. Musée de l'Homme, Paris. Photo by the
museum.

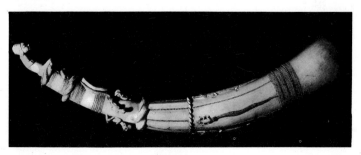

the Kunstkammer in Dresden. Unfortunately, the precise time when most of these works appeared in Europe is unknown.

Under Louis XIV, the son of the Agni king Ammon Tifou was baptized at Versailles, with Louis serving as godfather. It is likely that certain anthropomorphic potteries with black graphite coloring, used by the Agni in their funeral ceremonies, reached Europe at this time. Some were exhibited in Paris in 1931. Louis's collection also included two magnificent, exquisitely carved horns from Benin, now at the Musée de l'Homme. The famous collection of Father Athanasius Kircher included three Bakongo stone statuettes which arrived from Africa in 1695.

In France the appeal of exotic objects, still strong under Mazarin, began to wane. The change in taste was not the only cause, nor was the cessation of governmental support of antiquities solely responsible. In Africa, Europe had not absorbed a philosophy or religion that could motivate her own intellectual or artistic development, as she did during the eighteenth century with Voltaire's version of Oriental philosophy and the Jesuit translators of Tao. To the European mind, Africa was thereafter simply an inexhaustible reservoir where slave traders found the cheap labor urgently needed by the Spanish and Portuguese settlers after the massacre of the Indians.

Gold from the Sudan and the Penetration of Africa

Were curiosity and knowledge the only reasons for the love of African objects? Economic incentives, resulting in dangerous and costly expeditions to the coast of Africa or inland strongly influenced the opinion held by Europeans of the newly discovered civilizations. In the fifteenth century the currency problem became increasingly serious. Gold reserves grew smaller; the metal itself became scarce. Bruges in 1434 had half of its payments made in devalued currencies. In 1445 a committee of experts, mainly mint officers and bankers of the Saint-Georges office, considered the possibility of payment, by thirds, in gold, silver, and depreciated money. By the end of 1446, however, the powerful house of Centurione in Genoa, with important interests in the

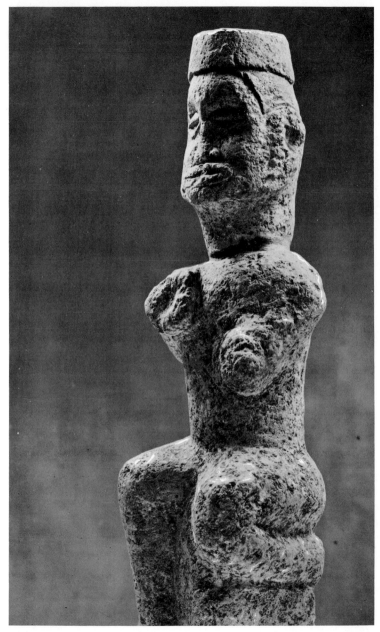

5. Statuette. Stone. 17th century. Bakongo. Congo/Kinshasa. Museo Luigi
Pigorini, Rome. Photo by the museum.

Levant, had used its influence to force the return to the gold standard governing the fluctuating currency exchange in Egypt. From then on, the entire market was in the hands of companies with significant reserves in solid gold. Large banks mustered their resources in order to reach the source of the fabulous metal, which it was thought the Arabs obtained in the Sudan region.

Certain facts, known very early, confirmed this assumption: in 1324 Gongo Moussa, Mandingo king of the Keita dynasty, whose portrait appears on the *Catalan Atlas*, brought on a devaluation in Cairo by his ostentatious expenditures of gold. Travelers wrote about the fantastic riches of Africa, but their works were not published until the seventeenth century, when the falsification of known facts in order to mislead competitors and the hiding of discoveries were no longer required by circumstances, since attention was now directed toward the Americas.

As early as the fourteenth century travelers were venturing into the Sahara, even before the coastal regions had been explored. A map drawn in 1320 according to the instructions of a Genovese living in Sijilmassa indicated a forty-day crossing of the Tafilalet, at Oualata. Besides the *Catalan Atlas* of 1375, there is a map dated 1413 which places Timbuktu at the crossing of four roads: one leads to Gao and Egypt; another goes to Tunis through the Hoggar; the third leads to Ciudad de Boudad and Tamstit, the capitals of Tuat, and beyond the capital of Tafilalet to Morocco; the fourth goes toward the Mandingo country.

In 1447 the house of Centurione, after having imposed a return to the gold standard, dispatched one of its buyers, Antonio Malfante, on a mission to discover the source of Sudanese gold. In

6. Portrait of Gongo Moussa. From *Catalan Atlas* (1375). Bibliothèque nationale.

his account of the journey, the emissary described Tuat and the Niger Basin; it is likely that he traveled to Timbuktu. He was not the first to venture so far into the continent. From 1405 to 1413 Anthelme d'Ysalguier, a Frenchman, lived in Gao where he married a Songhai princess; later he brought his wife and his two daughters back to France. An African doctor accompanied the couple and, while Charles VII was in Toulouse, treated and cured the King.

After Malfante's travels the interior of the Sahara disappeared from contemporary maps, for the largest banks found it to their advantage to conceal all sources of information, past or present, which might help their competitors. Yet the falsification of documents and the absence of precise maps could not obscure all African activity. Travel inside black Africa did not cease after 1447. In 1470 Benedetto Dei, employed by the Florentine house of Portinari, casually mentioned his trip from Paris to Timbuktu, where he proceeded after having witnessed the trial of Jacques d'Armagnac.

Pieter van Marées (1650), William Bosman (1704), and Father Godefroy Loyer (1714) all said that gold abounded in the coastal kingdoms of Guinea. Where did it come from? Since Ghana had traditionally been called the Gold Coast, was Eldorado situated in Africa? Between Grand Lahou and Accra the alluvial plains created by the disaggregation of the rock formation containing the original veins were rich in gold dust, though the percentage of gold content was lower than in the mines. This gold, which the Agni, the Ashanti, and the Baule melted into alloys to be fashioned into jewels, pendants, and funeral masks, was called "fetish gold" by the early travelers because of its ultimate destination. Some of the objects that Bowdich in 1819 thought were made of solid gold probably consisted of no more than a plating of chiseled or hammered sheet metal over a core of wood. The gold resources of the West African shores, though quite sufficient for local use, were inadequate for the demands and needs of a Europe ill-equipped for the exploitation of lodes whose location, furthermore, was kept secret.

The discovery of America rapidly altered the relationship between Africa and Europe and bore heavily upon the fate of Africa. After 1495 the slave trade became so heavy that a good part of the European economy and almost all the African economy depended upon it. Trading in slaves immediately became easier and more profitable than dealing in gold: easier, because slave traders were supplied directly by feudal princes on the coast; more lucrative, because the trade brought profit to many who were not directly engaged in it. According to Duarte Pacheco, in the period 1495–1521 the Portuguese paid 12 to 15 manillas (copper bracelets) for one slave. The choice of this currency was not accidental. At that time copper, lead, and tin mines were probably in the hands of Arabs who ventured beyond the Chad region. The need for these metals in the coastal kingdoms gave new life to the Flemish metallurgic industry (coppersmithing) and later, when Aachen became the center of this trade, to that of central Europe.

The Wicked Savage

This situation had important repercussions on European ideas regarding the arts and civilizations of Africa, and definitely influenced the course of both.

In the fifteenth century Arab and European travelers agreed that African states were well structured, that their people were prosperous, and that their cities were wealthy and had broad avenues. Yet an image of the black was soon created which, with little variation, has lasted up to very recent times. Some of the ideas were borrowed directly from the medieval myth of Sylvain, from the *Uomo Selvatico*. Montaigne was careful to distinguish between the savage and the barbarian: "savage," synonym of "natural," did not convey to him the derogatory meaning that the nineteenth-century writer gave it.

Africans have made no notable contribution, so to speak, to the myth of the noble savage. Shortly before the ecumenical council of 1439, which attempted to unify the Latin and Greek churches and possibly that of Prester John, blacks—except for

Gaspar, the third of the Magi kings, who became black in the fifteenth century—appeared only as servants or as secondary figures in Western iconography. (Watteau, Rubens, and Rembrandt made exceptions to this practice.) On monuments, on engraved frontispieces in atlases and travel books, blacks were represented merely as symbols of their continent.

The church of Saint-Jacques in Dieppe has three sixteenth-century bas-reliefs which symbolize newly discovered continents. Africa is represented by a black man and a woman nursing her child. Between these figures is an obvious reminder of original sin: an enormous serpent winds about a tree. According to the official doctrine of the Church, Africans could be considered as men only if they stemmed from Adam. The plurality of races was a difficult problem for theologians until an episode related in Genesis was recognized as a possible rationale. Noah's sons were the fountainheads of the three families that repopulated the earth after the Flood. Africans were reputed to have issued from the evil son Ham, whose children were cursed by the incensed father: "Cursed be Canaan; a servant of servants shall he be unto his brethren." In America the clergy had finally been aroused by the treatment inflicted upon the natives, already decimated by massacres and smallpox. It was thus with a humanitarian concern that slaves were deported from Africa. Moral scruples did not apply to blacks, much less pitiable than the Indians because they were physically stronger; at any rate, it was their lot to suffer the terrible biblical malediction. Thus afflicted, they had no alternative but to traffic with Satan. Were they not the bearers of his color? The popular medieval belief in the close association of black and the Devil was not solely to blame. Many eighteenth-century dictionaries gave "somber," "gloomy," or "infernal" as the meaning of *black,* and treatises on painting of the same period stated that black was the absence of all color.

The de Bry brothers' illustrations of the account of a voyage to the Congo by Filippo Pigafetta, nephew of Magellan's companion, include an engraving of the abjuration of Mani-Kongo 7 who was converted with his people and baptized under the name

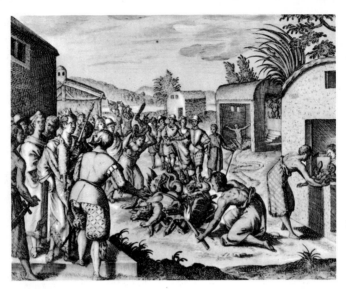

7. Théodore de Bry: Abjuration of the King of the Congo. Gravure, 1598. Bibliothèque nationale.

of Ferdinand I. All the idols are being burned in an enormous pile in front of the King, his dignitaries, and the Portuguese. In the background a Congolese prostrates himself before an altar over which towers a statue. On the right a zealous neophyte takes a sculpture from a sanctuary to throw it on the blaze. The idols are similar in form to numerous medieval monsters and the traditional representation of Beelzebub. The meaning of the bas-relief in Saint-Jacques in Dieppe is clear: according to sixteenth-century belief, blacks belonged to a stage of humanity which immediately followed the Fall.

It was not until June 1537 that Pope Paul III (Alessandro Farnese) issued a papal bill granting the rank of true men (*veri homines*) to the inhabitants of newly discovered regions, with the provision that they be recognized as capable of practicing the Catholic faith and of receiving the sacraments (*fidei catholicae et sacramentorum capaces*). In some areas, notably the Lower Congo, there were mass conversions, but they were superficial. After

the islands of the Pacific which nourished dreams and a pleasurable, slightly worldly exoticism from which Africa benefited only in the guise of pages in attendance upon great ladies. The notion of relativity in thought and mores set the pace in the thinking of the times. Philosophers enthusiastically discovered the technical skill, the ingenuity, and the tolerance of the Chinese; they marveled at the freedom of customs in the Pacific, in "New Cythera." But nowhere is there mention of Africa. Utopian constructs ignored it: Voltaire's Huron hero comes from America. When Europe finally recognized her ties with other continents, she was attracted toward the East, from the Indian war to the Egyptian expedition. Africa did not participate in "history," and thus the colonialist ideology found it easy to present the blacks as a primitive people still wandering in the darkness of man's infancy.

In countries where slavery prevailed, the economy was based on a traffic profitable solely to the class kept in power by its partners in the slave trade. Because it was supported from the outside, the feudal class structure was based on an unstable and gradually weakening foundation. But because of the slave economy from which it benefited, feudalism could subsist only at the cost of endless wars. Relations between states were warped and corrupted by the slave hunt. Societies disintegrated after having lost their best elements by death or deportation. An atmosphere of insecurity disrupted normal day-by-day existence. Societies, often isolated on barren soil and suspicious of all that was foreign, withdrew into themselves. During the nineteenth century, when European powers rediscovered Africa only to divide it among themselves, explorers, adventurers, and missionaries described morally and materially ruined states, barely surviving their own destruction. With neither comprehension nor generosity, the negative balance sheet of four centuries of slavery was attributed to the savagery of the African and to his ineptitude for so-called civilization. On two separate occasions, the encounter of European and African civilizations gave rise to immediate moral and intellectual justifications for undertakings that had neither moral nor intellectual aims.

Primitive Art

Scientific myths were the next factor influencing European judgment of Africa. Europe, discussing Darwin's biological evolutionism (a threat to her own religious beliefs) and elated by the first industrial revolution, shaped the concept of progress moving steadily forward on one unswerving path. This notion, based on technology, was immediately applied to customs, social life, and the arts. Technical progress was said to lie at the root of moral progress, serving as an impetus to the development of fine arts and letters. Non-European civilizations were classified according to their technological rating.

To follow the different systems elaborated by this historical perspective would be to go beyond the limits of this study. The principal idea is always the same: a shortcoming in one area has repercussions in other areas. For a given civilization, technological inferiority implies artistic inferiority. Neither science nor philosophy even began to question the notion of parallel development of all human activities in a single society.

Da Vinci bequeathed to us the very terms in which the problem is couched. The hierarchy of the arts is in complete harmony with the level of the civilization practicing them. Since painting is the foremost art, the blacks, limited to sculpture, are necessarily inferior artists. In 1846 Baudelaire (who two years later modified his opinion) wrote that "sculpture is a Caribbean art." In so doing he agreed with the statement of the museum specialist Edme Jomard (whose letter to de Siebold had been published the preceding year) that painting is the art of countries "already advanced in terms of civilization." The discovery of cave paintings later completely destroyed this theory, but not the principle from which it stemmed.

Under the impetus of Richard Andree, Alois Riegl, and Julius Lange, the structure of mechanistic determinism was shaken. In 1885 Andree admitted that nations on a low level of culture may have reached a higher level in the realm of art. As a logical counterstatement to this proposition, he even said that art does not always appear as the most elevated expression in the evolution

of a nation. Riegl, who opposed the mechanistic tendencies of the disciples of Gottfried Semper, held the view that style is the result of will manifested through three limiting factors: goal, content, and technique. Subsequently, the creative process and the selection of formal systems were emphasized. Although a work of art may be created within a primitive environment, it is not itself necessarily primitive. There was an increasing tendency to draw comparisons which, by diversifying reality, soon shattered the concept of primitivism. It was through the study of African, Oceanic, pre-Columbian, and archaic Greek art that Lange derived his law of frontality, thus establishing a link with the eighteenth century when Father Joseph Lafitau compared his observations among the "American savages" with facts about the ancient Greeks.

Without being purely academic, the debates nevertheless took place on a theoretical and general level; the works of art themselves seemed to be mere pretexts. As early as 1840 a substantial amount of artistic material flooded Europe, immeasurably enriching the original contents of the old collection rooms. Adolf Bastian was the first to urge his colleagues to "buy wholesale the products of primitive civilizations, if only to save them from destruction, and . . . gather them together in our museums." The plundering that ensued, a systematic and organized sacking of Africa, had immediate repercussions on Europe's interpretation of African civilizations. In 1914 Arnold van Gennep reacted violently, but justifiably: "Certain missions like those conducted by Leo Frobenius have stolen thousands of objects from western Africa and the Congo, ending native production in many tribes. What a revolting way to conduct scientific research! And all the more useless because, during this hasty and mercenary sacking, the explorer has neither the time nor the intention to study the social behavior that determines local productivity."

The collection of these artistic works served two purposes: to facilitate the study of already stored works and to instruct a varied public that might later have dealings with Africa about the customs, the mores, and the needs of the people about to be

colonialized. A classification system was set up whose apparently empirical basis resulted from a priori reasoning. Records prove that even before works began to arrive at museums, the system was already theoretically based in the most minute detail upon abstract European concepts: industry, clothing, currencies, and religion.

These concepts, prevailing among museum curators until 1914, as well as a preference for simplistic description of observed facts, have strongly influenced the interpretation and the aesthetic appreciation of African sculpture. Masks and statuettes were displayed in museum showcases or mentioned in monographs and treatises under such headings as religion, cult, and custom. Under the most favorable circumstances these works were considered to be mere ritual instruments; usually they were classified as fetishes and idols. From an artistic perspective they were looked upon as rough, clumsy, arbitrary representations of men, spirits, and gods. In fact, they were often judged in relation to classical sculpture which still remained the model of perfection, the ultimate step in artistic evolution. André Michel, in the 1898 edition of the *La Grande Encyclopédie*, confirmed these already accepted criteria: "Among Negroes, who are still very backward concerning art, as are all the races of central and southern Africa, one finds idols representing men, reproducing with grotesque precision the characteristics of the Negro race."

Although founded on an improper and scientifically erroneous identification of racial facts (physical characteristics) and cultural facts (intellectual modes of research and organization), Count Joseph de Gobineau's evaluation, dating from 1854, was nevertheless more sensitive: "The Negro possesses the highest degree of sensual feeling without which no art is possible." To be sure, the author of the *Pléiades* added a reservation: "The absence of intellectual aptitudes makes him [the Negro] completely unfit for the understanding of art and even for the mere appreciation of the high achievement this noble faculty of human intelligence is able to produce." The modern viewpoint destroys this restriction. Yet there is in Gobineau's statement a point that has been

more or less explicit in most artistic discussions from the nineteenth century until today: the existence of a duality between emotion and intelligence, sensation and consciousness, instinct and thought. This leitmotif was still present in the thought of Elie Faure when he discussed African art. It also pervades the interpretation of black sculpture given by expressionists.

Art historians, anthropologists, and aestheticians all concurred, at least until the early twentieth century, in a general deprecation of black art which varied only in degree. Sculptures and masks had arrived in Europe without indications as to their precise significance or purpose. Sometimes the origin of an object was known, but it seldom coincided with the village where the object had been acquired. Often the origin was quite vague, and the object identified on a card merely by ethnic group or by an enormous geographical region. There was no information regarding the personality or the individuality of the sculptor; in short, there was nothing that could help define his status in society, his calling, or his apprenticeship and its circumstances. Needless to say, no date, however inaccurate, was provided for a work except that of its listing in the inventories. It was taken for granted that primitive peoples had no chronological history.

European Artists Discover Black Art

Not only did these peoples lack a history; they also lacked an alphabet. Occidentals were perturbed by this fact. In spite of *Der schwarze Dekameron* by Leo Frobenius in 1910 and the *Anthologie Nègre* edited by Blaise Cendrars in 1919, Western ignorance of African literature produced important and unexpected consequences. Already lacking civil identity, the works of African art also bore no reference to written literary texts. No iconography was thus possible or even conceivable. If we recall that, even for Proust, the connoisseur in art was the one who could clarify the subject matter of a painting, we can fully understand the effects of such a deficiency on European appreciation. On the other hand, the absence of correlation between a plastic work of art and its literary counterpart was quite satisfying to painters

who aimed at a greater "autonomy of the plastic process" and the definitive rejection of a story line. Matisse, Braque, and Picasso strove for the suppression of the traditional rapport between painting and literature. No longer was it necessary that a painting illustrate a text or an event that might be interpreted in literary terms.

After 1906 the absence of reference to a text or a previous event was one of the factors that drew the attention of a few painters to black art. A mask or a statuette existed per se, in the fullness of its created whole. Well before the subject became known, the meaning of the work was expressed by strong and sensitive lines, the tension of contours and surfaces, the relation and equilibrium of masses, and the richness of volumes. Parisian artists, in their efforts to reduce the work to the plastic process and to its own unity, were encouraged by the reluctance of the African sculptor to convey anything fleeting or personal, by the rejection of imitation, description, and naturalism evidenced in statuary art.

The German expressionists of the Brücke and, to some extent, Vlaminck and Derain always maintained that African and Oceanic sculpture was authentically primitive. Emil Nolde, Karl Schmidt-Rottluff, Max Pechstein, and Ernst Kirchner shared a rather confused ideology when they preached the necessity of rediscovering instincts, ecstasies, almost visceral reactions attributed to the original man (*Urmensch*). Far from denying primitivism, German painters deliberately absorbed it without adaptation in spite of the fact that accepted dictates treated it negatively. In this process of identification they sometimes went so far as to substitute African masks for human faces in their paintings. Their statues were for the most part motley copies of genuine African sculpture.

Even before 1914 a few collectors had been acquiring black art along with modern paintings. The Stchoukine collection included several bronzes from Benin, and Eduard von der Heydt also gathered African works during that period. In France, Paul Guillaume, Frank Havilland, Félix Fénéon, and André Level

owned beautiful pieces. It may still be too early to appreciate
the impact of the movement to awaken the Western world to
the arts of different cultures. No doubt fashion played an im-
portant, if not a decisive, part in stimulating exoticism (which
Pierre Loti had already made unsavory), later reviving it by add-
ing previously untasted intellectual spices. Jewelers dealing in
feminine fashion were inspired by African pieces. The famous
couturier Paul Poiret reproduced a black mask in the advertise-
ment for his book, *En habillant l'époque*. The performing arts
were accustoming ears and eyes to other rhythms and colors.
Jazz, the Ballets Nègres, Josephine Baker, *A Negro Cruise* (Léon
Poirier's film), *Hallelujah* by King Vidor, and *The Creation of the
World* (by Darius Milhaud and Ferdinand Léger) all appeared at
the same time. These disparate conversation pieces also exerted
a profound influence on public consciousness. This Negrophilism,
as it was called, this affection for black culture, reached its climax
at the Exposition Coloniale de Vincennes in 1931. It swayed the
vote by which the national assembly granted financial support for
the Dakar-Djibouti Mission of 1931–1933.

Was the interest in Africa and its arts, partly related to vogue
and fashion, itself a passing fancy or merely a fad? It is as yet
difficult to answer this question with certainty; only factual
evidence will help to clarify the matter.

Fashion did have its effects, which from the beginning were
economic. It created a market which by 1965 had reached unfore-
seen proportions. As early as 1920 new private collections were
started in France, Belgium, Germany, and the United States. Gal-
leries that specialize in black art have been opening, quite a
change from the previous second-hand trade. Extensive exhibi-
tions (Marseille, 1923; Paris, Pavillon de Marsan, 1925; Galerie
Pigalle, 1931; New York, Museum of Modern Art, 1935) have
taken place with concurrent publication of illustrated albums or
catalogues. Last but not least, experts in primitive art have been
appointed for the famous auction sales at the Hôtel Drouot. In
1931 the collections of Paul Eluard and André Breton, as well as
that of Georges de Miré, were sold at very high bids.

The momentum of the movement can only increase. It has stimulated more detailed, more precise, and more scientific studies. Although research and reflection have not been the only results of the connoisseurs' interest, both have unquestionably received an impetus. The publication of or even the initial idea for certain studies would not have been envisioned had it not been that a real need existed. What is most important is that private collections, as well as those housed in museums, now possess most of the necessary tools for any type of research designed to go beyond the level of trite generalities.

The role of Africa in the new directions taken by European art is difficult to assess but extremely important. Perhaps the impact of African sculpture on Western culture is as significant as was the discovery of classical Hellenic antiquity for the Italian Renaissance. In 1920 Paul Guillaume thought so.

The work of Jakob Burckhardt and Arnold von Salis revealed that Italy during the Renaissance, and even in the Middle Ages, had not altogether lost contact with a past that permeated towns and countryside, a past whose traditions were rooted in literature as well as in sculpture and architecture. Actually the Renaissance merely strengthened rather than re-created such links, for the fundamental themes of antiquity were still very much alive. That of course was not the situation when Matisse, Picasso, and Braque discovered black art. The few examples of African sculpture known to these artists were often of average, if not mediocre, quality, but they were of interest because of the painters' specific preoccupations. From a mask or a statuette the artists sought technical solutions to the problems raised in their own work. They borrowed only to a limited degree, usually preferring to make broad adaptations.

To these artists, African civilizations, with their singular and enigmatic qualities, were truly alien. There were no texts—at least, no African texts—to facilitate initiation into their mysteries, to provide new themes for reflection, or to serve as a basis for the creation of a different concept of man. One could absorb the traditional thinking process of these cultures only through ar-

rangements of forms and signs. It materialized and expressed it-
self more easily and effectively in sculpture or in performing
ensembles such as choreography. Perhaps too much emphasis has
recently been placed on the role of the image in modern Western
civilization and on the essentially visual nature of perception.
Nonetheless, one should not misinterpret or ignore the impact of
an aesthetic revolution based on the discovery of a type of cul-
ture not grounded solely in literary phenomena, where the tra-
ditional relation between words and images was often deliberately
broken and frequently inverted. The real effect of African art
upon the course of modern art can now be appreciated. The arts
of Africa (and all the others produced by civilizations without
alphabets), acting together as formal sets, as catalysts, and as
model boundary lines, caused a reaction. Studies undertaken be-
fore the discovery of these arts and hence unrelated to them have
been amply confirmed.

Although cubism is not entirely an outgrowth of black sculp-
ture, it is no exaggeration to say that Matisse, Braque, and Picasso
have given to African art its patent of nobility, and that in so
doing they are at the very origin of the true discovery of the black
continent and of Europe's indebtedness to Africa. Truly a debt of
gratitude to Africa and to the primitive world was recognized,
at least on the artistic level, when in 1937 the Musée d'Ethno-
graphie in the Trocadéro became the Musée de l'Homme.

2

Historical Background

With few exceptions, Africans have not yet recorded their history in writing. Some Kotoko manuscripts survive in the Republic of Chad, but they are written in Arabic and date from later than the sixteenth century. Early in the twentieth century, Njoya, the sultan of Foumban (Cameroon), invented an alphabet so that a record of his reign might be preserved. He must have foreseen that from then on, because of European occupation, new ways of life would considerably alter native oral traditions. It was not until after World War II that a Nigerian chief had the history of Benin written down in English.

We should not, however, be misled. It may have been logical to question the existence of historical traditions at a time when African languages were not well known and ethnography was still exclusively descriptive, especially in view of the oral and sometimes esoteric nature of those traditions. In fact, such traditions, and local specialists responsible for their preservation and dissemination, do exist in Africa. Experts assist in training and conveying information to young men at the time of their

initiation into manhood and their integration into adult society in whose responsibilities they will share. Historians are often hired to record such events as the enthronement of a sovereign.

Black Africans have an appreciation of their own past and a need to find their roots in order to define themselves. Rhythmic narration of myths of origin, migration, genealogy, or heroism, sometimes complete with histrionic gestures, places the African in an organically developing time process, comparable to the growth of a plant. The present brings forth the past; the past provides the present with reality and authenticity.

In the Bambara country of the Republic of Mali, the people believe in the existence of caves inhabited by primitive men, their unclothed and illiterate forefathers. Their myths emphasize, among other things, the origin of speech and of the art of weaving, as well as of craftsmanship. They reveal that the main village role was played by the blacksmith. It is believed that in every village there lies preserved a copy of each of the tools made by blacksmiths. At each initiation, even before they reached the family altars, circumcised boys were shown the collection of tools identified with the ancestors who created them. Dogon myths have similar patterns: three "messages" or "ways of speech" are said to have been revealed to man. Each one marks an improvement in the evolution of technical inventiveness and indicates a transition in the concept of space from punctual (the point being equivalent to a seed) to linear (the line representing a thread in the weaving craft) and finally to three-dimensional space (volume being the equivalent of the armpit drum). These early observations make it evident that African societies have some consciousness and knowledge of their history, together with an evolutionary sense concerning material as well as spiritual progress. Techniques and ritual prescriptions are revealed simultaneously.

Despite the assertions of George P. Murdock, oral traditions do have value; they often constitute priceless, irreplaceable sources. But the reality of the stories transmitted by the traditions cannot be identified with events as they actually occurred. Traditions really are myths transformed into the customary vehicles

that convey mythical thought. Hired historians are not reliable, for they present an official, usually exaggerated version of events, all to the advantage of the sovereign in question. Yet, however difficult it may be to record traditions with accuracy, they are nonetheless a precious heritage. They can be checked against written documents of classical Greek and Roman antiquity, Arab works and archives since the tenth century, and records of European travelers since the fourteenth century. Archaeology also assists in restoring the African past to world history.

Prehistory: Mediterranean and African Cultures

Even when a mythical account seems to be formally correct, it can hardly conceal the incoherence and sporadic character of the information transmitted. So-called facts are often mere conjectures. Acceptance of them without question does not mean that they constitute an accurate configuration; in a way they are like black dots scattered on the white map of an unknown land. Remembering these precautions, let us consider what we know of the prehistory and populating processes of black Africa and what we can infer from its relation to Mediterranean and Egyptian cultures. First we must establish a framework within which the changeable reality of the Sudan, of the Congo, or of the Atlantic Coast kingdoms can best be historically defined.

Prehistoric Data

Lithic data characterize sub-Saharan Africa as very ancient Paleolithic, similar to Europe, or Mesolithic, passing to Neolithic with the introduction of pottery. In central Africa, bifaces of the Chelleo-Acheulean type and seemingly Neolithic weapons with tanged arrowheads have been discovered. Besides these tools, numerous human remains have been collected east of Chad, northeast of Timbuktu in western Africa, in Rhodesia, and in South Africa. None of the human remains even remotely belong to a black type as presently defined. According to Henri Labouret, "they all have characteristics in common with the Neanderthal, Cro-Magnon, and Negroid men of southern Europe exhumed in the Grimaldi caves near Menton." There are two possibilities:

first, according to Marcelin Boulle and Henri-Victor Vallois, the Grimaldi Negroids may have undergone, over thousands of years in the same location, an orthogenesis of specifically black characteristics; or, second, the ancestors of the present blacks may not have been native. The two hypotheses are not incompatible.

Mythical accounts say that when the blacks of central Africa settled the regions they now occupy, about 5000 b.c., they found a population of small men with light, reddish skin, probably ancestors of the Pygmies. This indigenous population survived by hunting and foraging, withdrawing into the equatorial forests. Herodotus, quoting Egyptian sources, mentions these small men, who were sometimes taken captive and sent to the Pharaoh's court to serve as acrobats and buffoons.

Valuable, reasonably uniform information is available on the demographic movements that populated Africa with blacks and on the possible contacts of these black people before they penetrated farther into the center of the continent. There is substantial evidence that the Sahara, at the time of the Roman Empire, was not a desert and that it was inhabited throughout by small black communities. Geological indications include traces, embedded in fossilized valleys, of mighty rivers which flowed down from the Atlas and Hoggar mountains. Zoological and botanical remains indicate that a residual flora and fauna, including crocodiles and midget elephants, still existed in the nineteenth century. Technological discoveries of massive, hard-to-transport equipment, such as polished ovate axes, stationary millstones, and crushers, suggest that the ancestors of the contemporary blacks were an agricultural people. Lightweight tools, probably used by shepherds, hunters, and warriors and including blades, knives, and arrow- and spearheads, were found in the north. Finally, artistic traces include frescoes and engravings located in the rocky relief of the Sahara, in the Hoggar, the Tibesti, and the Ennedi. Some of the paintings recently discovered prove the antiquity of institutions and customs still surviving in traditional Africa. In the Tassili, at the outpost of Aouanrhet, on a wall covered with representations of white, roundheaded women, a masked dancer

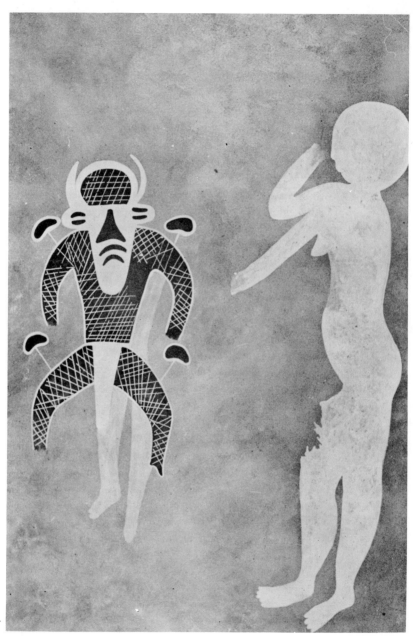

10. Masked dancer. Detail of fresco. Aouanrhet. Tassili, Algeria. Photo by
Mission H. Lhote.

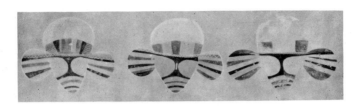

11. Three masks. Detail of fresco. Sefar. Tassili, Algeria. Photo by
Mission H. Lhote.

11 was found. A frieze (7.5 by 3 feet) showing three masks was
found at the outpost of Sefar. In the Ennedi Mountains, especially
at the outpost of Elikeo, Gérard Bailloud came across figures of
masks and masked dancers.

These discoveries prove that blacks were living, at an un-
determined period, in an area farther north than the region they
now occupy. They moved southward because of the gradual des-
iccation of the Sahara. Their rituals, similar to those presently
practiced by rural nonmigratory populations in many regions of
Africa, included agricultural, burial, and initiation rites, all mak-
ing use of masks. These agrarian peoples later made contact with
neighboring Mediterranean or Egyptian populations, some of
whom traveled to the Sahara. There is evidence of this movement
in the engravings and rock paintings indexed and classified by
Raymond Mauny in anticipation of a possible future synthesis.

Black Africa and the Mediterranean World

12 Isolation has too often been stressed as one of the essential
characteristics of the African continent. Of course, the reaction
against tendencies forbidding the Africans any cultural original-
ity made them distrust anyone who tried to define fields of in-
fluence or exchange. Yet, as information and data accumulate, new
analogies keep coming to mind. It would be unwise to discard
them without examination.

In *Peuples and civilisations de l'Afrique,* Hermann Baumann
13 reproduces a terra-cotta statuette fashioned by the Ibibio of the
Niger Delta. It represents a woman with outstretched arms bent
at the elbows and entwined with serpents passing under her arm-

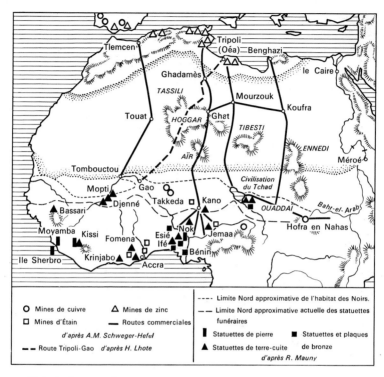

12. Historical map of western
Africa. After Henri Labouret.

13. Statuette. Clay. Ibibio.
Niger Delta, Nigeria. Drawing
by Hermann Baumann.

pits and around her neck and reaching down to encircle her naked
breasts. It brings to mind the earthenware snake goddess discov-
ered by Arthur Evans in the western chapel of Cnossus (Middle

Minoan III), though the two statuettes differ in many respects. The Ibibio work is definitely black in style, but the gestures of the two women and the way in which the serpent wraps itself around the arms and breasts are almost identical. Both works seem to be associated with analogous mythical and religious representations which, according to Ladislas Segy, can be found again and again in black Africa, in Egypt, and on the shores of the ancient Mediterranean. History and archaeology are now able to prove the existence of Minoans and Mycenaeans in the bordering territories, perhaps in Arabia and certainly in Egypt and Nubia where blacks had already settled, practicing customs that are still prevalent today.

In the House of Frescoes at Cnossus there is one African landscape with a blue Sudanese monkey and another with a white chief at the head of a black army, both of which belong to the same archaeological period as the snake goddess. Creto-Mycenaean objects have been uncovered in Egyptian tombs, such as those of the queen mother Aahotep and of Maket in Kahoun, and one has been found in a Nubian sepulcher. Pre-Hellenic remains from the Amarnian period are evident in Egypt, even in the palace of Amenophis IV. And perhaps Egyptian origins can be attributed to certain Mycenaean burial customs. Although it leads to no definite conclusions, there is an obvious and intriguing analogy between the so-called Agamemnon mask of Mycenae discovered by Auguste Mariette in the tomb of Khaemoast, son of Ramses II, and the eighteenth-century mask found among the treasures of the Ashanti king Koffe Kalkalli. These burial masks were made by the same technique of wax casting, now lost; both are of gold and were intended for similar purposes.

Among the Dogon, evidence can be grouped in a more uniform configuration. Denise Paulme has drawn parallels between the facades of African family dwellings and those of ancient Memphian and Theban houses. The appearance and motifs of the
14 "tower masks" recall the immense obelisk in Axum, Ethiopia.
15 Besides these analogies, there are similar mythical representations as well. Certain Dogon sculptures represent a couple, with the

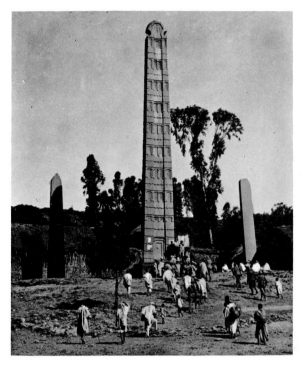

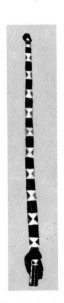

14. Large obelisk. Stone. Axum, Ethiopia. Photo by Viollet.

15. Tower mask. Painted wood. Dogon. Mali. Musée de l'Homme, Paris. Photo by the museum.

man's left hand always placed on the left shoulder of the woman. 16
Some of these variously stylized couples closely resemble the
Pharaonic sculptures at the Barnes Foundation in the United
States. Not every one of these works, but one characteristic series
of them, is quite close to Egyptian sculpture. Dogon myths some-
times recall certain traits of Egyptian mythology. Nommo, a spirit
who plays an essential role in Dogon cosmogony, is sacrificed to
heaven; his body is hacked into five parts which are thrown,
respectively, to the four cardinal points and to the center of the
quadrangle. Osiris comes immediately to mind. Nommo, some-
times represented as a figure with uplifted arms imploring rain, 17

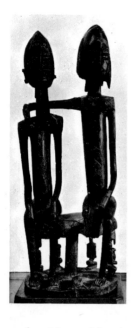

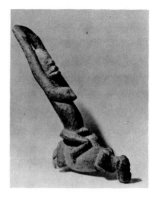

17. Representation of Nommo with
raised arms. Stone. Dogon. Mali.
Musée de l'Homme, Paris. Photo by
the museum.

16. Seated couple. Wood. Dogon.
Mali. Copyright 1966 by The Barnes
Foundation.

evokes ideas of fertility and birth, of purification of the primeval realm, and of the life-force. The Egyptian hieroglyph *ka*, with two uplifted arms, represents man and his double. According to Alexandre Moret, this character has a determinative function in the hieroglyphic system. When placed next to another sign it defines the latter's class and elevates it to the sacred; it also unites and symbolizes ideas of generation, food, and life-forces.

Another parallel drawn by Denise Paulme reveals similarity between the Ashanti and Baule technique of hammering gold sheet metal onto a core of wood and the ancient Egyptian technique. The similarity can be seen in certain sculptures (called *akuaba*) carried by pregnant Ashanti women and in the copper, bronze, or wooden Egyptian mirrors fashioned in the New Empire style. Finally, some Baule masks undoubtedly recall Pharaonic figures.

Numerous other analogies may be suggested. In Ife, among the Ashanti, the theme of the double human figure, probably associated with the worship of twins, is similar to that of some

small Etruscan bronzes. In Guinea other bronze figures evoke Coptic art. On a different level, Pierre M. Schuhl, in his *Essai sur la formation de la pensée grecque*, asserts that "a direct influence of Greek myths on the mythology of the Sudan is not unlikely." He illustrates his point with the analogy between the symbolic use of the spindle in chapter x of Plato's *Republic* which, according to Marcel Griaule, is also applicable to the spindle of the Dogon.

African cultures are characterized by a lengthy chronology and a slow evolution. It is nonetheless surprising to observe that recent wooden pieces, two centuries old at the most, evoke or retain the stamp, or at least a trace, of models as far removed in time as pre-Hellenic, Egyptian, or Coptic works. Yet one should

18. *Akuaba* (doll). Wood. Ashanti. Ghana. Piron Collection, Brussels. Photo by Mardyks.

19. Weight for weighing gold. Brass. Ashanti. Ghana. Musée de l'Homme, Paris. Photo by the museum.

beware of optical illusions. If all the evidence bearing on the direct or indirect influence of Mediterranean culture is gathered together, it may appear more significant than it actually is. It must be cautiously evaluated in its proper perspective; the objects that constitute such evidence are in fact scattered and form only a minimal part of the total data. Such analogies apply only to certain populations and, in each population, only to a narrowly localized stratum.

Archaeology

Archaeology can furnish documents and specify the elements that give coherence to the phenomena just described. In some regions, which have been more thoroughly studied than others, the present state of knowledge permits scholars to define a historical framework and to advance hypotheses on the origin and evolution of populations long established in the same territories. The Rhodesian complex, already an abundant source of indirect or highly emotionalized research, is now being scientifically examined. In addition, archaeology has supplied positive information and spectacular, enriching, and stimulating data on two important areas of research—the civilizations of Chad and Nok.

The Chad Civilization

The civilization of Chad, discovered by Jean Paul Lebeuf and A. Masson Detourbet, was developed by a people called Sao whose present descendants are probably the Kotoko. It arose in a vital area of ancient Africa crossed by age-old routes that ended most often in Kano, an important center for trade with the western Sudan and the Atlantic Coast. Presumably the area was originally much larger than the one presently occupied by the Kotoko.

20 The Chad civilization grew mainly in the delta region of the Chari River. Traditions, though in general agreement that the Sao came from the east, disagree as to their physical appearance. Some say their skin was black; others say they were fair. The so-called Sao population probably belonged to successive waves of immigration, but specific dates are rare. In the seventh century it was reported that a group of black Sao were slaughtered in the

oasis of Bilma, about 300 miles from Lake Chad. About 950 the Sao settled in the Chari Delta, living there in peace until the thirteenth century when the kings of Kanem-Bornu tried to enlarge their realm at the Sao's expense. The period of war ended at the close of the sixteenth century, and the Sao disappeared from written records.

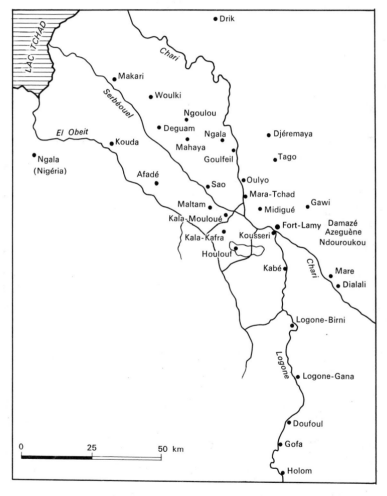

20. Archaeological map of Chad. After J. P. Lebeuf.

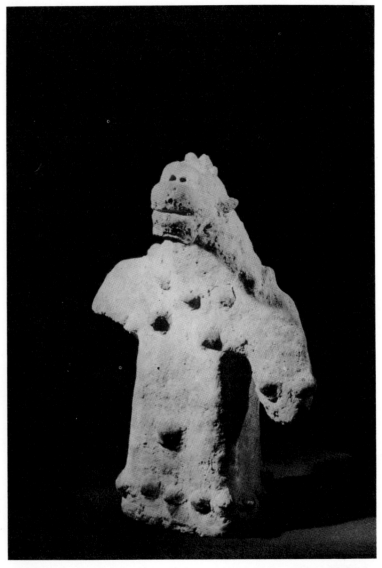

21. Statuette. Terra-cotta. Sao. Tago, Chad. Owner unknown. Photo by Edouard Berne, Caravelle Films.

Clay was the primary building and artistic medium of the Sao. Objects unearthed from sepulchral mounds range from large double burial urns to statuettes, spindles, and weights for fishing nets. Present processing of the clay, according to Lebeuf, reflects the earliest known methods of composition and treatment. The materials used, however, were not all of the same quality: pieces modeled in a delicate clay have been found near objects made of a rough clay mixed with particles that resist firing. Funeral jars were fashioned in a spiral design. The Sao sometimes used interior or exterior basketwork. The nature of their firing technique is not accurately known, but the characteristics of excavated objects suggest that the Sao used an open fire. This method would account for the fragility and the poor preservation of the more massive pieces. Yet, in general, urns and vessels, religious or domestic, show remarkable craftsmanship, and the different motifs indicate a variety of styles. The most spectacular pieces are 21 the pinkish earthen statuettes representing masked or deified 22 ancestors. Although of different styles, they all share a common function.

The Chad art of casting dates from the same period as their ceramics. According to Raymond Lantier, the fine work displayed "implies a long industrial past." Discoveries consist principally of bronze ornaments: arm and wrist bracelets, anklets, beads for stringing, earrings, pendants, and necklace clasps shaped like the head of a gazelle (at Midigué), a crocodile (at Mahaya), or a duck 23 (at Woulki, Mahaya, and Makari), a ring with a duck motif, and breastplates (at Midigué). Bronze libation cups excavated at Midigué disclose delicate, stylized, uncluttered patterns which even a master carver would find difficult to reproduce. Twisted cord, fringes, and braided designs appear on almost all the decorated pieces, and spiral shapes can often be found on the pieces of this collection, according to P. Hamelin. The complexity and refinement of the decoration were possible only because there was a close relationship between the lost process of wax casting and this kind of ornamentation.

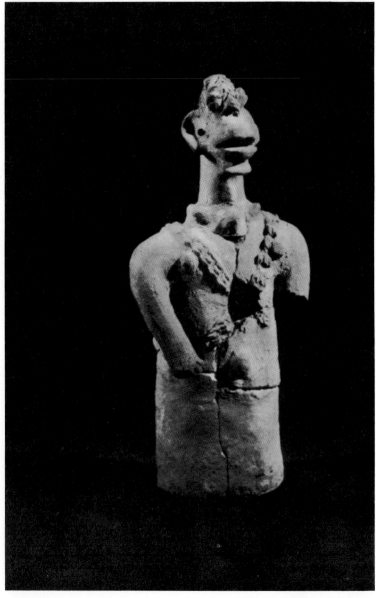

22. Statuette. Terra-cotta. Sao. Tago, Chad. Owner unknown. Photo by Edouard Berne, Caravelle Films.

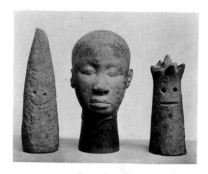

24. Three figures from a tomb.
Terra-cotta. Abiri, Nigeria.
British Museum, London. Photo
by the museum.

23. Head of gazelle. Bronze.
Sao. Chad. Musée de l'Homme,
Paris. Photo by the museum.

The Civilizations of Nok and Ife

Nigeria possesses almost all the elements needed to outline the history of African art, though much still remains to be excavated. This unusual situation exists only because the peoples currently living there either settled very early or adapted themselves to an already long-established culture. Continuous occupation favors the development of customs deeply rooted in the past, whose internal evolution can then be studied on the spot, and provides relatively homogeneous comparative data which strengthen scholarly assumptions. It has given rise to a certain historical consciousness which, although expressed in official and conformist terms, nevertheless left its mark on the culture of these people.

Evidences of the Nok civilization were excavated by Bernard Fagg in the tin mines of northern Nigeria. Although dating from the second half of the first millennium B.C., they do not seem to mark the beginning of a tradition. According to William Fagg, it is possible that "older terra-cottas of the same origin existed outside the area under study" or that the pieces "that preceded them may well have been of crude clay or of wood," thus leaving no trace.

The art of Nok has unity of style as well as broad diversity 24

in the conception of form. It oscillates between two extremes that might cautiously be defined as naturalism and an almost abstract stylization. There is no evidence that Nok art ended in the second century A.D., yet proof that it survived or expanded is lacking. There seems to have been a gap of approximately ten centuries between Nok art and Ife art. William Fagg deems it "logical to consider the possibility of a link between Nok art (the earliest known sculpture) and the art of Ife." Yet the comparison can be based only on terra-cotta pieces; no bronzes have been discovered in Nok. A relationship probably does exist between the two styles, but it is impossible to decide whether it is direct or collateral.

In 1950 William Fagg suggested that the Yoruba, present inhabitants of Nigeria, might have come from the upper Nile River during the early centuries of the Christian era. Perhaps it is more than mere coincidence that this migration occurred simultaneously with the introduction of Coptic Christianity into Meroë (Nubia) in the reign of Justinian and Theodora in the sixth century. Since contacts and relations between Nubia and Nigeria existed as early as the fourth century B.C., these movements took place over a long period of time. Migrations probably came in successive waves. According to this theory Nigeria was regularly populated by migrants from Nubia, where pre-Hellenic and Egyptian traditions were kept intact. Because the migrants ended up in regions occupied by peoples of the same origin, the situation was particularly favorable to the success of cultural grafting.

In the light of recent excavations, the art of Ife has been dated between the tenth and fourteenth centries A.D. It is not the only one conveying Mediterranean influences, but it has reconverted them to its own system of values. In spite of the thousand-year gap, the art of Ife is in fact related to the art of Nok. We are familiar with terra-cotta work and quartz stools, as well as with a few stone sculptures, one of which is a ram's head showing acquaintance with Yoruba beliefs in Shango. This work, in contrast with the ethnic art of the Yoruba, seems more like courtly art.

The kingdom of Benin was formed in the thirteenth or four-

teenth century. According to tradition, it was a caster from Ife who taught the art of bronze to the Bini. The link between Benin and Ife having thus been established, Bini art later evolved in its own way. Enough busts and plaques survive so that scholars can set up a chronology of Bini art from its origins up to the period of decadence, which began in the eighteenth century and ended at the close of the nineteenth with the British invasion and the pillage of the oba's treasures, now scattered throughout museums in London, Edinburgh, Leyden, Stuttgart, Berlin, Vienna, and Leningrad.

The first period of Bini art, still dependent on the Ife style, ended in the late fifteenth century with the arrival of the Europeans. The metal is thin, and the style stresses naturalistic tendencies although ears and nostrils are stylized. Stylization increased in the sixteenth century, the period of the busts of the queen mother, a title of nobility created at the beginning of the century by the oba Eséguié, and also of the most beautiful ivory work. By the end of the sixteenth century a sudden change had occurred: objects had become four times heavier and their variety and quantity had increased. Until the end of the seventeenth century the Bini continued to cast the plaques decorating the pillars in interior courtyards of the palace. During this ostenta-

25. Head. Terra-Cotta. Nok. Nigeria. Museum at Jos. Photo by Edouard Berne, Caravelle Films, from casting at British Museum, London.

26. Head. Bronze. 13th century. Ife. Nigeria. British Museum, London. Photo by the museum.

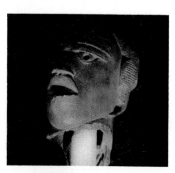

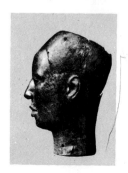

tious period Bini kings emulated foreigners who supplied bronze in exchange for slaves. The process of decadence started early in the eighteenth century: craftsmanship declined, manufacturing defects were more numerous, size superseded quality, traditional proportions were no longer heeded, and ornaments became more important at the expense of the facial features.

To the arts of Nok, Ife, and Benin must be added a homogeneous group of almost eight hundred large statues discovered in Esié, about 60 miles from Ife. This stone statuary may be dated after the beginning or even at the height of the kingdom of Benin, but the question remains open.

The Empires of Monomotapa and Zimbabwe

Monomotapa is the title of the king who governed the territory included in the curve of the Zambezi River. The Portuguese maintained relations with him as early as the sixteenth century, the companions of Vasco da Gama having learned about the existence of this land in 1498. The empire disappeared at the beginning of the modern period, but numerous sites distinguished by stone architecture remain. The ruins of Van Niekerk, of Inyanga, of Penhalonga (southeast of Salisbury), of Dhlo-Dhlo and Zimbabwe (near Fort Victoria), of Khami (near Bulawayo), and of Mapoungouboué (on the left bank of the Limpopo River above Bitbridge) cover a wide expanse. Other remains discovered in

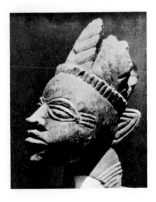

27. Head. Stone. Esié, Nigeria.

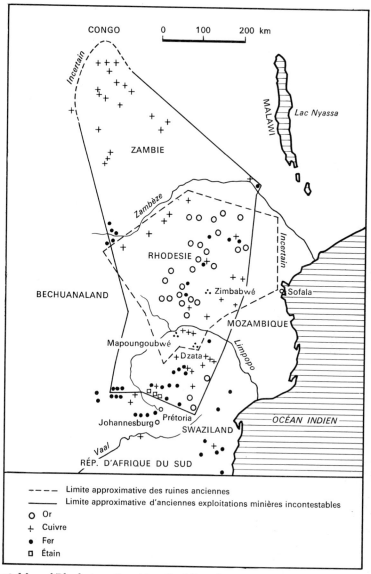

28. Map of Rhodesian sites. After Basil Davidson.

Angola, such as tombs and stone walls of unusual proportions, make credible what the Portuguese traveler Duarte Barbosa wrote in 1517: "The lord of Monomotapa is master of an immense land. It extends far into the interior and even to the Cape of Good Hope."

In all likelihood, the influence of Monomotapa was purely theoretical, or was the result of a prevalent myth against which the Portuguese were defenseless. If this region, Angola, and the Congo shared common cultural traits which formed a political unity, it is because in these countries small powerful kingdoms arose whose chiefs, among them the Lunda and the Luba, had a common origin, according to local tradition. Internal tensions probably caused members of the royal family to scatter and to spread their civilization throughout other countries.

Monomotapa literally means "Lord of the Mines." The history of this region before the arrival of the Portuguese seems to have been determined by the discovery of iron and the existence of gold and copper mines. Gold and copper were the bases of analogous, abstract representations of the person of the king. Moreover, according to João de Barros, a Portuguese historian of the fourteenth century, "the natives of this country call all buildings *Symbaoé*, which in their language means 'court,' since any place where Bénamétapa might reside would be a court. They say that all the other dwellings of the king, being royal properties, would bear this name." Indeed, between 1933 and 1935 in Mapoungouboué, the most ancient of all the sites according to the more recent research of G. A. Gardner, more than thirty skeletons were found buried with finely chiseled plaques, bracelets, and gold beads. Such remains, which in the nineteenth century were attributed to the Phoenicians or the Arabs and were accepted as the ruins of the mythical city Ophir, or King Solomon's mines, attest to a purely African type of construction. The present-day explanation is that during the first millennium of the Christian era agriculture and the use of iron gradually extended from Nubia toward the south, introduced by the ancestors of the present Bantu or by men of different origin. The Bantu

established their supremacy and intermarried with the people already settled there. Their descendants built Great Zimbabwe and its towers. Up to now only about 5 percent of the hill of Mapoungouboué has been excavated. It is a huge mound, probably artificially constructed, where chiefs and heroes were buried. 29

From its eastern coast, Africa started to trade with the East: coins and Chinese porcelain of the twelfth and thirteenth centuries as well as eighth-century Indian pearls have been found there. The Arabs usually served as intermediaries, but under the rule of the Oceanic Party the Chinese apparently reached the Somali coast on their own. A Chinese text, "Sung Annals" (1083), seems at times to suggest that the Emperor Cheun-Tsoung received an ambassador from the Zandj country on the east African coast, famous for its supply of ivory. The Arab historian al-Masudi, in "Meadows of Gold and Mines of Precious Stones"

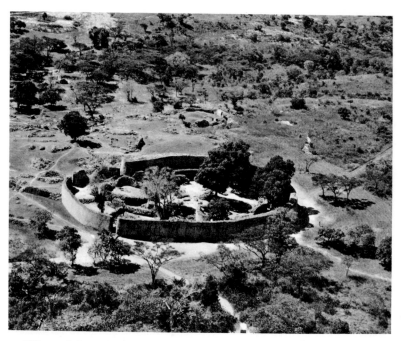

29. Ellipse of Great Zimbabwe, Rhodesia. Stereotype, Rhodesia House, London.

(947), says the tusks sold by the Zandj "are usually sent to Oman whence they are shipped to China and India." It was mainly through the Arabs, however, that Africa held the exclusive market in slaves and ivory. In the twelfth century, according to the Arab geographer Idrisi, India was ordering large quantities of African iron.

The presence of the Arabs, who traded on the coast and sometimes even inland, and commerce with the Orient have often served and still do serve as evidence to question the originality of the ancient cultures of the Rhodesian domain. Racism has no doubt made the discussions more emotional, thus hindering and finally paralyzing all research. The monuments, the most famous of which is Zimbabwe, were of African origin and can be linked to a culture whose traces still exist among the Chona, present inhabitants of the area. Archaeologists have outlined three broad periods. The pre-Monomotapa period extended from the fourth to the twelfth century, when the migration from the north took place, and led to the Monomotapa period, also called Chona I, which ended about 1450. When the Portuguese learned of the existence of this empire, the country was undergoing a period of turmoil, the Mambo period, called Chona II, which ended in the eighteenth century.

The massive stone works found at Zimbabwe date from the
30 Mambo period. The huge birds with folded wings are probably diving eagles linked to the water and thunder cults. Cups with diameters varying from 15 to 25 inches are decorated with broad exterior friezes of geometric design or depicting animals with
31 lyre-shaped horns, similar to the cattle found in southern Ethiopia. The backs of the standing Zimbabwe figures are marked by wide, deep, vertical grooves, and their legs are joined. The architecture of Zimbabwe probably dates from the period of Monomo-
32 tapa. The enclosure, with walls 33 feet high tapering upward from a base about 20 feet thick, was constructed without cement from large stone blocks. On the front is a chevron made of oblique tiles perpendicular to one another, which Damião de Goes and João de Barros interpreted as an inscription dating the site.

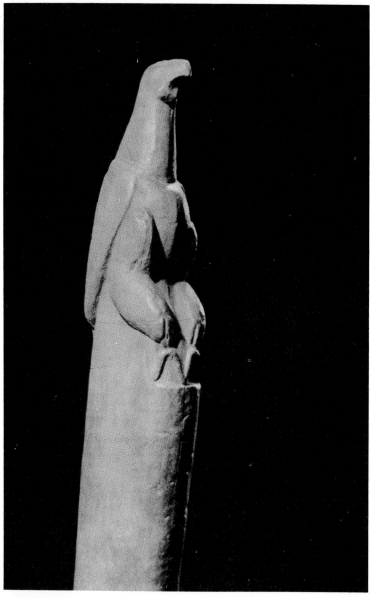

30. Fishing eagle. Steatite. Zimbabwe, Rhodesia. Photo by Edouard Berne, Caravelle Films, from casting at British Museum, London.

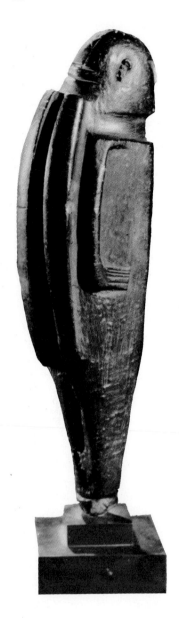

31. Figure. Stone. Zimbabwe, Rhodesia. P. Tishman Collection, New York. Photo by Edouard Berne, Caravelle Films.

32. Outside wall of ellipse of Great Zimbabwe, Rhodesia. Stereotype, Rhodesia House, London.

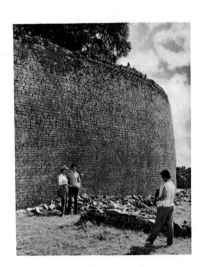

Kingdoms and Empires

Although these archaeological centers are far from solving the riddles of history, they at least are landmarks enabling us to sketch a rough framework in terms of geography, politics, culture, and chronology.

It is thought that the Rhodesian complex is linked with the Congolese civilizations. The archaeological data, specifically the excavations in Bigo (now Uganda), suggest that invaders from the north moved southward and, by introducing metallurgy and terraced agriculture, eventually became the aristocracy of the conquered peoples. If this supposition is correct, the variety of cultures spreading horizontally from Mozambique to the mouth of the Congo River reflect the great diversity of peoples that have been affected by similar cultural transplants.

The discoveries made in Nigeria depict a homogeneous culture, unified perhaps by a specific government (a hierarchy of noblemen with the royal family and the king at its head) or by a kind of militarism, together with urban development and the use of the lost art of wax casting. Nigerian art might be one manifestation of a type of culture which extended from Guinea to Cameroon, a culture whose traits were reinforced by the presence of Europeans and the slave trade.

The civilization of Chad, which calls for a more subtle interpretation, can be seen in the general perspective of Sudanese culture. Since the southern border of the Sahara from Senegal to Chad turned to Islam at an early date, Koranic proscriptions precluded the representation of animated beings, either men or animals. Nevertheless there was some artistic activity in the pre-Islamic period. Ceramics unearthed in Djenné and Mopti, between 33 the southern border of the Sahara and the fifteenth parallel, have 34 been attributed by Raymond Mauny to the twelfth century. The private collection of Baron du Ménil contains a terra-cotta figure 35 from the Dogon country whose style, texture, and firing point to a significant link connecting the Mopti, Djenné, and Chad figures.

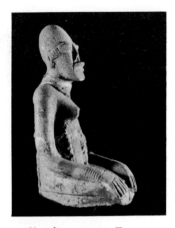

33. Kneeling woman. Terra-
cotta. Djenné, Mali. Musée
I.F.A.N., Dakar. Photo by
Edouard Berne, Caravelle Films.

34. Woman with crossed arms. Terra-
cotta. Mopti, Mali. R. Rasmussen
Collection, Paris. Photo by Edouard
Berne, Caravelle Films.

Western Sudan

36 In the pre-Islamic period (before the ninth century), accord-
ing to oral tradition, Mauritania was occupied by the Bafur, a
population of mixed origin from whom the eastern Songhai, the
central Gangara, and the western Serer are derived. In the Mau-
ritanian Adrar there are numerous ruins, and pottery decorated
like that of the present-day Senegalese has been excavated. The
Gangara founded the empire of Gana (not to be confused with the
present Ghana, formerly the Gold Coast) which, for some time
during the Middle Ages, ruled the Sahel and its neighboring
provinces. The capital of this empire was a meeting and trading
center for caravans coming from the Berber country on their way
to the middle valleys of the Niger and Senegal rivers. In the
eleventh century al-Bekri described the city as divided into two
sections, one inhabited by Muslim scholars and merchants, the
other containing the royal castle, the court of justice, and the
stone houses with acacia woodwork belonging to high dignitaries.
The fantastically rich king was able to ensure the respect and
obedience of his vassals with the help of a 200,000-man army.

 Between 300 and 790 the people living in Hohd, Aoukar, and

Ouagadou were conquered by unknown tribes. Arab historians claimed that this newly founded dynasty included forty-four kings. In 790, when the ruling king was assassinated, the country

35. Seated figure with necklace. Terracotta; iron necklace. Dogon. Mali. Baron du Ménil Collection, New York. Photo by O. E. Nelson, Kamer archives.

36. Historical map of western Africa. After Henri Labouret.

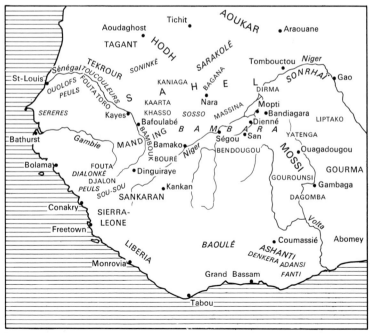

was taken over by Kaya Maghan, king of Ouagadou. This king, who was head of the lineage of the Sissé Tounkara, extended the northern limits of the empire to the Berber country, the western limits to the lands of Galam and Tekrur on the middle Senegal, and the eastern limits toward Djenné and Timbuktu. In 990 the reigning king seized Aoudaghost (possibly on the site of the present Tegdaoust). All Arab accounts concur in stressing the prosperity and the security of this empire. Its wealth, however, was also its sudden undoing: about 1061 an Almoravid ruler undertook a war against Gana which lasted fourteen years. When the empire disintegrated the small kingdoms resumed their independence. One of them established the Sosso empire which lasted until 1180, when the reigning king was overthrown by the warlord of the Kanté clan. In 1235 the empire crumbled, abandoning its lands for several centuries to the successive reigns of the Mandingo, the Songhai, and eventually the Hausa.

The Mali Empire

According to Henri Labouret, the inhabitants of the provinces now called Mandingo or Mali "bear no general name, but are designated by specific regional terms. One of them, the Mande district, was the cradle of the celebrated Keita dynasty which ruled the western Sudan in the Middle Ages and maintained close relations with the Moroccan sultans and with the most famous scholars of the Maghreb, of Egypt, and even of Portugal." About 1050 the chief of the Mande province was converted to Islam. For a century and a half three rather mediocre princes ruled. The last one, though powerful enough to terrify the emperor of the Sosso, was defeated by him and was assassinated with eleven of his sons. Soundiata, the only son spared, mobilized an army, reestablished his authority, raided the Tinkisso, attacked the eastern Balbara, and in 1234 entered Diériba, the capital. The emperor of the Sosso retaliated, only to be beaten in 1235. Soundiata became the ruler of the Sahel and of the gold-rich provinces, Gangara and Bambuk, of the former empire of Gana, and developed the economy of the country. When he died in 1255 he was succeeded by Mansa Oulé (1255–1270), a pious and wise

prince who augmented the land inherited from his father; but his two brothers, weak and cruel monarchs, were overthrown by a freed bondsman who took power and reestablished order between 1285 and 1300. After this interregnum the Keita regained power during an obscure period that ended with the accession of Kankan (or Gongo) Moussa (1307–1332) is represented on European maps, especially the *Catalan Atlas* of Charles V. His ostentatious expenditures dazzled Europe and the Islamic world; on a pilgrimage to Mecca in 1324 he spent enough money to bring about the devaluation of gold. During his reign the empire reached its height. Kankan Moussa maintained close relations with the Muslim states of Morocco and Egypt, and invited merchants from the Maghreb and various scholars to join him. One of the latter was Es-Sahéli, the poet and architect who is said to have created Sudanese architecture.

When Kankan Moussa died, the empire weakened despite a temporary improvement under the reign of Suleiman (1336–1359) during which Ibn Batuta visited the region (1352). From 1359 to 1390 fratricidal struggles increased. From 1400 on, data become scarce. The Yatenga Mossi devastated the western provinces. In 1443 the Tuareg occupied Timbuktu, Arsouane, and Oualata. Beginning in 1465 the Songhai, former vassals of the Mandingo, held the Niger Valley. Ill-informed Europe still thought of Mali as a powerful state, and in 1484 John II of Portugal sent ambassadors there. In 1534 the reigning emperor called in vain for the help of the Portuguese settled around the Gulf of Guinea. In 1542, and again in 1546, the Songhai sacked the province of Bendugu. In the seventeenth century the Bambara declared their independence, and the last of the sovereigns retired to the village that had been the cradle of his dynasty. In 1670 the Mali empire disappeared from the history of the Sudan.

The Bambara Kingdoms

The history of the Bambara kingdoms of Segu and Kaarta is more confusing and not well known. Segu, founded in 1679 by Fotigué, called Biton Kouloubali (1660–1710), lasted until 1890 when Colonel Louis Archinard arrived there. The only note-

worthy events were the battles against the kingdom of Kaarta and later, from 1859 to 1862, against the conquerer Hajj Omar. The kingdom of Kaarta, founded by a dissident group of the Bambara, survived until 1854, the date of Hajj Omar's arrival.

The Songhai Empire

The history of the Songhai empire is known through the accounts of two scholars from Timbuktu, Tarikh-es-Sudan and Tarikh-es-Fettach. The Songhai, who presently live in the Niger Valley, left the northern part of Dahomey in two rival groups, the Songhai and the Djerma. The first group consisted of fishermen who proceeded up the Niger River; the second, a group of farmers, remained in the south. The Djerma chose as their leader a Berber who founded the first capital in Koukya, whose site remains unknown. In 890 they conquered Gao, and in 1010, when their king converted to Islam, they transferred their capital there. The new capital became an important political and commercial center. Songhai history before the fourteenth century is much more complex than is suggested by their trade with Maghreb merchants.

From 1325 the history fuses with that of Mali, since the new strength of the Songhai came about at the expense of the rival empire, primarily under the reign of Sunni Ali (1465–1492) who retook Timbuktu from the Tuareg in 1468 and Djenné in 1473. In 1480 Sunni Ali repulsed the Mossi of Yatenga and finally defeated them in 1483. The son of Sunni Ali was overthrown in 1492 by one of his father's lieutenants, Mamadou Touré (1493–1529), who founded the Askia dynasty and showed excellent qualities as a statesman and organizer. He undertook a series of reforms, attracting scholars and learned Muslims. After a period of battles and conquests, Mamadou, by then old and blind, abdicated. From then on turmoil did not cease until the accession of the Askia Daud (1549–1582), and after his death disorder again prevailed. On 12 March 1591, in Tondibi, the Songhai armies were defeated by mercenaries in the service of the sultan of Morocco, under the command of a Spaniard named Djouder. The sultan lost all interest, however, when he learned of the conquered

country's poverty. Anarchy prevailed until 1780, when the territories subject to Morocco actually lived under the rule of the king of Massina or the king of Segu.

Hajj Omar (1797–1864), reputed to be a saint, waged a holy war against the infidels. In 1854 he defeated a Bambara tribe, but soon clashed with French outposts and General Louis Faidherbe in Senegal. Hajj Omar then concentrated his efforts on the Bambara and the Peuls. In 1861 he entered Segu and in 1862 captured Massina without being able to convert the Peuls. The last of the Sudanese conquerors was Samory Touré, born in Upper Guinea between 1830 and 1835. He opposed the French troops occupying the Niger Valley and was taken prisoner on 29 September 1898.

Central Sudan

Little is known about the empires of central Sudan because 37 chronicles are scarce. The few empires that actually existed were destroyed by the Peuls at the end of the eighteenth century and at the beginning of the nineteenth. Most important were the empire of the Hausa, which lasted from the beginning of the eleventh century until 1807 when the country passed into the hands of the Peuls, and the empire of Kanem-Bornu, first mentioned by al-Bekri about 1050, whose sovereign was converted to Islam in 1086. The reign of Idriss III (1571–1603) was the most brilliant period in the history of the latter empire, which disappeared in 1853. The history of the kingdom of Wadai coincides with that of its neighbors, Darfur, Kanem, and Baguirmi. Established as a state before the fourteenth century, Wadai disappeared in 1909 with the French occupation.

The empires instituted by the Peuls were in constant strife with their neighbors. The Peul kingdoms of Senegal, Massina (whose Dialloubé dynasty ruled from 1400 to 1810), and Fouta Djalon (seventeenth to nineteenth century) resisted Islam for a long time. On the other hand, the empires of Nigeria and Adamawa identified themselves as Muslim about 1804 under the leadership of Usman. When he died he left an empire encompassing the Hausa states, the kingdom of the Nupe, and northern Cameroon. The anarchy and revolt that followed soon after his

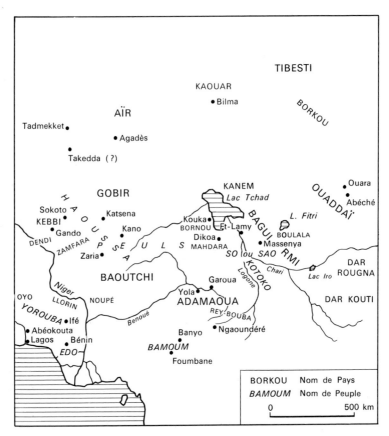

37. Historical map of central Sudan. After Henri Labouret.

death (1810–1815) lasted until 1900, when the country passed into the hands of England. One of Usman's disciples, Adama, undertook a holy war; from Cameroon, which he governed, he penetrated north to convert the infidels. After having fought the sultan of Mandara, he died in 1854, and his work perished with him; what remained were small rival emirates, ceaselessly struggling with one another.

Art in Federal Empires

An empire or a kingdom created in the western or northern

Sudan does not usually represent the same political or historical realities as its Western counterpart. Unification, seldom realized, often remains theoretical and is definable only in terms of lord and vassal. As subjects of a prince invested with authority, peoples who are grouped together in an empire maintain their individuality, their character, their cultural and economic interests. Groups identifying themselves as Muslims who undertake the conversion of infidels should, however, be considered as exceptions to this pattern. Yet such conversions, like Christian ones, are largely opportunistic and extremely superficial; only in cities and among ruling classes are they effective. The common people remain for the most part faithful to their own beliefs. Only in fringe areas, where a strong Islamic influence is felt, do traditional ritual objects such as statuettes and masks disappear.

Each population subject to a so-called large federation more or less retains its own traits: language, culture, economic interests. It is satisfied to reconvert or absorb new and foreign objects or abstract concepts. The Dogon, for example, have three separate myths of creation which can be reduced to the same fundamental structure. They state and explain the arrival on earth of a creator who brought with him the original seeds and agricultural techniques as well as the first ancestors of men and animals. In each myth his vehicle of conveyance is different: a bin filled with unadulterated soil; a kind of two-decked ark; or a trough-shaped *38* receptacle with a horse's head and showing a rider and his mount. The first, probably the oldest of the legends, is the only one known among the Fali of northern Cameroon. The third vehicle, which exists in many carved copies, was utilized in the purifica-

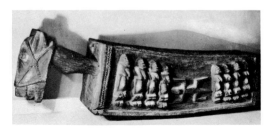

38. Trough with horse's head. Wood. Dogon. Mali. H. Kamer Collection, New York. Photo by O. E. Nelson, Kamer archives.

tion rites preceding a military campaign. The Dogon, however, live partly in an area where horseback riding would be almost impossible. From the fourteenth century on, the plains peoples were subjected to the forays of the Mossi of Yatenga and, in the nineteenth century, to those of the Peuls. Both these peoples were horsemen. The Mossi believe that the horse is endowed with exceptional powers associated with the military aristocracy and with the person of the king, the Mogho Naba. Many characteristics of the Dogon culture seem to have analogous elements or equivalents among the Mossi or the Peuls. Even though these characteristics are borrowed, they have since been fully assimilated.

If the establishment of Islam had not prohibited all representation of human or animal figures, the art of the western or central Sudan would not have been dependent upon the course of empires or kingdoms. It is indeed logical to think that each culture has a local art history: forms change within a specific style; vocabulary or themes may be borrowed from a neighbor-
ing art. If, however, a sculpture of a type identical with that of a Dogon statue were found accidentally among the Senufo of the Ivory Coast, or if a work similar to Bambara models were found among the Dogon, such discoveries would in fact be mere coincidences. Too many elements are missing to permit an interpretation of these analogies, or to consider them significant.

African wooden sculpture deteriorates rapidly because of termites and the climate. Far too often the works studied cover a span of time too short to enable us to understand their evolution. Without specific indications it is difficult to date such works more accurately than within two centuries. But there are exceptions:
numerous statuettes discovered at the cliff of Bandiagara have been attributed by the Dogon to their predecessors, the Tellem. When analyzed with carbon 14, however, they can be dated between the thirteenth and the fifteenth centuries. It was precisely during this period that, according to oral traditions and other sources, the Dogon arrived in the region.

Other indications make possible the tentative dating of orig-

39
40
41

42

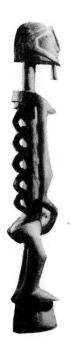

39. Statuette of an ancestor. Wood; polychrome face. Senufo. Ivory Coast. H. Kamer Collection, New York. Photo by Edouard Berne, Caravelle Films.

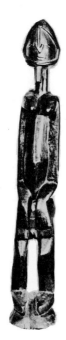

40. Statuette seen from front. Wood. Dogon. Mali. J. J. Sweeney Collection, New York.

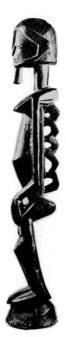

41. Statuette seen from side (40).

inal settlements: the Fang (or Pahouin) settled in northeastern Gabon in the first half of the eighteenth century. They have produced no sculpture since 1934. An artificial palm-oil patina protects the wood, so that the sculpures of this people, among the most beautiful in Africa, are also perhaps the most ancient. Still, because of the date of the Fang migration, it is impossible to go farther back than the early decades of the eighteenth century. The brief interval between this date and the time that sculpture disappeared partly explains the relative uniformity of Fang art, in a stylistic and especially a thematic sense. In contrast, among

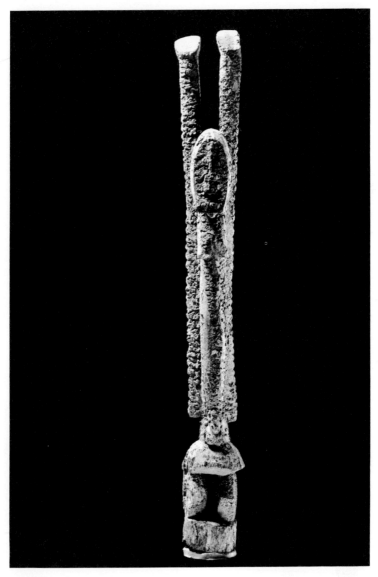

42. Nommo with raised arms. Wood. Tellem. Mali. H. Kamer Collection, New York. Photo by Raymond de Seynes, Kamer archives.

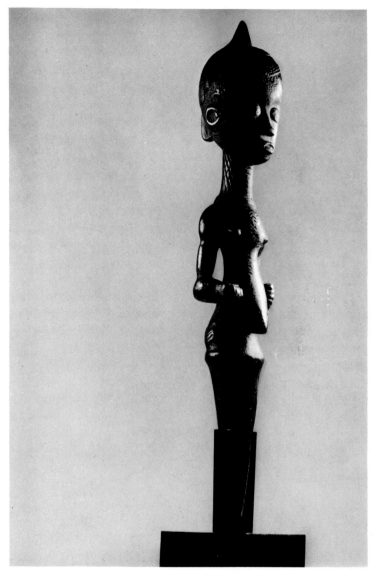

43. Female figure. Wood. Bena-Lulua. Congo/Kinshasa. Vérité Collection,
Paris. Photo by Mardyks.

43 the Bena-Lulua (Congo/Kinshasa) statuettes date from just be-
 fore 1880. At that time sculpture, the use of scarification, and the
 traditional coiffure were proscribed, to be replaced by the cult of
 hashish.

The Kingdoms of Guinea

Along the Gulf of Guinea and in the Congo, art and po-
litical history may be correlated. In these regions, characterized
by a permanent but evolving settlement of one ethnic group,
power is relatively centralized in the hands of representatives of
the same people. Whenever power is exercised by invaders, the
society becomes stratified. The conquered people keep some of
their specific traits and the cult of their ancestors, but a distinction
is established between tribal art and the courtly art reserved for
the ruling class. In federalized empires, on the contrary, each
people maintained its individuality, relations were established
according to an intertribal system of classification, and the rul-
ing class was frequently Muslim. These empires neither en-
couraged nor created courtly art.

The Empire of the Mossi

The empire of the Mossi deeply influenced the Kurumba
and Dogon cultures of the western Sudan. The empires of Yatenga
and Ouagadougou probably stem from the kingdom of Bambaga
(northern Ghana) whose sovereign, as early as the eleventh cen-
tury, held the entire region of Tenkodogo on the right bank of
the White Volta River. According to legend, his daughter, who
was in command of a small army, withdrew or escaped from
camp and met a hunter whom she married. The couple had a son,
Ouedrago (literally, "stallion"), who later conquered the lands
along the banks of the White Volta and hunted down or absorbed
the native populations, undoubtedly including the Dogon and
the Kurumba. The Dogon emigrated; the Kurumba remained in
the area and instituted agrarian practices. Some of these people,
who were renowned for the work of their blacksmiths, were em-
ployed by the Mossi to make arms.

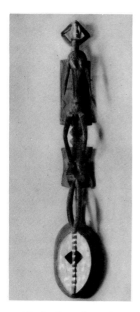

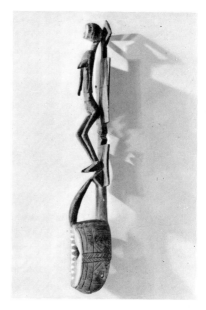

44. Blade-shaped mask seen from front. Wood. Mossi. Upper Volta. Princess Gourielli Collection. Photo by Edg. Elshoud.

45. Blade-shaped mask seen from side. Wood. Mossi. Upper Volta. Princess Gourielli Collection. Photo by Edg. Elshoud.

A few masks, called *wango*, are ascribed to the Mossi. Louis Desplagnes in 1906, as well as Lucien Marc, suggested that they are similar in structure to certain Dogon works. Young masked men were named Naba (i.e., "leader" or "master" in Mossi) by the Dogon. According to Louis Tauxier, when the Mossi occupied Yatenga they encountered the Dogon and pursued them toward the cliff of Bandiagara. Raoua, youngest brother of Ouedrago, established the settlement of Sangha in the thirteenth or fourteenth century, grew old there, and left a son whose descendants are probably still on the land. On the other hand, the Kurumba are probably akin to the Tellem with whom the Dogon came into contact when they migrated into the area. It is possible that the works attributed to the Mossi might actually have been Dogon; if so, the analogy between the *wango* and the Dogon blade-shaped masks would be explained. Finally, a fundamental characteristic

44
45

of Mossi culture is related to the horse cult; the importance of the equestrian theme in Dogon art and thought is well known.

The Mossi of Yatenga are connected with the Mali and Songhai empires. In 1333 they raided Timbuktu, occupied at the time by Mali armies. In 1477 the Mossi invaded the province of Bagana (vassal of the Songhai), ransacked Oualata in 1480, and were defeated by Sunni Ali in Gao. Later they successfully resisted the Moroccan sheiks of Timbuktu.

The Ashanti and Baule Kingdoms

In the mid-sixteenth century many small kingdoms of increasing strength appeared in the southern part of present-day Ghana: the Adansi, the Dyenkera, and the Akwamu. Around 1590 the Adansi dominated the Akan group, which included the Ashanti, the Agni, and others. The Adansi, in turn, were subjugated by the Dyenkera who maintained their hegemony until about 1680, when a young Ashanti chief rebelled and, with the help of his tribesmen, defeated the rulers of the country and expanded his territory. On this firm base he laid the foundation of the Ashanti empire which remained in power until the twentieth century. When he died between 1720 and 1730, his nephews Dakon and Apokou Ouaré struggled over the succession. When Dakon was killed, his sister, Aura Pokou, assembled his followers and fled with them to the central Ivory Coast where she founded the Baule kingdom. It lasted until 1880. Apokou Ouaré ruled until 1740 or 1749, strengthening his authority and power over the countries conquered by his uncle. For his ventures he bought firearms on the coast and exploited the resources of the land, particularly its gold mines.

46 It is very likely that during the reign of Apokou Ouaré the use of funeral masks on royal tombs and of pendant masks representing kings taken captive or killed in war became general.
47 Closely associated with the gold trade, small copper weights came
48 into use; their earliest motifs are thought to have been purely ab-
49 stract or geometrical. Weights that illustrate a proverb with a
50 figurative scene seem to be more recent. Except for the *akuaba*
carried on the backs of pregnant women, Ashanti art is essentially

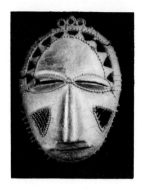

46. Mask. Gold. Ashanti. Ghana. Musée I.F.A.N., Dakar. Photo by the museum.

47. Weight, with abstract motif, for weighing gold. Brass. Ashanti. Ghana. Musée de l'Homme, Paris. Photo by the museum.

48. Weight, illustrating a proverb, for weighing gold. Brass. Ashanti. Ghana. Musée de l'Homme, Paris. Photo by the museum.

49. Weight, illustrating a proverb, for weighing gold. Brass. Ashanti. Ghana. Musée de l'Homme, Paris. Photo by the museum.

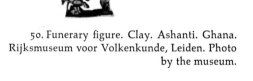

50. Funerary figure. Clay. Ashanti. Ghana. Rijksmuseum voor Volkenkunde, Leiden. Photo by the museum.

one of clay modeling or of the lost process of wax casting in copper and gold. Their kin, the Agni, are best known for their delicate terra-cotta figurines molded in clay by the women and destined for the royal tombs.

The group that emigrated with the queen Aura Pokou and took the name of Baule are distinguished by their sculpture in wood (masks, statuettes, doors, etc.) and their lost wax casting (gold masks, jewelry, pendants, etc.). The Baule may have learned the technique of carving and the use of masks and statuettes from their Senufo neighbors or from the people living in the area when they settled there.

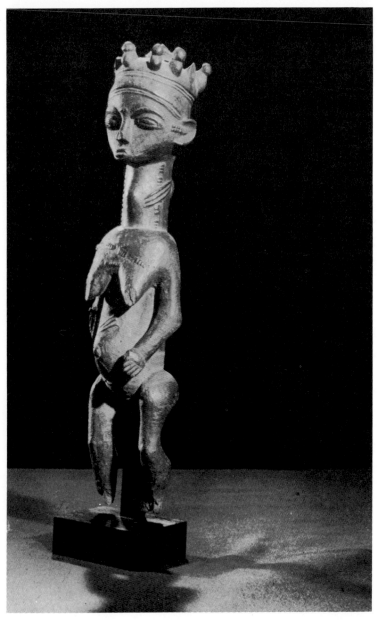

51. Statuette of a queen. Wood. Baule. Ivory Coast. P. Langlois Collection, Paris. Photo by Edouard Berne, Caravelle Films.

For the Ashanti, it seems, art is essentially regal, destined for the king and his family, embodying the values related to royalty or to the celestial afterlife of kings who watch over the destiny of their people from the great beyond. For the Baule, gold objects belong to the religious realm and are destined for the same ends. Woodcraft, related to family and village cults, appeared at the same time as the goldsmith's craft. Many Baule statuettes are obviously connected with royalty. One beautiful statuette of a queen possibly represents Aura Pokou. Most of the presently known sculptures, however, are related to an ancestral cult, to beliefs about celestial life preceding birth, or to cults of the genii associated with demonic possession. 51

The carving of wooden statues seems to have undergone an evolution. Some representations of couples in the great beyond, with severe and angular lines and faces painted white, have the appearance of ancient works but are not earlier than the second half of the eighteenth century. Other more secular works, characterized by carefully modeled curved surfaces and round shapes, show a subtle refinement and a certain elegant finesse and are probably of more recent date. Stylistic contamination of the effects achieved in cast objects may have occurred as modeling techniques influenced the art of carving. 52

The Kingdom of Dahomey

As early as the sixteenth century Europe obtained some slaves from the southern part of Dahomey. According to oral tradition, in the twelfth and thirteenth centuries a people named Adja lived on the banks of the Mono River between Tado and Athiémé. Later a split occurred, and some of the Adja moved to a nearby territory whose capital was Allada. The prosperity the new state enjoyed after subjugating its neighbors was endangered by rivalry among members of the royal family. One of the pretenders founded a small kingdom north of Abomey, and in the south another set up the kingdom of Porto-Novo. Although both these kingdoms were related to that of Allada, they became virtually independent in the sixteenth century.

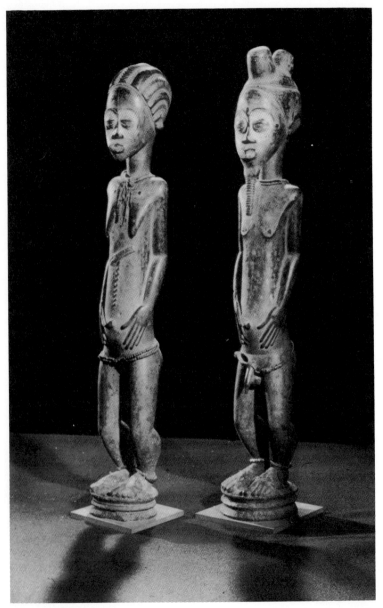

52. Couple. Wood. Baule. Ivory Coast. Museum of Primitive Art, New York.
Photo by Edouard Berne, Caravelle Films.

The kingdom of Abomey flourished through its profits from the slave-trade economy. Its first king was Deko (1625–1650), whose father had captured the Fors of the Abomey plateaus. Ouegbadja (1650–1680) and Akaba (1680–1708) completed the conquest of the region and subjugated countries to the east. Agadja, brother of Akaba, secured an outlet on the coast in order to increase his trade with Europeans. He occupied the kingdom of Allada in 1727 and two years later claimed to have control of the coastal cities. His successor, Tegbessou (1729–1775), clashed with the Yoruba who seized Abomey in 1738 and exacted annual tribute until about 1850. Kpengla (1775–1789) tried in vain to free Abomey from the foreign yoke, and under Agonglo (1789–1797) royal authority weakened. After a period of turmoil Gezo (1818–1858) re-created a powerful army, defeated the Yoruba, and stopped the payment of tribute, but he could not capture Abeokuta. In organizing the country he took numerous captives whom he disposed of at great profit on the coast. He concluded a commercial treaty with France in July 1851. His son Gléglé (1858–1889), and above all Behanzin, through their uncompromising attitude occasioned the annexation of the country by French troops in 1894.

Abomey art is closely linked with royalty and, at the same time, with daily life and religion. Sculptures and reliefs concerning the monarch place him chronologically as an actual participant 53 54

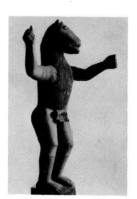

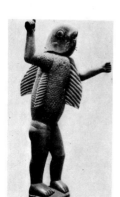

53. Gléglé as a lion. Detail of bas-relief. Clay; polychrome. Fon. Abomey, Dahomey. Musée de l'Homme, Paris. Photo by the museum.

54. Behanzin as a shark. Detail of bas-relief. Clay; polychrome. Fon. Abomey, Dahomey. Musée de l'Homme, Paris. Photo by the museum.

in leading historical events. Since the king is of divine essence, the pieces themselves are also endowed with a sacred character.

The Kingdoms of the Congo

The only written data on the kingdoms founded in equatorial and southern Africa are furnished by the Portuguese, who were often deluded by their impressions and had a tendency to exaggerate the importance and the size of these states. When Diogo Cão arrived with his fleet at the mouth of a river he called Zaire (the Congo), he was told of the existence of two large states: Loango, north of the river, and the Congo, south of it.

Loango, extending from Cape Lopez to the mouth of the Congo, controlled two small vassal states, Kakongo and Ngonyo, both inhabited, as they still are today, by the Fiot and the Bavili. By 1482 Loango had weakened and no longer controlled Mayombe or any of the small western kingdoms bordering on present-day Bateke. It seems, however, that Loango, as well as its neighbors, was subject to the authority of the Congo. It was customary for its sovereign to marry a royal Congolese princess.

The Congo was probably founded in the thirteenth century by a hunter-magician, a foreigner from the valley of the Kwango or possibly even from a territory farther east. Before the arrival of the Portuguese the land extended from the Congo River to the Kwango and Kwanza valleys. In 1491, when the Portuguese entered Mbali, capital of the Congo, they saw it as a simple native village. By 1550 they had built churches, a cathedral, and stone houses and had renamed the capital San Salvador, a name also designating the kingdom. When the sovereign, Nzinga Nkuwu, was converted to the Christian faith, his people followed suit. The conversion was superficial, for even before Nzinga Nkuwu's death a violent reaction occurred which his son (1506–1541) forcibly put down. Adherence to Christianity did not last long in spite of the efforts of John III of Portugal in 1548 and of Philip II in 1580, both of whom sent Jesuits and, later, Carmelite friars to the country.

In the second half of the seventeenth century rebellion alter-

nated with war. Several provinces broke away from the kingdom of San Salvador, and the country itself ceased to be Christian. This troubled period is reflected in contemporaneous art. Many crucifixes, statues of saints, and staffs of religious dignitaries were inspired by Portuguese models. Even when they bear the stamp of African genius, they are far from convincing. They were soon to be converted to the traditional cult usage. Thus a rather startling Catholic influence can be sensed in objects whose usage was not at all Christian. This land is prone to fetishism, and it seems reasonable to think, as some writers do, that the nails on 56 certain statuettes are related to a multiplication of the nails on 57 the Cross. The reliquaries enshrined in the abdominal part of cer- 55 tain sculptures, and occasionally hidden behind a mirror, could be an adaptation of the reliquaries of saints.

Data concerning the Congolese interior, the kingdoms of Lunda and Luba in Angola, are much more scarce and contradictory. Recent research in ethnology and archaeology, however, suggests that an individualistic and homogeneous civilization, closely related to the empire of Monomotapa and the Rhodesian complex, flourished in that area. Division into small kingdoms and ethnic groups, quite common in this country, could be explained as a result of secession and migration. A common origin linked the kings of Lunda and Luba.

Some of the ethnic groups in the central part of the country, the Bakuba in particular, have adhered to the customs of successive ruling kings. Tradition endows these kings with the invention and introduction of important crafts. Miélé, the eighty-sixth king, was a skilled blacksmith. During his reign the art of iron work reached a high degree of perfection; figures of men and animals were wrought on a very large scale. Shamba Bolongongo (1600–1620), the ninety-third king, introduced the weaving of cloth made of raffia fiber and the famous embroideries known as the velvet of Kasai. He especially encouraged sculpture and basket weaving. He was the first to entrust an artist with the task of representing him so that his successors could retain the memory of his person and his laws.

Art and the Historical Perspective

However fleeting and changing it may be, the historical out-
line sketched above brings into focus various relationships be-
tween art and the structure of society and political institutions.
Depending on whether they are created by culturally independent
ethnic groups still belonging politically to federalized communi-
ties or, on the contrary, by much smaller ethnically or culturally
homogeneous kingdoms with more permanent borders, these

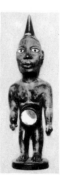

55. Statuette with rel-
iquary and mirror.
Wood; painted eyes.
Loango. Congo/
Kinshasa. Musée de
l'Homme, Paris. Photo
by the museum.

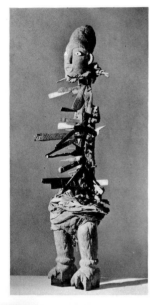

56. Figure pierced with nails.
Painted wood. Bakongo.
Congo/Kinshasa. Musée de
l'Homme, Paris. Photo by the
museum.

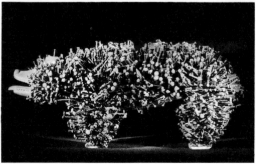

57. Animal pierced
with nails. Wood
and nails. Ba-
kongo. Congo/
Kinshasa. Musée
de l'Homme,
Paris. Photo by the
museum.

relationships are either flexible, favoring some innovations, or rigid, with certain fixed aims.

Most of the great empires came into existence in regions of dry savanna. Huge stretches of land and unlimited horizons aroused the spirit of adventure, inevitably shaping the fate and the historical perspective of sub-Saharan regions. The dynasties that were formed usually consisted of simple village chiefs who soon attracted adventurers. Many of these conquerors were endowed with political sense and a spirit of opportunism. When conditions seemed propitious, they converted to Islam. The course of their empires was, nevertheless, dependent upon their own capacities as organizers and chiefs of state. The surprising rapidity with which the empires were created can be matched only by the equal rapidity of their undoing. Huge states whose very expanse was an obstacle to the exercise of a personal omnipresent authority were by their nature decentralized. They comprised peoples with diverse interests who clung to their own cultural and economic background. This diversity partly explains the continuity of beliefs and cultural traits that violently resisted political and dynastic change, invasions, and the very existence of a system that, in some areas, tried to control the interrelations of various ethnic groups.

The Guinean and Congolese kingdoms were also founded in areas of grassy savanna, but primarily in forests. They were smaller and of relatively greater stability. As early as the fifteenth century those established on the Gulf of Guinea maintained relations with the Western world; the effects of this connection, although indirect, cannot be overlooked. The authority and prestige of the sovereigns were fortified, and the influence of the West was evidenced both economically and psychologically. It introduced a new conceptual and observational perception of the world. Even when encompassing diverse populations, these kingdoms were far from being federations, for the central authority was close to the areas it governed. Provinces sent their representatives to the court, organized as a hierarchy of dignitaries with the king at the top. Around the palace buildings cities were built, with

areas sectioned off for artisans. The king, surrounded by an aristocracy of noblemen and military chieftains, ruled through divine right.

When, as in the Congo, the aristocracy consisted of invaders, it had its own ritual customs and objects which it spread throughout the nation, retaining the sole rights to its own cult. The subject tribes kept their family cults, using more modest objects in the observance of them. Kingdoms of the Guinean or Congolese type reveal a clear difference in the materials of which objects were made, according to whether they were designated for the ruling invaders or for the conquered people. In the federalized empires this differentiation according to social class did not exist or, if it did, it was less obvious and only on the level of the ethnic group.

These observations invite new queries regarding the personality and the status of the sculptor and the rapport between art and society. Only after these facets are explored can the nature and the intent of masks, statues, and reliefs be systematically examined.

3

looks separately at masks

The Black Artist

The Western world indulges in dramatic, sometimes romantically spiced, biographies of its celebrated artists, even displaying a tendency to see in a painting nothing but the personal tragedy of the man who painted it. Yet, strangely enough, when the West looks at African art it shows little interest in the personality, the working conditions, or the position in society of the black sculptor. This difference in approach must be resolved, for even though the black sculptor is not granted a social status comparable to that of the European artist, he is not altogether a modestly anonymous craftsman.

A painting or a sculpture is not less beautiful or moving because its creator is unknown. Such anonymity, however, can hinder the observer's appreciation of a work of art. African arts are still waiting for their Calvacaselle. Usually the simple determination of the ethnic origin of a sculpture with a reasonable degree of accuracy exhausts the available information about it. A more thorough and precise analysis of the art of one ethnic group reveals the wide diversity concealed behind a superficial

unity. What is the cause of this variety? Is it the wide geographical distribution of workshops or studios? Or is it a historical evolution based on communication, imitation, or contamination? Is it a reaction to the pressures of social and religious systems and their possible transformation? A combination of these reasons is the most probable explanation.

First, it is necessary to analyze the nature of the black artist in order to describe him in relation to his technical environment. Under what conditions does he actually start learning his craft? How does he practice it, and for whom? What are his reasons for working? And, finally, how is he judged by his circle of friends and associates?

Techniques, Materials, and Tools

In Africa, sculpture in wood predominates, but the wood used is never chosen haphazardly. Rather, a series of regulations determines the substance to be carved. For example, certain models of masks and statuettes must be sculpted from specific tree trunks. Writers like Hermann Baumann and Eckart von Sydow, partly on the basis of this regulation, hypothesize a primitive cult of the divinity of the tree or the post to be used for sculpture. A piece of sculpture carved in a prescribed substance is, like the tree from which it was hewn, linked to the vital force of a spirit or an immortal ancestor on whose power a whole family of things and beings depends.

There are also technical reasons for the use of certain kinds of wood. Some species of trees are unsuitable for carving, either because they are too hard or too gnarled or, on the contrary, because they deteriorate too quickly from climatic conditions or under the assault of termites. It is noteworthy that ebony has been used only in objects intended for the tourist trade.

Depending on his locale, the artist possesses a more or less complete set of tools: various types of adzes, broadaxes, chip axes, hollow chisels, and double-edged knives. To this equipment he adds rough-surfaced leaves for polishing the finished sculpture and special palm-oil preparations for obtaining an artificial patina.

For polychromic statuettes or masks, the palette is quite limited. Colors are prepared from natural ingredients: kaolin for white, charcoal for black, and sometimes ochre for red or yellow. Since the colonization of Africa, chemical colors from European factories have appeared.

After taking the prescribed ritual precautions, the artist fells the tree he has chosen and marks off the part that seems suitable for carving. At times he takes advantage of a natural distortion in the wood, such as a knot or a forked branch, which strikes him as a figurative element that will enhance his own idea. He now has at his disposal a block in which he can work directly or in which he will carve a cylinder whose outline will be retained in the finished piece. Sometimes he makes notches to show the proportions he will give to each part of the carved figure. The carving is always done directly on the wood; the sculptor never employs a chisel. A wide-bladed chip ax is used to sketch in the outline of the head and the body. To rough out this vague silhouette, the artist utilizes two kinds of adzes with a short helve and a long, thin, slightly bent blade. A third type of adze is then used to complete the statue. For the details, such as eyelids and locks of hair, the artist employs knives. The Bakuba have a carving knife similar to an arrowhead, helved on a short, thick shaft; both edges of the pointed blade are sharpened. It is possible to carve by holding the blade firmly in the hand between thumb and index finger, the handle resting on the inside of the artist's elbow. In 1871 Georg Schweinfurth affirmed that the Mangbetu of the Ituri forest were the only people who used a one-edged knife. Various kinds of gouges and scrapers with two-branched forks for hollowing out wood have also been found. In general, according to William Fagg, "most sculptors prefer to work on the whole statue by successive stages, but some finish the head almost completely before dealing with the torso and its members. . . . It seems that the sculptor always bears in mind the whole composition of his work except for a few decorative details."

Sculptures in materials other than wood are less widespread. Sculpted stones have been discovered in specific localities: the

Kissi and Mende stones in Guinea and Sierra Leone, and Ife and
Esié work in Nigeria as well as in Zimbabwe. A sculpture acquired
in Sangha is Dogon in style and theme; its quality alone proves
that it is not an isolated work. Ivory has also occasionally been
used; from Benin come large elephant tusks carved with com-
plicated scenes in relief, sometimes placed on bronze heads. Other
Bini works include horns not always expressly made for Euro-
peans, pendant masks, and leopards in pairs. It is very likely that
ivory was used in Benin because of Portuguese interest in a ma-
terial rare and precious in the West. In the Congo, ivory was used
for musical instruments and ritual objects; the masks and small
ivory sculptures of the Warega are famous.

 Besides wood, stone, and ivory objects, there are sculptures
in clay, bronze, or gold cast by a technique similar to molding.
Pottery is women's craft; starting with simply shaped utensils, it
progresses to anthropomorphic vases, the most famous of which
are made by the Mangbetu. The woman potter rolls the clay paste
spirally, and then superimposes the layers, sometimes adding in-
ner basketwork to support the pot or the jar. With a gourd frag-
ment she smoothes the inside, then the outside surfaces which
she decorates with fine incisions and finishes with a coat of veg-
etable glaze. The jars are baked on a direct flame or simply dried
in the sun. Exclusively emblematic ceramics such as funerary
statuettes currently serve as archaeological data. Except for tomb
pottery recently produced by the Agni women in Ghana, it is not
known who molded these sculptures or what processes were
used.

 In the same style, works of bronze and of gold were decorated
by the lost wax process, which can be described in broad outline.
First the artist molds his work in wax, providing an outlet for the
melted metal in a kind of extension. The wax core is then covered
with powdered clay which, when wet, clings tightly inside every
intricate depression. On top of this first coating he adds another
of rougher clay mixed with kapok floss. When everything is
heated, the melted wax drains off the mold. The smith or the
goldsmith then puts the metal in a crucible which he adapts to

the neck of the mold, carefully sealing the two parts with clay. With the crucible at the bottom, he puts everything over the flames of an open fire which he stokes. When the metal begins to melt, the mold is turned over with a pair of pliers; the melted gold or bronze runs into the hollow form left by the wax. When the metal has cooled the mold is broken. The work is then separated from its stem, and the rough edges are removed with a chisel.

African artists, besides being wood-carvers, stonecutters, ivory engravers, molders, and melters, are accomplished iron-workers. Ironwork has been produced, however, in only a few areas: by the Dogon and the Bambara of Mali, the Senufo of the Ivory Coast, and the Bakuba of the Congo. Huge iron statues, sometimes more than life-size, originated in Dahomey. Among them was the statue of the god of war, storms, and forges which was transported to France in 1894. Certainly one of the masterpieces of world sculpture, it was made of pieces of European scrap metal, such as rails, bolts, and iron bars, which were hammered and riveted together. Dogon and Bambara ironwork includes ritual irons driven into the upper part of sanctuaries or laid on top of altars. Such an object is usually made of one piece of metal, which the smith has hammered and divided on the anvil while it was still a white-hot bar. The iron statues of the Bakuba are little known, though some of them are of high quality. They were also hammered and embossed from an incandescent mass of metal, without being soldered or riveted.

African artists can be classified in two large groups. First, the sculptor is a specialist from whom the client orders the objects necessary for his rituals. In addition to being the only one entitled and qualified to carve masks and statuettes and even practical wares, this specialist assumes further social responsibilities. In western Africa he is also the village smith. Second, the sculptor is a real professional practicing his art who, on occasion, is granted certain privileges and receives special honors. Two types of society seem to correspond to these two groups: the blacksmith-sculptor operates in societies based on a federalized

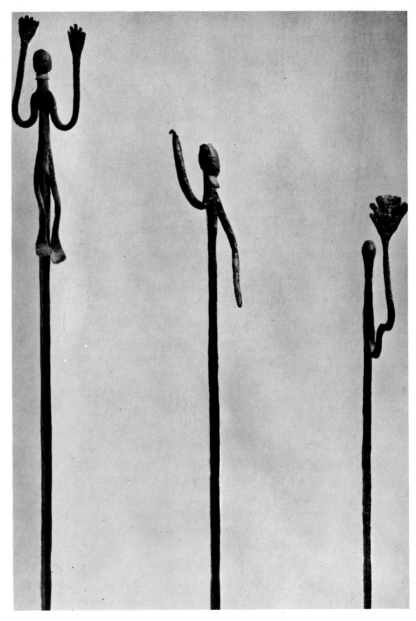

58. Ritual irons. Dogon. Mali. H. Kamer Collection, New York. Photo by
O. E. Nelson, Kamer archives.

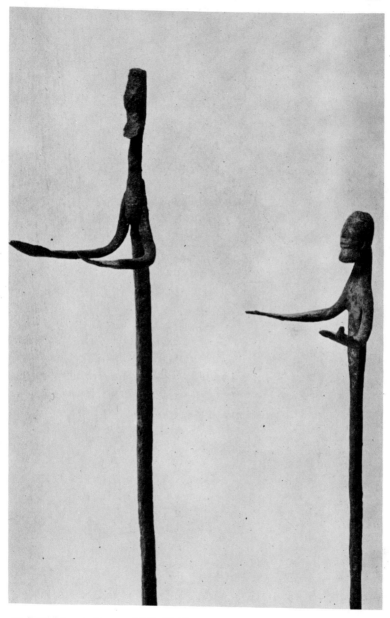

59. Ritual irons. Dogon. Mali. H. Kamer Collection, New York. Photo by O. E. Nelson, Kamer archives.

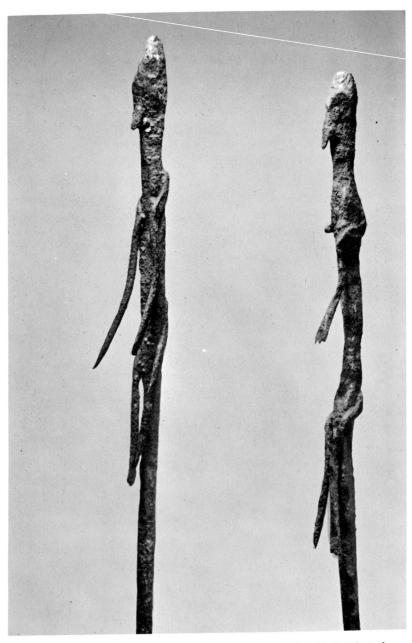

60. Ritual irons. Dogon. Mali. H. Kamer Collection, New York. Photo by
O. E. Nelson, Kamer archives.

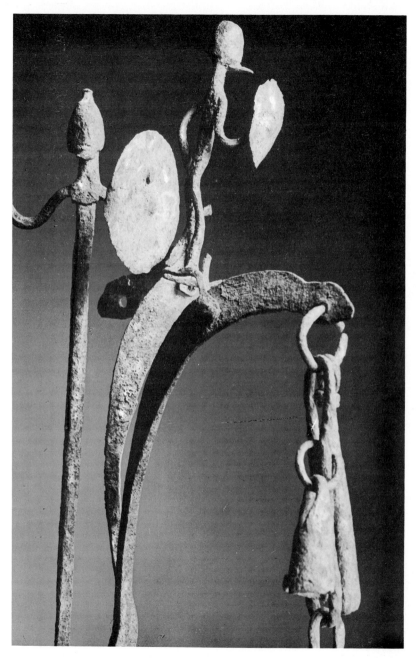

61. Ritual irons. Bambara. Mali. Vérité Collection, Paris. Photo by Mardyks.

62. Ritual iron. Bambara. Mali. Vérité Collection, Paris. Photo by Mardyks.

political system; the professional artist is found in kingdoms with a centralized and hierarchical power structure, and in most instances works in close proximity to the sovereign and his court.

The Blacksmith

Close study of African art reveals, in the background, an enigmatic character who seems to have in his possession the key to African cultures, whose origins and mechanisms otherwise remain singularly obscure. The smith is unquestionably a central figure, at the crux of many major concerns of the civilizations of Africa.

The blacksmith is primarily the craftsman who produces the iron tools (axes, adzes, knives, etc.) or the weapons (spears, daggers, blades, arrowheads, etc.) needed by an agrarian or a hunting people. Both the routine and the ritual life of the community depend on his activity. Besides producing the metal tools, he is also the only individual capable of utilizing them in the carving of ancestral and spiritual images for the local cults. To this dual activity, both technical and practical, he adds other functions of a specifically social nature. He often plays the role of pacifier or mediator, not only between members of the community, but also between the world of the dead and that of the living.

The social status of the blacksmith varies according to his locality. Attitudes the group adopts toward him also differ widely. Sometimes he is feared and held in contempt, sometimes he is regarded with respect; his rank in the hierarchies that regulate the society is not at all uniform. Quite often his wife is the potter; it is she who fashions, among other items, the earthen jars for the bellows. Among the Dogon, the Bambara, and the Senufo the blacksmith often lives apart from the village or in a restricted section. Because of the more or less sacred function entrusted to him, local attitudes regarding him tend to be ambiguous. For the Dogon he embodies a central and important element of their myths of origin: it is he who has descended from the sky bearing the ark containing the first grain, the primeval techniques, and the ancestors of men and animals. Among the Bambara, where a

similar myth seems to exist, the chief of the Kono initiatory society is, according to tradition, a blacksmith.

Because he is descended from the Creator and plays a vital part in myths, because he is by status also a craftsman who deals with equipment and necessary tools, the blacksmith seems particularly qualified to serve as a sculptor. The connection between metallurgy and artistic activity is not always so evident as it is among the Sudanese peoples; in the Congo, for instance, it is apparently ignored. The link between blacksmith and sculptor is part of the ways and myths of a given people and may well define the individuality of its culture. Or perhaps the original link weakened and finally broke because of historical circumstances or because of the differing trends followed by cultures in the process of internal evolution. To settle this issue would also be to answer the important unsolved question of the diffusion of iron in Africa. At any rate, the crucial role of the blacksmith in diverse African legends of origin emphasizes the historical importance of iron for the black continent.

Denise Paulme has stressed one peculiarity of black Africa: it omitted the typically Eurasian period of the Bronze Age, passing directly to the Iron Age. As to the origin and diffusion of metallurgy, two contradictory hypotheses are available. According to

63. God of war. Wrought iron. Fon. Abomey, Dahomey. Musée de l'Homme, Paris. Photo by the museum.

64. Detail of god of war (63).

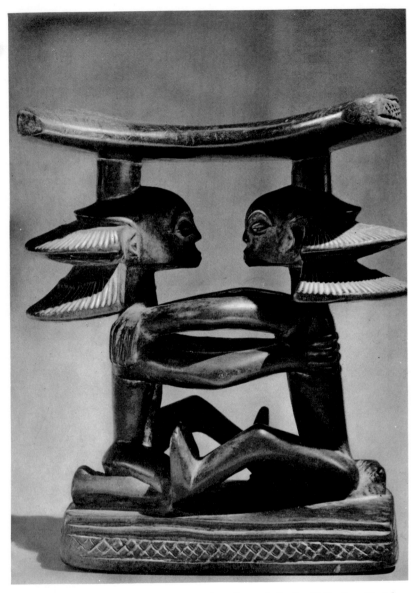

65. Headrest. Wood. Baluba. Congo/Kinshasa. J. Studer Collection, Zurich.
Photo by Musée Rietberg.

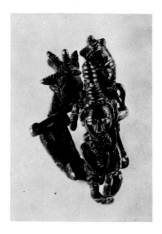

66. Weight. Brass. Ashanti. Ivory Coast. Vérité Collection, Paris. Photo by Mardyks.

Raymond Mauny, iron was transported via Saharan routes from Phoenician trading ports in Libya, whereas J. Laclant affirms that it came down from Meroë and the Nubian region. A study of the networks of communication and migration neither denies nor confirms either theory. The iron coming down from Libya or Kouch was used as early as 300 B.C. in the Sudanese savannas and had spread far beyond the forests by the end of the first century A.D.

In Meroë, slag heaps are located rather close to the Temple of the Sun, implying that the art of ironwork was a royal or priestly secret. The thesis of the Nubian origin of African metallurgy clarifies the respect enjoyed by the blacksmith in certain regions. Sometimes this craftsman had so much prestige that he took on high political functions. At the end of the fifteenth century the Portuguese learned that Mani-Kongo was a member of a very exclusive guild of blacksmiths. In the mid-nineteenth century, according to Heinrich Barth, the Tuareg held the blacksmith (*enhad*) in such high esteem that he was often the chieftain's prime minister.

The groups scattered throughout Libya or Nubia who were responsible for the diffusion of iron were neither ethically nor culturally similar. The people adopting the new techniques were also different, as were attitudes toward the status and the func-

tion of the blacksmith. A correlation can be established between the diffusion of iron coming from Nubia, where metallurgy was a royal or a priestly privilege, and the high rank enjoyed by the blacksmith in Congolese societies. On the other hand, iron coming from Libya was transmitted to the Sudanese societies. Here the blacksmith played an important role in the myths of origin, wherein he was considered a creator, as well as in the organization of social life. Yet, in spite of this double function, the blacksmith remained apart, belonging to a class of artisans whose status was determined by the Sudanese hierarchy.

The Professional Artist

There is a tendency to dissociate the sculptor from the blacksmith when these craftsmen attain respect and a high status. The sculptor then becomes a true professional, particularly in cultures where power is centralized and hierarchized. In some instances he is even considered a kind of royal functionary. The Bakuba send a representative of each profession to the court. The envoy of the wood-carvers, the most important one, carries his insignia—an adze with a carved handle in the shape of a human form—on his left shoulder. In Benin, work in bronze was exclusively reserved for the oba and his family. Craftsmen in bronze were united in the guild of Iguneromwo and lived in a special part of the city. The ivory workers (Igbesamwan), though also wood-carvers, did not work exclusively for the king. There was, in fact, a stratification of artistic work according to the rank of a craftsman's clientele.

In societies where power was in the hands of a king with divine right, sculptors enjoyed high prestige but were, by the same token, under a certain degree of bondage, particularly in the duty of reserving their production for the king or chief. Their office was not hereditary; they occupied it only after a period of apprenticeship. In this respect Africa resembles medieval Europe: the work of art is not a pure product of instinct, nor is it the result of an exalted and ecstatic act of creation which some misinformed minds have long thought to be characteristic of African

art. Africa produces artists in the full sense of the word. It is absurd to compare the work of the so-called primitive artists with that of young children or of the mentally disturbed, as was done in the twenties and thirties, in order to define a special and more or less pathological category of artistic creation. The African artist is a man who first of all learned a craft according to specific rules of an aesthetic as well as a social order.

A young man may become an artist either through inclination or through election by his colleagues. Among the Bakuba, for example, he learns the rudiments of the craft and, according to his capacities, may or may not be accepted. When, moreover, the artistic craft harmonizes with individual choice, the sculptor enjoys the benefit of being held in the highest respect. When the profession is hereditary, the status and the social position of the artist are rather like those of a craftsman. Among the Dan and the Ngere of the Ivory Coast, for example, the son succeeds his father who teaches him the craft; yet even in this instance the apprentice is encouraged to specialize in the type of carving in which he excels. Thus it is quite obvious that in African societies the sculptor is not by any means an inferior person; nor is he regarded as a mere producer of goods ordered by the group. In fact, his situation is enviable, for in some regions he is traditionally exempted from menial tasks; in some villages the people even used to raise money to spare him the payment of taxes.

"Some peoples in Dahomey," writes Michel Leiris, "have an attitude toward the artist which recalls, in a way, what we find in our own societies. According to Professor Melville Herskovits, the Dahoman artist is admired, it seems, for his talents, yet he has a definite orientation toward nonconformity; he is respected for his art but disdained because of his lack of interest in riches and prestige, the goals of most Dahomans." One Dahoman held an opinion about artists which might have been expressed by a young bourgeois European girl: "They are likable fellows but they don't make good husbands. Months go by and they don't seem interested in anything but their blocks of wood."

The Clientele

In Africa all artistic work is done on commission. The sculptor enjoys his craft and yet he does not work for the sheer pleasure of creating; the function of art is strictly social and is closely tied to religious life.

An order may be placed by a family, a village, or a state. Domestic and commonplace objects are usually commissioned by families: jewelry boxes and vanity cases, cups, butter jars, headrests, chairs, carved shutters and doors, and jars and pottery
67 dishes for the preparation or preservation of food. The wide va-
68 riety and the high quality of these objects are evidence of the
69 artistic refinement and elegance that characterize the most trivial
70 activity of everyday life. Even tools, such as Nigerian wrought iron axes and the bobbins used by the Baule for weaving in the Ivory Coast, are delicately carved. Whether it be a brass weight
71 from the Ivory Coast, a Bamoum drinking horn from Cameroon, a Baluba pestle for crushing cassava from the Congo, or a simple
72 Dan spoon, an object is never designed for utility alone. Even though there is, strictly speaking, no tableware in Africa, gourds

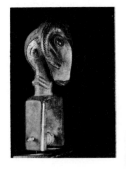

67. Bobbin used in weaving. Wood. Baule. Ivory Coast. Vérité Collection, Paris. Photo by Mardyks.

68. Bobbin used in weaving. Wood. Baule. Ivory Coast. Vérité Collection, Paris. Photo by Mardyks.

69. Bobbin seen from side (68). Photo by Mardyks.

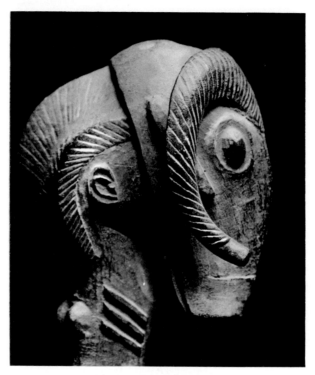

70. Detail of bobbin (67). Photo by Mardyks.

from Dahomey and Cameroon are skillfully carved with delicate and artistic geometric patterns.

The same diversity can be seen in textiles (notably, Kasai velvet and Baule loincloths) and in jewelry, sometimes of abstract design, sometimes stylizing animal or human shapes. The fine arts of ornamentation are highly developed in Africa, and the affectation shown by Africans, men as well as women, in their dress is to be credited to their aesthetic sense.

Because of the uses for which these objects are destined, they are obviously of a secular nature, yet an interpretation of their sculpted elements almost always detects a religious significance. Musical instruments in particular have this quality, for music is always linked to a ceremony or to a cult. Examples are

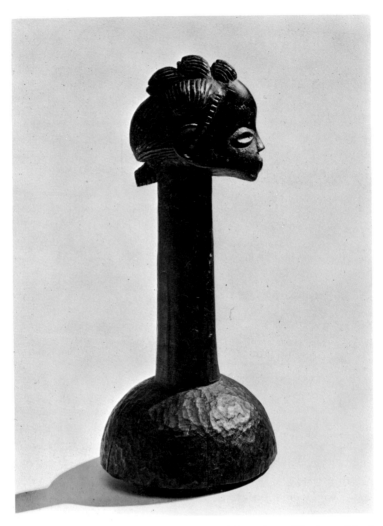

71. Pestle for crushing cassava. Wood. Baluba. Congo/Kinshasa. Musée Rietberg, Zurich. Former von der Heydt Collection. Photo by the museum.

72. Carved gourd. Bariba.
Dahomey. Musée de l'Homme,
Paris. Photo by the museum.

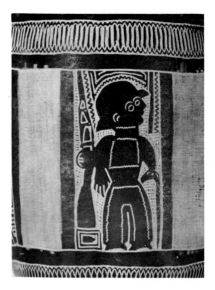

73. Harp. Wood. Mangbetu.
Congo/Kinshasa. Musée
Rietberg, Zurich. Photo by the
museum.

74. Detail of harp (73).

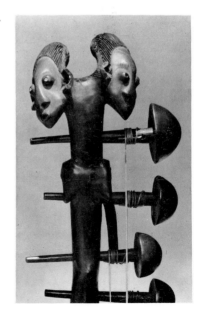

75. Drum. Wood. Yangéré.
Central African Republic.
Musée de l'Homme, Paris.
Photo by the museum.

76. Reliquary figurine. Wood covered with copper leaf. Osyeba. Gabon. Musée de l'Homme, Paris. Photo by the museum.

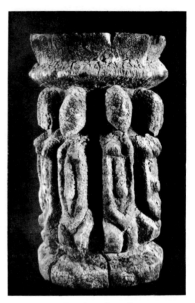

77. Statuette on basket of bones. Wood and wickerwork. Balumbo. Gabon. Musée de l'Homme, Paris. Photo by the museum.

78. Stool with eight caryatids. Wood. Dogon. Mali. Owner unknown.

75 the famous Yangéré drum at the Musée de l'Homme and the
73 strange Mangbetu harp, with its neck shaped like a hermaphro-
74 dite, recalling an episode from an ethnic myth. The eight small
78 figures supporting some of the Dogon stools represent the eight
genii, the Nommo, who are the ancestors of man.

The religious dimension is even more apparent in some of the objects ordered by the head of a family to affirm the ancestral cult. Every house has earthen altars holding ritual libation cups and statuettes which, without actually representing an ancestor, are considered to contain the family's life-force and thus ensure its prosperity. The Bakota of Gabon keep the remains of the
76 dead in a basket upon which they have mounted wooden figurines

covered with hammered and embossed copper leaf. The well-
known Balumbo statuette at the Musée de l'Homme also seems to 77
rise from a basket of bones. When a village became too small for
the whole population, families were split up. The chief of the
newly created group, carrying with him some of the earth from
the altar, had a new statuette made so that the ties of the family
with the ancestor of the group would be preserved. At the village
level the procedure is the same. When a new community is
founded, the chief of the village orders a statue which is some-
times buried on the premises. The sculptor is responsible for the
production of statuettes, ritual and everyday objects that only
he has the right to handle. Finally, at the state level, it is the
sovereign who wants his heroic deeds and those of his ancestors
commemorated. It is perhaps in this situation that the order and
the customer are the most demanding.

In most of its manifestations, African art is a tribal art. It may
even be called a village art, if this term is not given a derogatory
slant. Indeed, it may also be a courtly art. But only on occasion,
and then hypothetically, can it be designated a popular art, as in
the example of the masks made by nonprofessionals, such as
young men at the time of their initiation. The Dogon always have
their masks carved by those who are going to wear them during
burial or agricultural ceremonies. As noted by Michel Leiris, "an
art that is the product of professionals (in the cities, at least, where
the craftsmen are highly specialized, it could be termed 'schol-
arly' art) can sometimes be contrasted with an art of the com-
mon people." Research could then determine whether the art of
the people is really popular art.

Aesthetic Judgment and the Individuality of the Artist

Although it is tribal, courtly, and sometimes popular, African
art is certainly neither a collective nor an anonymous phenom-
enon, even if its function is to satisfy the spiritual and social needs
of a society. Even scholarly minds are still encumbered with a
great many romantic prejudices. First, the sculptor does not adopt
archetypes emerging from the depths of the ages, representing

the collective unconscious. If he did, he would have to be very careful not to alter them; he would have to suppress his own individuality in the face of tradition. Nor does he work in fear and trembling under the pressure of obscure and unknown forces. He simply fulfills an order and is paid a fee. The finished product he delivers is not itself laden with emotive content; only after the appropriate rites is it consecrated and impregnated with religious meaning. An unconsecrated sculpture may be sold, given away, or thrown out as rubbish, for it is lifeless. Never does an African confuse an image with what the image represents.

In fact, an artist is not free to choose his themes, which are prescribed by the future owner; neither is he free to choose his technique since, theoretically, he is bound to the style of the group in which he works. Not once in the course of his work does he yield to subjective impulses, at least not consciously. It may therefore be said that African art is essentially a classical art. The artist works within a framework of regulations which define the purpose of the finished pieces and specify the stylistic conventions; thus he concentrates all his attention on his work without being distracted by external considerations. Like the classical artist, he faces only problems of a plastic nature. The content is given to him; it is not what he has to say which matters, but the way in which it is said. Far from yielding to an irrepressible call that he would have to obey instinctively, helped only by his natural gifts, the sculptor succeeds his father or his older brother who supervises his apprenticeship and teaches him a trade along with the established repertory of themes and formulas. African art is a self-conscious and even an intellectual art; it is exactly the opposite of the instinctive delirium, the spontaneous creation, the primitive hysteria which Vlaminck and the German expressionists thought they had found in it.

Nevertheless, it does not follow that the artist is not an individual. Various styles emerge from the same ethnic group; among the Dogon and the Baluba there are at least four distinctive styles which do not correspond in the slightest to chronological evolution. The obvious fact that there are in Africa, in addition to

the first-rate sculptures, many more that are of average or of frankly mediocre quality seems to have escaped even some of the specialists. At the museum in Abidjan, Baule and Senufo sculptors copy masks and statuettes of their own ethnic groups. They work with models before them, chosen by visitors from display cases in the museum. The resulting works are faithful, honest, and carefully done reproductions, but they are as lifeless and as drab as the efforts of students at the Ecole des Beaux-Arts. Theoretically, the status of these artists is similar to that of their fellow artisans who work in their own villages for traditional customers, yet the directions given to the latter deal with the purpose of the work, not its style. On the other hand, those who work for the European tourist, or the African for that matter, must furnish a copy of a specific model, and thus follow prescriptions as to appearance and style. The village sculptor works without a model; the copier faithfully reproduces an object standing before him. It is when an artist works for a customer belonging to his own ethnic group that he feels the least inhibited. He does not repeat the same traditional model over and over again, but gives form to abstract elements. Although he follows the canons of his ethnic group, the fidelity with which he conforms to a type, probably quite loosely defined, allows for all sorts of improvisations.

It cannot be overemphasized that, in the eyes of Africans, sculptures are not always and not necessarily anonymous. Even after his death, an artist remains known. Michel Leiris cites the example of a Dogon artist, a certain Anségué, who enjoyed a reputation as an excellent sculptor. An antelope-shaped mask with long, pointed horns, found in Sangha in 1931, was attributed to him. The African artist is perfectly aware of his own talent. According to Baule beliefs, every human being lived in Heaven before he was born, but his earthly mate is not necessarily the one with whom he lived in Heaven. The celestial husband (or wife) may be manifested in a dream. The interested party then calls on the sculptor and, describing the heavenly spouse, orders his or her portrait. The Dan believe that the model of the very first mask was shown in a dream to a man ordered by some spirit

4

Art and Society

Differences in the status of artists are correlative to specific social and political situations. Can it also be said, then, that these situations define an aesthetic standard and determine artistic styles?

Temporarily, two distinct stylistic groups that seem to be connected with certain types of society may be defined. The first includes statuettes and masks whose technique and elemental design seem more or less rigid and geometrical. In the second group these same elements would be called "naturalistic." These two groups represent the two extreme poles of the highly diverse African artistic production. By examining the arts of the Congo, Nigeria, and the Sudan, each in their own milieu, we can characterize the two types of artistic output.

In the Congo and Nigeria (Ife and Benin) the function of art is to make known and exalt the abstract life values embodied in the chief, who is also said to be their guardian. Yet in these societies this function is expressed by widely differing styles. Two societies ruled by similar political and administrative systems do

not necessarily give rise to artistic works of a similar type, even when both produce courtly or official art.

The civilizations of the Sudan, on the other hand, differ in that they attach importance to the social relations among individuals and groups and to the link between the ethnic group and the rest of the world. Sculptures are not exhibited but are hidden from sight in the shadows of sanctuaries. Their stylization reveals that the sculptor's task is not to reproduce flattering and engaging likenesses but to create significant art objects. For instance, the headdress and the beard are compulsory attributes of the spiritual and earthly chief of the Dogon, the *hogon*. In masked ceremonies dancers wear the masks of the strangers whose parts they play.

Congolese Societies

The political and administrative organization of the Bakuba is complex. At the top is the Nyimi, direct descendant of Bumba, the god Chembé who created earth and all living beings. The Nyimi was an absolute monarch by divine right, but his rather honorific power was limited by an assembly of authorities, the Kolomo, representing nationalistic interests. The country regarded the Nyimi as embodying the supreme power, at least on the executive level. His power was not merely temporal, however, for he was responsible not only for the smooth functioning of society but also for the regularity of the elements—rain and sun —and the fertility of the soil. He had to observe some restrictions: not to speak while holding a knife in his hand; not to shed human blood even in war; not to touch the ground. His slightest ailment was interpreted as a sign of danger for everyone.

The statues of these kings, whose memory is also preserved in chronicles, are the masterpieces of Bakuba art. They are relatively small (about 20 to 25 inches). Each Nyimi is seated cross-legged on a cubical pedestal whose sides are decorated, and in his hand he holds a knife. The facial expression is impassive; the eyelids are half closed. Artistically carved bracelets are worn on the forearms and a belt goes around the hips and crosses over

the belly. Bracelets and belt are ornamented with cowrie shells. Sometimes a necklace is carved into the statue or hangs independently around the neck.

Each statue bears the distinctive signs of royalty and is the image of a specific sovereign. The full, rounded form of the statue *79* of Kata-Mbula (1800–1810), the 109th king, conveys a lively and almost voluptuous feeling. The hieratic attitude is tempered, leaving an impression of serene calm, timeless rest, peace, and profound wisdom. Although the artist did not really try to convey exact anatomical proportions, he did strive to characterize some of the individual features of the face. The lips, thick and prominent, are strongly delineated and carefully carved. The king is corpulent, with the relatively thick neck hidden by the head; his chin droops on his chest.

However striking or complex their nontemporal, religious dimensions, these sculptures were originally created as memorials and should be looked upon as true historical records of the Bakuba. As works of art they are strong and severe, serene and meditative; the posture of the king represented, however noble, remains human. Shamba Bolongongo predicted that when his successors "look upon my statue, they will probably think that I see them, console them in their sadness, and give them inspiration and courage." Here the sculptor bore in mind a living model. Forms are softened under the skin; surfaces are almost sensual, with curves neither tensed nor completely relaxed. The sculptural

79. Statue of Kata-Mbula. Wood. Kuba. Kasai, Congo/Kinshasa. Musée Royal de l'Afrique Centrale, Tervueren. Photo by the museum.

80. Statue of a king. Wood. Kuba. Kasai, Congo/Kinshasa. H. Kamer Collection, New York. Photo by Edouard Berne, Caravelle Films.

81. Statue of Mikope Mbula. Wood. Kuba. Congo/Kinshasa. Musée Royal de l'Afrique Centrale, Tervueren. Photo by the museum.

design clarifies and controls the free development of forms with tasteful contours, which are nevertheless very distinct. In the finest of the statues the artists seem almost to have transmitted the palpitation of living flesh to the ornamented, rigid wood.

80 Traditional authority is expressed by the pose of the royal personage, his headdress, his cowrie bracelets, his belt and cap, and finally, by the knife he holds in his left hand. Each king is identifiable by a personal attribute: Shamba Bolongongo holds a twelve-square game (*lela*) which he is said to have invented; in

81 front of Kata-Mbula is a carved drum which he is known to have played marvelously; before Mikope Mbula stands a small feminine figure which recalls his marriage to a slave with whom he had fallen in love and whom he had freed. These three statues bear little resemblance to one another. The face of Kata-Mbula is oval-shaped and his cheeks are well rounded. Shamba Bolongongo's face tapers down toward the chin. The head of Mikope Mbula is smaller than those of his predecessors and does not obscure his neck. These individual traits seem to have been observed and transposed from life. In fact, early commentators regarded the statues as portraits, as indeed they are—but not in the European sense.

82. Statue of Bope Kena. Wood. Kuba. Congo/Kinshasa. Musée Royal de l'Afrique Centrale, Tervueren. Photo by the museum.

Nevertheless, in this valuable series of sculptures a stylistic unity becomes readily apparent. Except for a few details, a number of these pieces are virtually identical, such as the statues of Mikope Mbula and Bope Kena (who died in 1895). They cannot, *82* then, have truly been life portraits with respective kings as models. Today the prevailing opinion is that the best-known statues were carved not at the time each Nyimi died, but at a much later date, probably in the last years of the nineteenth century. Thus the Nyimi are not necessarily personalized by features taken from their own physical appearance; the sculptor, however, was not satisfied with merely characterizing them by function. Each is identified with objects or motifs related exclusively to him, referring to events contemporaneous with his reign or narrated in his biography. Summed up in an unpretentious carving, the events portrayed are concerned with the king not as an individual, but as a national symbol, inseparable from the fate of the people. These statues embody mythical values, but situate them in a temporal line of succession: ideals slowly shift into history. The shift is likewise noticeable in other aspects of the culture. The Bakuba take their national chronicles very seriously, and they have a strong and confident awareness of the value and of the individuality of their culture.'

Beliefs that identify the sovereign as the keeper of all human and cosmic life, the keystone of society and the world, are here associated with figures tending to individualize the royal person.

Although a strong tendency to personalize the works is felt when
the king's position is similar to that of the Nyimi, the opposite is
not always true. In other societies where the king bears the same
symbolic burden, the style of the figures may be entirely different,
as seen by observing three neighboring peoples, the Bakuba, the
Baluba, and the Bakongo, all of whom traditionally support a
royalty by divine right. Their societies are of an aristocratic type.
The example of the Bena-Lulua is not so clear-cut, for they seem
to have kept a village-like organization with local chiefs. This
organization may be a consequence of the break-up of power, the
dismantling of the Congolese kingdoms.

For these peoples statuary has a function analogous to that
of the royal Bakuba sculptures. Unfortunately, Baluba art is un-
known except for the works of the eastern region, which escaped
missionary fanaticism. Some models are portraits of the dead
(*mukusi muhasi*). These carved representations of ancestors are
meant to appease the deceased who pursues the living in his
dreams. Others are more closely linked with power: representa-
tions of chiefs or their ancestors, figures on top of a command
staff, chiefs' thrones supported by caryatids. The Bakongo used
to sculpt statues that were called *mintadi* (lit., "guardians") and

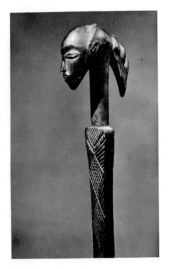

83. Command staff. Wood. Baluba.
Congo/Kinshasa. Musée Rietberg,
Zurich. Photo by the museum.

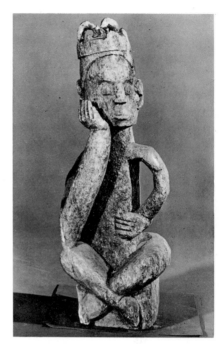

84. Statue of tribal chief. Steatite. Bakongo. Congo/ Kinshasa. Musée Royal de l'Afrique Centrale, Tervueren. Photo by the museum.

very likely were images of the village or clan chiefs (*mfumu*). *84* Entrusted to the direct heir of the *mfumu*, these statues were held by the family until the death of its last member. Then they were displayed on his tomb as embodiments of the spirit of the deceased chief and as guardians of his descendants and the destiny of his people. At first they were carved in wood, but later examples are in stone, probably because of a desire for permanence and durability.

The Bena-Lulua produced finely sculpted masculine figurines, helmeted and armed. These works are fairly old, for the practice of covering them with scarifications ended in 1880, when introduction of the hashish rite ruled out that practice as well as the use of elaborate headdresses and even sculpture itself. Such statues were carved before a chief set out for a war or for a hunt, so that his effigy could watch over his people during his absence.

The posture of the royal Bakuba statues is identical with

that of the Bakongo *mintadi* from which they probably derived.
The pose—a meditative and contemplative sovereign sitting
cross-legged—conveys the essential reason for the carving of the
statue: the king is in meditation, still protecting his lineage and
his people after his own death. His effigy is a token of the per-
manence of his presence. Yet there the similarity between the
Bakuba and the Bakongo statues ends. Although these works are
linked together by a common belief and purpose, as well as by
certain aesthetic analogies, their styles nevertheless seem quite
different. Imitation is never entirely passive, and, in spite of direct
influences in this instance, similarities between social systems do
not produce uniformity in style. Here again the determining per-
sonality of the black craftsman manifests itself.

In the same way the Bena-Lulua have assimilated qualities of
Bakuba art which expressed their own taste and sensitivity. The
pattern of decoration used in Bena-Lulua statuettes is similar to
the Bakuba design sometimes found on royal statues but usually
seen on everyday objects, such as vanity boxes and cups. The
same pattern is even woven into the raffia fabric commonly
85 known as Kasai velvet, whose motifs have been classified ac-
cording to the precise names given them by the people. But,
whereas the Bakuba ornamentation enhances the richness and the
almost sensual sumptuousness of these works, the patterns on
86 Bena-Lulua sculpture follow the quiet, graceful elegance of the

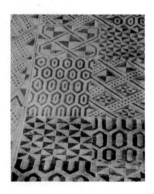

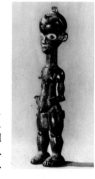

85. Kasai velvet. Detail of
fabric. Raffia. Kuba. Kasai,
Congo/Kinshasa. H. Kamer
Collection, New York. Photo
by Edouard Berne, Caravelle
Films.

86. Female figurine.
Wood. Bena-Lulua.
Congo/Kinshasa. Musée Royal
de l'Afrique Centrale, Tervueren.
Photo by the museum.

forms themselves. This simple decoration, seemingly the work of an engraver or a goldsmith, covers every surface, but it remains an integral part of the sculpture and never creates a cluttered look.

It is difficult to claim that Bakongo and Bena-Lulua statuettes are effigies of specific kings since neither type displays unmistakable personalizing elements. One of the presently known *mintadi* does have one leg shorter than the other, a detail that may refer to a specific king's disability, but it is a unique example. Apparently the Bakongo and the Bena-Lulua never tried to individualize their statues.

Baluba sculpture, when compared with that of the Bakongo, the Bakuba, and the Bena-Lulua, shows a highly individual feature: even when it was made to commemorate kings, feminine figures predominate. Among the Bakongo, sisters and nieces on the maternal side of a king who died without leaving a male descendant were allowed to reign temporarily as regents and were even entitled to wear the royal insignia. Among the Baluba, the mother and the sister played outstanding political roles.

A dozen Baluba sculptures (statuettes, vessels, caryatid seats, etc.) have been stylistically classified by Frans M. Olbrechts, who has ascribed them to the Master of Buli (from the name of the village where the artist presumably lived). Another smaller, uniform series displays the so-called cascade style, showing a distinctive architectural structuring of spatial forms. These works

87

88
89

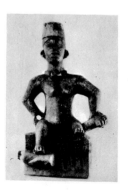

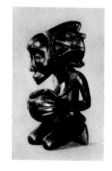

87. *Mintadi* with short leg. Wood. Bakongo. Congo/Kinshasa. Musées royaux d'art et d'histoire du Cinquantenaire, Brussels. Photo by the museum.

88. Cupbearer. Wood. Baluba. Buli, Congo/Kinshasa. Musée Royal de l'Afrique Centrale, Tervueren. Photo by the museum.

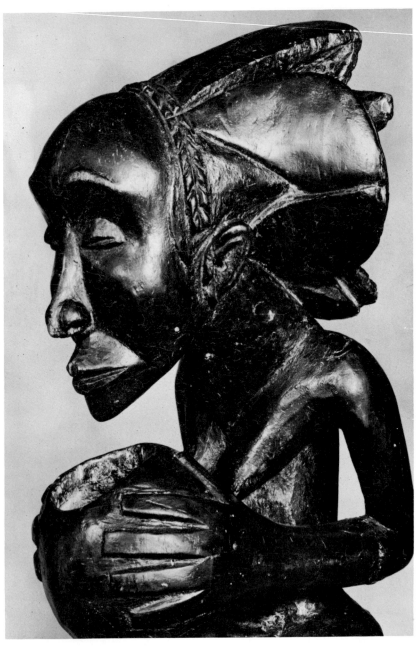

89. Detail of cupbearer (88).

could also be attributed to a single craftsman. The diversity of Baluba art is evidenced by several distinct styles, whose existence is a clue to the location of the workshops if not to the identity of the sculptors. This diversity is, however, severely circumscribed: all the works show a definite realistic trend. The realism, nevertheless, expresses individual aspects identifying it as African, and more specifically as Baluba. A chief's chair, the kneeling statuette (mistakenly called *The Beggar Woman*) by the Master of Buli, a headrest in the cascade style—all bear witness to the same aesthetic inspiration that distinguishes them from Bakuba, Bakongo, or Bena-Lulua art. In aggregate, Baluba pieces are less hieratic and decorative and strive to express the reality of a face or of a posture with strongly accentuated forms.

Some writers stress the link between this realism and the matriarchal character of the Baluba culture, as shown by the use of matrilineal descent and by the role of women in political life. And, in fact, the essential elements of Baluba sculpture do appear to be feminine. Such studies, however, treat only the subject matter, not the artistic style. Sculpture in the cascade style endows women with soft, flowing, almost voluptuous shapes, with a refined image whose elegance is accentuated by complicated and highly sophisticated headdresses. On the contrary, works ascribed to the Master of Buli are treated in a more abrupt style: the head and the body show a distorted approach. The distinct and almost insensitive angular edges elongate the figures and display a range of clearly differentiated profiles.

These traits might appear to be specific to the subject portrayed. Yet the individualization that at first glance seems characteristic of certain Congolese arts is more often an expression of the sculptor than of his model. In the extreme instance of the royal Bakuba sculptures, identification occurs not at the level of physical resemblance but by means of marks and insignia. The connection of statuary that shows signs of individualization with its social environment, where power is centralized and hierarchized, is neither direct nor causative. Certainly the political system and the internal organization encourage the development

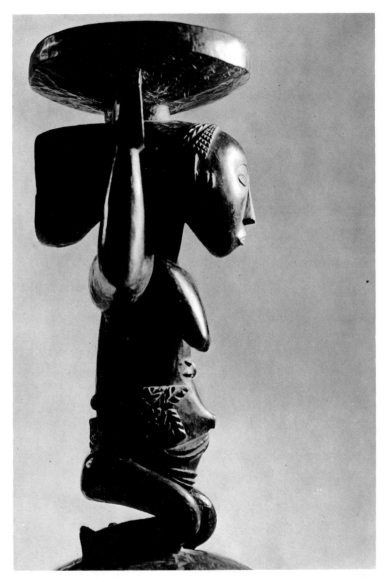

90. Chief's stool, profile view. Wood. Baluba. Congo/Kinshasa. Vérité Col-
lection, Paris. Photo by Mardyks.

of a courtly art, since they assemble qualified artists who are ensured specific commissions. Orders are placed by the king and his dignitaries who, because of their rank, demand respect and the expression of stable values but who have only a moderate effect on the style created. On the other hand, their requirements, by causing either a feeling of competition among artists or a stultifying academic atmosphere, could be a factor in the degree of artistic activity and creativity.

The values making up the concept of royalty by divine right are independent of the personality of the sovereign. As the very foundations and determinants of belief and thought, these values are by definition stable. The king, descendant of the god Chembé, will himself become a god after his death. As he is the incarnation of a god anything individualistic about him is negligible, but the memory of his passage on earth will remain in the guise of technological discoveries or of moral qualities. One king invented the forge; another was a pacifist. There is one restriction the sculptor will surely heed. The individualization process never resorts to anecdotes in order to restore a physical resemblance; it is based on a specific reference to an event or on an exemplary decision in the king's life or reign.

The individualistic elements that enable one to identify a figure are of an intellectual nature. Only occasionally is there a tendency to follow the features of the human body, and even then the emphasis is on a system of thought hierarchizing physical elements according to the importance conferred upon them, rather than on a faithful portrayal of the anatomy. Whatever reasons are put forward to justify the proportions of the body and head, they can all be reduced to the same common denominator: the head is generally more important and better carved because it is considered the center of man's primary activity. The importance given to the head is related to anatomical problems which can be solved only within the realm of aesthetics. The artist creates a harmony founded on sculptural proportions rather than on the features of the anatomy in order to compensate for the disproportionate parts of the body. In a Kata-Mbula statue, for

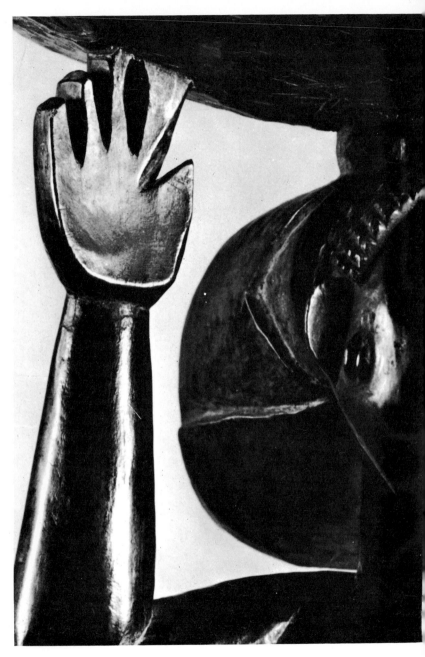

91. Detail of chief's stool (90). Photo by Mardyks.

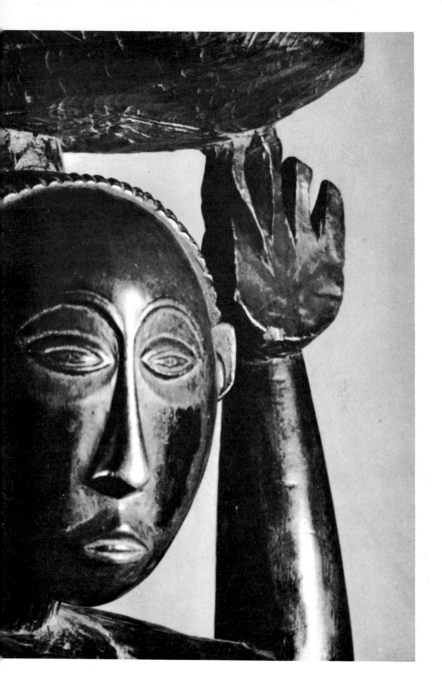

instance, the crouching posture of the body was a device the artist used to balance the volume of the head.

The apparent realism is an effort on the sculptor's part to convey the general concept of specific expressions, sometimes original and linked to his personal vision, rather than to reproduce the dominant traits of a living model. Any individuality that shows through belongs to the artist, who expresses his own taste and ingenuity without infringing upon a system of values and beliefs. He is careful to abide by the standards of the group to which he belongs and for which he works.

One feature of the Bakuba culture is shared only with the Ife and Benin civilizations. The Bakuba have a lively interest in their chronicles and manifest a keen awareness of the value and originality of their culture. Traditions relating the crucial events of their history have been carefully recorded, as well as the names and the feats of successive kings, thus providing chronological landmarks dating as far back as the end of the fifteenth century. It is likely that both the lasting settlement of the territory and the stability of the institutions and of the dynasty have had a favorable influence on the development of a historical consciousness. Events are not seen in the perspective of the cyclic time of myth, but in a linear chronology.

The relative individualization of royal figures might be traced to this historical consciousness. When retold by the people, history is steeped in a legendary and epic atmosphere; events are stressed in proportion to their significance in the larger system of values and beliefs. Precisely because these events are distorted by the perspective within which they are perceived, they reveal a moral ideal ruling life and culture and inspiring art—even if it is of an orthodox nature. The events furnish a set of themes that stimulate the creation and the reevaluation of the signs and the attributes that identify each king.

The manifestations of this art reflect man rather than spiritual forces. They express the value of prestige and a taste for emblems rather than for symbols, for the decorative rather than for the functional. In short, such an art corresponds to a type of cul-

ture that stresses a linear concept of time. In order to substantiate this view, it is worthwhile to examine the question in reference to other civilizations, such as those of Ife and Benin. Superficially, at least, they resemble the Congo civilizations, especially in the importance they attach to history and to political systems.

Ife and Benin

The Bakongo carved in stone; Bakuba blacksmiths erected a few iron sculptures; Congolese civilizations prefer wooden sculpture. Quite a different situation can be seen in Ife and Benin, where materials of many kinds are used. Specialization is accompanied by the hierarchization of artists according to their techniques.

The oba, or king, of Benin held both temporal and spiritual power, at least before the British punitive expedition of 1897. A descendant of Eweka I, who reigned sometime between the twelfth and the fourteenth centuries, the oba was considered a reincarnation of the divinity as well as of the founder of the dynasty. He had complete control over ritual and held the monopoly of trade with Europe, strictly controlling all transactions. He alone was entitled to legislate and to organize the police of the state. Military chiefs were directly responsible to him, and for the most part they remained faithful. Slaves taken captive during wars were the oba's personal property.

The oba's power was grounded in the traditional and mystical values originating in the palace, the center of political and religious life. The court—about a hundred people lived in the palace—was broken up into factions and hierarchies. Each tribal unit (small sovereignty, cluster of villages, village, district, etc.) was controlled by a dignitary who lived in Benin and rendered homage to the oba on behalf of his territory. He was the intermediary between the people and the king, and more particularly between the king and the chief of the village. In the past, it seems, the administration of the kingdom was carried on by means of private consultations and transactions between the oba and the eldest dignitaries. The Great Council assembled in its entirety for

the most important decisions, such as issuance of new laws, waging of war, levying of special taxes. The oba announced his decision to the council, and the dignitaries discussed their reactions in smaller groups in preparation for a second meeting during which their representative would present their point of view. There were usually two groups of elders: the first one, comprising dignitaries under the patronage of the oba, generally approved all royal decisions; the second group included a large proportion of people whose prosperity and influence were not dependent upon the palace. History records that the representative of the latter group, the *iyase*, often participated in the opposition. After the king, he enjoyed the strongest influence in affairs of state.

The highly structured society of Benin may be likened to a pyramid whose summit is the king. From the outset the monarchy showed a marked tendency toward absolutism. The oba institutionalized the law of primogeniture at a very early date; he could not be dispossessed and enjoyed limitless power to create other nonhereditary titles. The rulers implemented that right to the point where, from the seventeenth century on, there was a continual stream of newly created honors.

Before the establishment of Benin the Ife civilization (where their offspring, the present-day Yoruba, developed) was constituted as a kind of federation, grouping innumerable kingdoms and city-states under the authority of the *oni*, a religious chief. From the *oni* the most important kings received the right to wear the crown of red pearls, made of bloodstone or of Ilorin carnelian. The *oni* was believed to be one of the three descendants of Olorun, the head divinity sent to earth to supervise creation. Ife, said to be the first city to rise from the sea, was, according to Yoruba beliefs, the hub of the world. It became an important center for pilgrimages as well as the seat of the court of justice of first instance for the settlement of dynastic quarrels.

Ife art includes terra-cotta and bronze heads and busts, stone sculpture, stools and religious pieces carved in quartz, monumental granite monoliths, statues of humans and animals. Both the terra-cotta and the bronze pieces belong to a series that has been

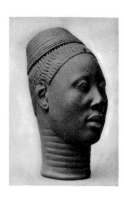

92. Supposed head of usurper Lajuwa. Terra-cotta. Ife, Nigeria. British Museum, London. Photo by the museum.

93. Supposed head of Obalufon II. Bronze. Ife, Nigeria. Photo by Antiquities Commission (funds for the preservation of Nigeria's art).

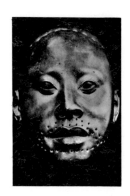

interpreted as consisting of idealized portraits, and occasionally a bust or a head has been identified as that of an *oni* or a dignitary. One of the most famous of these pieces is probably a representation of the usurper Lajuwa; another, in bronze, depicts the *oni* Obalufon II. Together these works reveal a remarkably homogeneous style; they were all produced within a period of not more than one or two hundred years, in the thirteenth and the fourteenth centuries. 92 93

The art of working in bronze was later to become famous in Benin. Until about 1400, in the reign of Oguola, the sixth oba, the commemorative heads intended for the altars of ancestors were cast in Ife. According to legend, Oguola asked his suzerain, the *oni*, for a master in casting who might instruct the craftsmen of his palace. The master who was sent by the *oni*, Iguegha, is still worshiped by the bronze workers in the district of Iguneromwo. Although the influence of Ife is clearly evident in the first works of Benin (dated about 1500), a certain stylization is apparent as artistic objects became less individualized and tended toward the creation of a type.

The only influence of Ife arts felt by Benin was in the use of a molding technique, which was reserved exclusively for bronze casting. Apparently Benin has produced neither terracotta nor stone carvings. The art intended for the oba and the palace of the Eguae was exclusively a bronze art; sculpture in

the strict sense was the monopoly of another class of artisans, who worked in wood and ivory.

The metal (copper and orichalc) came from mines situated south of the Sahara, probably from Kano or Takkedda or from Hofra-en-Nahas on a trail linking Nubia to Wadai. At the end of the fifteenth century, however, the Arabs penetrated inland toward the Chad region, thus cutting off the road to the mines. At the same time the Portuguese reached the capital of Benin, and, beginning in the sixteenth century, trade expanded with the consequent enrichment of the royal treasury and enhancement of the destinies of the kingdom. Portuguese merchants exchanged bronze basins or bracelets (called manillas) for slaves. The expansion of bronze art in the sixteenth and seventeenth centuries was a direct consequence of this commerce.

The delicacy that characterized bronze works of art before the arrival of the Europeans was replaced by a heavier style as early as the sixteenth century. Bronze artists began to use a larger amount of metal, and the weight of bronze heads increased fourfold. As output increased, the work was no longer limited to heads (*uhumwelao*) to be put on ancestors' altars. During the sixteenth and seventeenth centuries plaques were cast and were then nailed to the quadrangular pillars of the palace. The Dutch traveler Olfert Dapper left a vivid description of these decorated pillars in 1668, but in 1702, when David Nyendael visited the city of Benin, he described at great length a recently built palace without even mentioning any plaques. Presumably there were no longer any qualified craftsmen or mineral resources were becoming scarce. In fact, as early as the eighteenth century a decadent trend started in courtly art. It gained in momentum until the heads customarily done in bronze in an earlier period were carved in wood and simply covered with sheet metal.

Here is an art whose elaboration, development, and decline seem to have been closely linked to the destiny of the monarchy and its values, as well as to the historical and economic history of the state. The oba possessed a monopoly of bronze. The slaves he traded for metal from the Portuguese were his by right. The

94

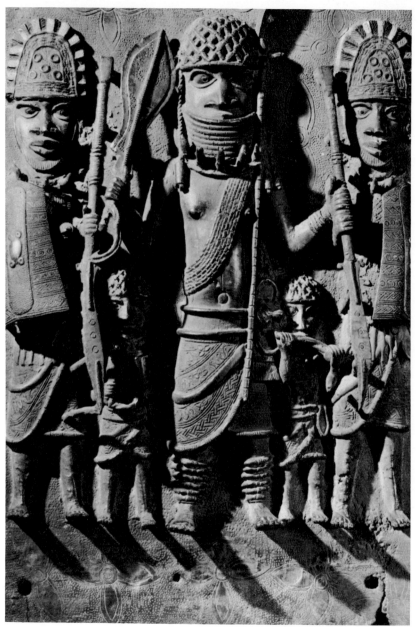

94. Oba with two guards. Bronze plaque. 16th or 17th century. Benin, Nigeria. Musée de l'Homme, Paris. Photo by the museum.

beliefs that sanctified the obas by divine right, linking the fortunes of the country to their life-forces, justified their craving for power. These beliefs also enriched the obas who, in spite of their divine essence, were nonetheless men, greedy for power, wealth, and luxury. It was they who determined values; it was to celebrate the events of their lives that artists consecrated themselves and their work.

Thus the bronze plaques nailed to the pillars in the interior courts of the palace constitute a chronology recounting the main episodes of civil, religious, and military life of the oba and his court. (See chapter 7 for a closer examination of these plaques, especially as to their illusionistic qualities.) The forms of the plaques and the efforts of the artists to achieve a certain degree of perspective suggest that these works were inspired by engravings in illustrated European books which the artists had in their possession. But even if this hypothesis should be verified, it must be remembered that the pursuit of illusionistic effects and perspective is related to a psychological mode of apprehending the world and man: the concept of a stable and measurable space as the location of human activity or a spectacular setting for it. This concept is unique to Africa, and even if the borrowing from Europe were an established fact it would alone not be sufficient to account for the whole phenomenon. It must be studied and analyzed in its psychological and intellectual environment.

The political and social structures of Benin may have been favorable to the production of an art showing these specific traits, but they did not determine the styles. In the kingdoms of the Congo, statuary recalls historical and legendary events, not through a narrative style but by translating them into intellectual elements. Congo reliefs, scarce as they are and reserved only for everyday objects, show no illusionism. What explains this tendency in Benin is not so much a political system as the conjunction of such a system with technology, the economic situation, a particular history and psychology.

The bronzes of Benin are the outcome of a long tradition. Despite the passage of more than a thousand years, with many

intermediary links missing, they perpetuate, through the Ife bronzes, the art of Nok which had emphasized terra-cotta. The long familiarity with molding techniques may have encouraged a tendency toward naturalism, a taste for carefully molded shapes, since these works were fashioned directly by hand without the use of tools, except possibly a piece of wood or bark as a polishing device. The same naturalistic traits can be seen in the stones discovered in Esié, to the north of Ife, and dating after the beginning if not during the height of the Benin civilization. It looks as if the artists strove to accomplish effects similar to those of the terra-cotta pieces.

Technique, however, does not completely explain style. One of three terra-cotta heads which were unearthed in a tomb at Abiri, 10 miles from Ife, is naturalistic while the other two are carved in abstract, geometrical forms. The material used, the firing technique, and the state of preservation suggest a common origin. It is to the encounter between a political system and an artistic technique that we can assign the style that ended with the spectacular Wunmonije heads.

Nor can the negative influence of political systems on the evolution of styles be overlooked. Artists who used bronze lived and worked in the same district of the city, and their output corresponded to the demands of the *oni* and the oba. Although woodworkers and ivory carvers were also grouped into guilds, they were not like bronze artists either in clientele or in the purpose of their work. They catered to the community, mainly filling orders for family and village cults or supplying the demand of merchants who bought carved ivories for European royal courts. Such commissions must have favored creative liberty and ingenuity among artists who became socially more independent. The academism that was rapidly spreading throughout courtly art was not felt in tribal art, whose aesthetic values were paradoxically preserved by the very absence of formalism. The celebrated pair of ivory leopards in the British Museum are among the last works of art produced by the culture of Benin.

The Peoples of Mande

The arts originating in courts contributed to the creation and strengthening of values whose possessor and beneficiary was the king; in contrast are those produced by federalized societies, such as the arts of the peoples of Sudan who consider themselves descended from a more or less legendary region—the Mande country.

In Dogon, Bambara, and Senufo territory the position of art is directly related to social and political organization, to beliefs and myths, and also to demography. These regions have little of the urban concentration that ordinarily reflects centralization of power. Comparatively recent observations (dating back to the early twentieth century) indicate that the political system of these peoples was of a federalized type. Among the Dogon each village was under the authority of a *hogon*, the eldest and most respected member of the community. The grouping of villages depended, at least in theory and through the intermediary of the village chief, upon a supreme *hogon* who was chosen at an early age in a prescribed manner and about whom little is known.

The Dogon, the Bambara, and the Senufo have in common one important feature: their artists never tried to represent the outward signs of political power, as Congo artists did, nor did they represent the more or less historical personages exercising such power, as was characteristic of Ife and Benin. It is true that the Dogon have a historical sense, for they are able to distinguish their present state from their primitive state when the genii taught them moral rules, including circumcision and forbidden foods, and the techniques of agriculture, weaving, and forging. This primitive state, however, is never represented in sculptures. Rather, sculpture reflects the myths of origin. Its extreme diversity may be explained in terms of the loose political organization, which allows each village to express whatever aspect of the myth it feels is more attuned to its own individuality. History can occur only when nations are born; at the village level, the vitality of both myth and legend precludes history in the European sense.

Certain statuettes from the Dogon or the Tellem will serve

as an example. Some of them form a single undifferentiated volume, front and back. The head and the body are secondary forms added onto the plane defined by the uplifted arms and the legs. 95 This plane recalls the blade that surmounts the head of a tall mask. In some statues the plane grows out of a cylindrical base; in others the legs, carved in the same block or separated, are more 96 or less evident. In still other examples the plane stops short at the hip level and disappears; the other parts of the body become independent and freely extend into space. At times these statuettes have been interpreted by the Dogon as a prayer for restorative rain. They may also be understood as a representation of the myth explaining how the human body has been articulated to enable it to work.

At the beginning of the Dogon cosmogony there were eight genii (called the Nommo) whose bodies and limbs were lithe as befits the genii of water, the most treasured guardians in regions of dry savanna. One of them, the blacksmith, descended to earth in an ark bringing techniques, primeval seeds, ancestors, and animals. With the rough landing of the ark, the limbs of the blacksmith broke at the joints. The Nommo are sometimes said to have only one leg, accounting for the column-like base of some 97 statuettes, but they are also described as having two distinct legs.

The development of shapes curiously parallels the episodic succession of the myth. A superficial glance suggests that certain works are more archaic than others, but as yet nothing permits the establishment of a chronological order. In works executed by various artists in different villages, it is likely that each sculptor stressed those aspects of the myth which accorded with his artistic intent; it is even possible that individual aesthetic interpretations eventually produced new mythical elaborations. Certain sculptors, more partial to articulated shapes than to those in block form, might be at the origin of the episode of the blacksmith and his broken legs.

When the model of a statue passes from one village to another, both theme and style are modified. Among the numerous statues of androgynes found among the Dogon, some have one 98

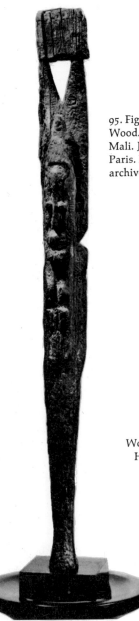

95. Figure with raised arms.
Wood. Tellem-Dogon. Ibi,
Mali. J. Lazard Collection,
Paris. Photo by Kamer
archives.

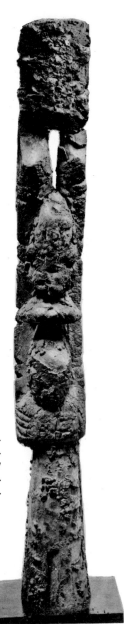

96. Figurine with pestle.
Wood. Tellem-Dogon. Mali.
H. Kamer Collection, New
York. Photo by O. E.
Nelson, Kamer archives.

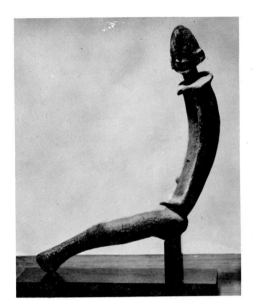

97. Nommo with one leg.
Wood. Dogon. Mali. R.
Miller Collection, New
York. Photo by Kamer
archives.

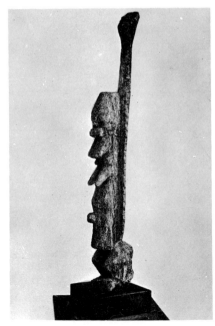

98. Figurine with raised
arm. Wood. Tellem-Dogon.
Mali. H. Kamer Collection,
New York. Photo by Kamer
archives.

raised arm, others two, still others three or four. Such differences represent another version or another episode of the myth, but the different version may have stemmed from a plastic modification traceable to a specific village artist, which then brought forth a new mythical interpretation. On the other hand, the fluidity that characterizes myth allowed the sculptor's imagination free play. It would be useless to think of all works as graduated variants of a yet undiscovered primitive model. The variation of shapes connected with the same meaning, and the proliferation of meanings attached to a certain form, are not distinct phenomena, but are continually interacting. Myths are elaborated through the incarnation of formal systems as tangible shapes which they endow with meaning, and which in turn determine them.

This fluidity can be found at the level of each work of art considered per se. A statuette does not have a unique and definite meaning enabling one to interpret the posture and the gestures, and then to relate the work of art to a specific event in a rigidly fixed myth. It has several meanings whose secret, it seems, is only progressively made known, associated with the stages of initiation. By the uninitiated, sculpture can be apprehended only in its literal sense. As he raises himself to a more advanced position in the hierarchy of the initiated, man attains deeper meanings, closer to a central point where notions acquire a solemn sense and dealing with more essential aspects and a more encompassing view of man, of his place in the world, and of the universe itself. But even if a certain sign and a fixed meaning were connected with each step (totally unverifiable since initiation is a lifelong process), it would still be impossible to state that initiation inevitably leads to an end point where all mysteries are clarified. Man's thought actually plunges slowly into an ever-widening and infinitely profound questioning.

According to Marcel Griaule, an equestrian figure such as that of Orosongo at first suggests an episode in the myth of the landing of the ark: "The horseman-guide stands as the deputy of the Creator, entrusted with the mission of revival." Yet the initiated would be aware of a group of signs, a pattern of chevrons

99

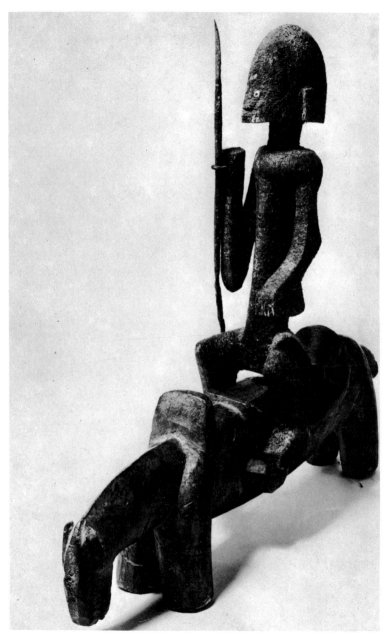

99. Rider. Wood. Dogon. Mali. M. Griaule Collection, Paris. Photo by Mardyks.

whose essential meaning would express vibration. The ramifications of this meaning would be much richer and, in the eyes of the initiated, much more essential than a sequence of the myth. They would manifest at the same time a concept of matter, a cosmogony, a certain wisdom, and even the founding of social strictures. This vibration evokes the spiral movement of the blacksmith as he descended to the earth. At a higher level of initiation it represents the vibration of matter, light, and water. The work of art here puts a philosophy, in the pre-Socratic sense of the word, into concrete form.

Anecdotes as such do not enter into the art of these ethnic groups. The problem is not to represent this or that person with his traits and his individual psychology, but to establish modes of permanent relationships depending on ancestry by assigning to each being a place in society and a technological role (blacksmith, cobbler, weaver, farmer, etc.), and by prescribing a set of rules (relating to forbidden foods, sexual restrictions, etc.). Status, activities, and rules have been revealed progressively to man by the genii from which he descends; they are archetypes defined in the beginning by the Creator-God. They rule all human activity in order to avoid serious turmoil and chaos. The function of the work of art is to maintain stability and to materialize in the present the mythic philosophy to which all earthly life must conform.

The study of a Dogon work of art helps to illustrate this concept. One statue that represents an old man perched on the shoulders of another old man refers to a migration myth. The three heads of families from whom the Dogon allegedly descend were traveling hand in hand in search of a country where they could settle. Arou, the youngest, exhausted by the march, climbed onto the shoulders of his older brother Dyon. When they approached a big cliff, the youngest, who had a broader view because of his position, pointed to the country before him and, giving it a name, appropriated it. Enraged by such audacity, Dyon abandoned Arou and, accompanied by Ono, the middle brother, quickened the pace. Arou proceeded alone and rejoined

his brothers at the next stopping place. Before overtaking Dyon and Ono, Arou met an old woman who gave him, as a reward for his politeness, three objects that enabled him to become a *hogon*. The representation of Arou on the shoulders of his brother marks a beginning: the settlement of the Dogon, the organization of society, the distribution of political and religious powers. Yet, whatever its position in the context of what precedes it, this beginning does not inaugurate a chronological history. It confers authenticity and reality on a legitimate social and religious system which itself reproduces an archetypical situation.

The two sculptures on this theme with which I am familiar are neither real nor imaginary portraits of Arou and Dyon. In one of them, certain immediately observable details such as the protruding belly reveal an anecdotal tendency. Nevertheless, the aim of the sculptor was to represent myth, not just any realistic form. For this reason Arou, who is a young boy, is depicted with the attributes of the *hogon*, the headdress and the beard. In the same statue the initial and terminal stages of Arou's destiny are recounted, insofar as his destiny concerns and interests the Dogon

101

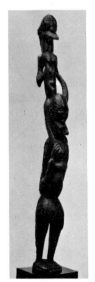

100. Arou on brother's shoulders. Wood. Dogon. Mali. Owner unknown.

101. Arou on brother's shoulders. Wood. Dogon. Mali. H. Kamer Collection, New York. Photo by Edouard Berne, Caravelle Films.

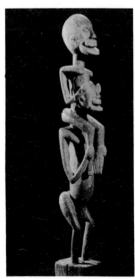

community. The anecdote (or what appears to us as an anecdote) is not relegated to the past: it encompasses the future of Arou as *hogon* and, furthermore, the future of the political institutions and their functioning. What appears to us as a condensation of time, by the omission of the time lapse separating the taking over of the land and Arou's accession to the throne, may be interpreted as the seizing of both the past and the future by the immediate present, which can bring tradition up to date and prefigure things to come.

The statuettes of the peoples of the Mande region represent either genii or heroes of their legends, but they never depict real historical figures. Some of them no doubt recall events that are not directly related to the myths of origin. These events tell of an absolute beginning, earthly or heavenly, before which there was nothing at all. Mythic time is superimposed upon and integrated into that of daily life. On the other hand, celestial events predetermined those that have occurred on earth; at least, they constituted models.

Sculpture is therefore less closely related to the personality of a given monarch than to the set of relationships upon which authority and social organization are grounded. It seems that the few Bambara queen statuettes must be interpreted in this way. Among the Dogon, the *hogon* cannot be identified as an individual; it is the *hogon* function that is incarnated in these works, hinging on various mythic representations to which the work itself allows access.

Style and Tradition; Norms and Innovations

Statuettes and masks are fashioned in order to fulfill needs that are not relevant to the aesthetic realm. They have a specific function and a specific purpose. Yet this purpose and this function do not entirely determine their character as works of art.

Art is neither the residue left after the reason for the creation of the work is discovered nor a superfluous element such as the technique used to ornament an object otherwise having no artistic intent. Art is, of course, profoundly rooted in a society to

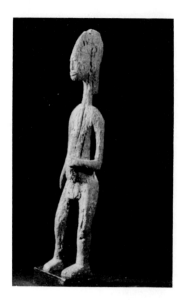

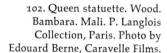

102. Queen statuette. Wood. Bambara. Mali. P. Langlois Collection, Paris. Photo by Edouard Berne, Caravelle Films.

whose social, religious, and semantic exigencies it responds. This rooting must not be understood as a submission to deterministic processes irrelevant to art, but it can be described as an integration that preserves the nature of art and its creative quality. The sculptor draws from his society the elements that he then arranges according to specific modes. If the relation between art and society is considered in a unilateral way, as if art were simply a product of the environment, all that is characteristic of and specific to art would vanish; the important quality that it represents would fade, to be absorbed into the great mass of sociological data. This fading would be effected only at the cost of the truth of the image of the very culture reflected by art. Marcel Griaule writes that beauty "for the black man" is "the identification of the object with that for which it was created." But even when the identification is obvious, art nevertheless possesses an intrinsic and objective value: it influences the society wherein it grows.

Looked at freshly and innocently, a piece of sculpture communicates two kinds of information by itself and about itself. It is the result of certain techniques and specific conventions. At

the same time it is also an image whose immediate significance is its theme: a rider, a couple, a mother and child. This theme was one chosen among the many mythic possibilities in a particular society. The artist has thus made a double choice, given that the ensembles from which he draws are limited.

The field of choice is limited but not restrictive, even if the artist has been given instructions. If at the outset the nature of the commission implies certain restrictions, the instructions the artist receives are mainly directed toward the purpose and the function of the work. Since such instructions are of a very general nature, the finished product has been oriented, to a certain degree, by its theme.

In a given culture formal conventions are limited in number. The artist does not work with a model before him; he creates according to a mental image, settled in his mind, formed by all he knows of the work of his predecessors or by what he has learned during his apprenticeship. From this point of view, the restrictions imposed on style arise less from social requirements or from the demands of a community having strictly fixed limitations than from the more or less extensive stock of inherited forms upon which the artist draws. Thus the workshops and even the artists themselves can be identified and sometimes located. Such are the working conditions of the sculptor that the pieces tend to differ increasingly one from the other.

These observations permit consideration in more concrete terms of the links already established between artistic style and the social and political background. The feeling of repetition, immutability, and impersonality which one sometimes experiences when seeing all the works of a single ethnic group is probably a strictly European impression. If there is a relation between art and institutions, it is of the same nature as that observed in the Middle Ages or in the baroque period.

Such a relationship is more obvious in societies where power is centralized and reserves for itself the exclusive use of certain products. Courtly art develops more slowly than so-called tribal art, because of the more restrictive nature of commissions to the

artist. Moreover, in such communities craftsmen do not work in isolation. They live in separate districts, as in Benin or Dahomey, or are grouped into corporations as among the Bakuba. Thus they are in close contact with one another and can easily pass judgment on one another's work. Such conditions have a determining and leveling influence on style. Courtly art stabilizes rather rapidly around a stylistic formula which soon becomes a dry and sterile norm. A norm of this kind cannot be ignored by the artist; it appears to be a tradition-forming model, or a set of models, to which he refers. It became institutionalized, not by outside influences, but through the taste of the customers and through long usage.

The circumstances are entirely different if we consider tribal art, keeping in mind the contrast between societies ruled by a centralized power and those grouped into federations. The sculptor learns his craft from an older brother or from his father. Nevertheless, he remains professionally isolated in his village and therefore has at his command a narrower range of forms and a limited number of models. Paradoxically, tradition here is less restraining. Since the artistic past of the village is both limited and difficult to discover, the artist is left to his own devices, dedicated to an empiricism that usually favors and even forces innovation.

The broad diversity of statuary in some regions can thus be explained or at least somewhat clarified. A specialist of course conforms his statuettes to the general tendency of the art of his own ethnic group, including the models he learned during his apprenticeship. Disparities are numerous, however, and sculptures become differentiated from one village to another. The myths themselves acquire depth depending on which of their elements are emphasized. An instructive example is the statuettes with raised arms, mentioned earlier. The Dogon believe that the Creator designed the world at the beginning. There is only one word in their language to express both design and creation. Every element in the world reflects a divine pattern and was, so to speak, predestined, always referring back to the position it oc-

cupied in the original design. Each element, however, is also en-
dowed with a meaning given by the Creator: it is the true sign
of that which it merely duplicates on earth. If a new sign appears,
it necessarily expresses a heretofore unknown dimension of divine
thought. It serves as a new starting point for the exploration and
rediscovery of an aspect of the inexhaustible myth. Yet even if
all forms have a precise and indexed meaning, and if this mean-
ing occupies a specific position in the shifting and iridescent pat-
tern of the myths, it is not necessarily proven that all artistic
forms were conceived and created in order to satisfy the thirst for
meanings. From the myth each artist chooses elements attuned to
his own temperament. The two Arou figures mentioned above are
as different as Flemish and Catalonian representations of the
Virgin Mary. African art constitutes a history in itself, and the
meaning of a single work in no way exhausts its reality. If it were
otherwise, all statuettes with the same meaning would be inter-
changeable. From the art of all the peoples who are said to have
descended from the Mande and who have the same metaphysical
background, it becomes immediately clear that the artists can
easily be identified as Bambara, Senufo, or Dogon. Thus forms,
and the way they are arranged, have an inherent meaning in-
dependent of mythic significance.

5

Masks

From the evidence of rock paintings found in Tassili, Ennedi, and Chad, masks have been used for an undetermined period, probably beginning before the Christian era. Nowadays masks are most often associated with agrarian, funeral, and initiatory rituals; they appear when peoples whose activity is principally agricultural become permanently settled. No sculpted pieces are known to have issued from shepherd communities. Can it be said, then, that masks appear only in connection with work on the land? The present-day agricultural societies that are ignorant of the institution may have given up the use of masks or may never have made them an element in the religious or social system.

The absence of sculpted material among nomadic peoples may be explained by their need to reduce encumbrances to a minimum. The Peuls, who otherwise possess a consciously refined taste, have no sculpture, probably to avoid transporting bulky equipment. According to Jacqueline Delange, however, they commissioned artists of other ethnic groups to execute works for which they furnished designs and instructions. Certain Dogon

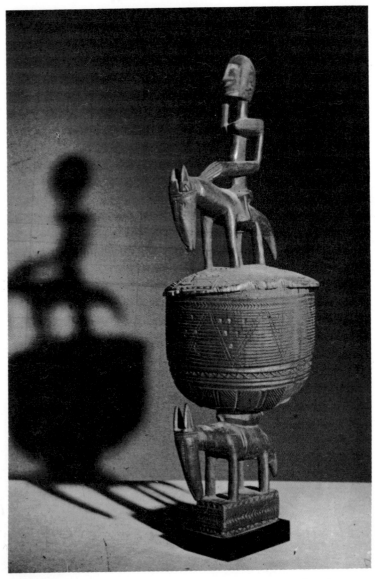

103. Cup. Wood. Dogon. Mali. R. Jacobsen Collection, Paris. Photo by
Edouard Berne, Caravelle Films.

sculptures, especially the egg-shaped cups with carved lids, were *103*
probably produced under these circumstances or at least are of
Peul inspiration.

There are many indications of the existence of a Peul art.
Rock paintings from the Bovidé period, uncovered in Chad and
Ennedi by Gérard Bailloud, may be attributed to the Peuls. The
brands on the haunches of animals depicted seem identical to
the ones still used today. The Bororo, a subgroup of the people
roaming the savanna in Niger, west of Lake Chad and south of
the Sahara, have a system of values based on aesthetics which
regulates individual behavior as well as the appreciation of phys-
ical and moral beauty.

The sophistication of the culture is manifested in the ex-
istence of genuine courts of love (reflected in paintings from
northern Chad) and in courtly poetry. Peul women, renowned
in western Africa for their beauty, wear highly complicated
hairdos, which are in themselves sculptures. At the time of the
Gerewol, the annual celebration during which Bororo girls choose
the handsomest young men from the assembled tribes, everyone
is carefully and aesthetically groomed. The people apply facial
paintings which are the equivalent of masks, for they conceal *104*
the real features and substitute others.

Masks and Ritual Ceremonies

Ceremonies in which masks are exhibited are usually agrar-
ian rituals or funerals. These ceremonies are spectacles in which
music, chanting, and measured recitation of mythical poems form
a broad dynamic and colorful choreographic ensemble, played
out over several days in the public square. The initiated serve
as actors, and the spectators are those villagers who are not bound
by any prohibitions, temporary or permanent. The wearing of
masks is generally a male prerogative; women are not allowed
to see them. In societies such as the Mende in Sierra Leone, how-
ever, there exist strictly feminine ceremonies.

At a funeral or at the start or close of seasonal labor (sow-
ing, tilling, harvesting), the display of masks serves to recall

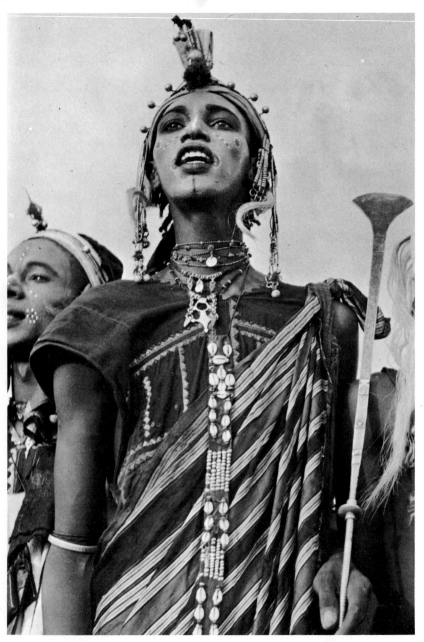

104. Young people groomed for celebration of Gerewol. Bororo. Photo by H. Brandt. From *Nomades du Soleil* (Lausanne: La Guilde du Livre).

noteworthy events of an early period which structured the world and the society. These events are recalled and repeated, thereby assuring their permanent relevance. In a sense, masks reaffirm the context of present reality, evolved from a mythic era when it was conceived and projected by the god and his genii. Among the Kurumba, masked dancers repeat the deeds of the hero-founder Yirigué and his children, mask wearers descended from Heaven. Dogon dancers wearing *kanaga* masks (one of the meanings of *kanaga* is "hand of God") reproduce, by circular movements of the upper body, the gestures of the god who created the universe.

The role of the mask is to reaffirm, at regular intervals, the truth and the immediate presence of myths in everyday life. Masks strengthen the collective existence in all its complex aspects. The Dogon exhibit masks depicting foreigners (Peuls, Bambara, even Europeans) as proof of the diversity of the world. Such ceremonies are ongoing cosmogonies, regenerating time and space, drawing man and his values away from the temporal decay that attacks all aspects of life. But these are also truly cathartic spectacles during which man becomes aware of his place in the universe and sees his life and his death given meaning by being inscribed in the collective drama.

Masks are used in a completely different fashion in initiation ceremonies. The young men, gathered in an isolated area at the outskirts of the village, submit to a series of tests calculated to measure the degree of their physical and moral development. They undergo an indoctrination that gradually reveals to them certain esoteric religious details and inculcates respect for society's laws. The masked initiator himself appears from time to time as the incarnation of the spirit that instructs mankind. At other times the people are summoned for closing rites in which masked dances bring to mind the original meaning of initiation: the adolescent dies to be reborn into his new adulthood. The same idea underlies general beliefs. In Congolese cultures a man's soul lives on for some time after his death, to be reincarnated in

the second or third generation as his grandson or as his great-grandson.

Furthermore, masks are used to protect the society against wrongdoers and witches. In the hands of members of secret societies, they become tools of political pressure. In the Congo masks are used in this way by the dreaded sect Aniota, the leopard men, and also in dances preceding military campaigns.

Masks and Spiritual Possession

A mask is a being that protects the wearer. It is designed to absorb the life-force that escapes from a human being or from an animal at the moment of death. The mask transforms the body of the dancer who, never yielding up his own personality but using the mask as a vital, dynamic support, incarnates another being. A spirit or a mythical or fabulous animal is thus temporarily represented.

The mask protects. Indeed, should the vital force liberated at the time of death be allowed to wander, it would harass the living and would disturb facial composure. Trapped in the mask, it is controlled, one might say exploited, and then redistributed for the benefit of the collectivity. But the mask also safeguards the dancer who, during the ceremony, must be protected from the influence of the instrument he manipulates.

The widely diverse appearances taken by masks show clearly that they must absorb the totality of the energy spread throughout the world. Indeed, masks differ from statuary in that they often combine human and animal characteristics, producing composite monsters with traits of several species. They present the most varied themes and contain many fantastic and imaginary elements. Sometimes familiar or bizarre animals that made their appearance at the time of creation or initiation are portrayed: hares, gazelles, antelopes, apes, birds, occasionally serpents or even elephants and panthers. This art seems to be a hunter's art: the life-force of an animal just killed must be trapped in a piece of wood carved in its likeness. Other masks depict human beings or creatures with human traits. Masks are idealized among the

Mpongwé and the Dan, for example, or seem to be caricatures of young coquettes, old women, stammering men, or foreigners. Other examples, more complex, represent objects: for instance, the house where the initiated make their retreat, or, in Dahomey or Nigeria, a conglomerate (perhaps even a motorcycle) whose parts are sometimes borrowed from the West.

Facial paintings, erased after the ceremony, may rightly be considered as belonging to the general category of masks, no matter what their function, which varies from one group to another, may be. Since facial paintings are ephemeral, limited to the duration of the dance, they must be distinguished from anything that constitutes a permanent modification of outward appearance, such as tattooing, scarification, or dental filing. The latter transformations should be considered as a part of cosmetics, for they do not emerge directly from traditions associated with masks. The mask represents other beings with human support, whereas permanent physical alterations place a particular individual in his social and worldly framework.

To act as a human support for the creation of a new being is not, however, without danger for the masked man. The mask usually represents a well-known being already classified among gods and spirits, possessing its own history and biography. It must furthermore protect its bearer against the effects of the personality he temporarily assumes, a personality that literally invests him. Under no circumstances must the dancer be recognized. To this end many precautions are taken: the mask may be finished off with a cowl of fibers, enveloping the head, so that it does not come undone; or it may be made in the form of a helmet, fixed firmly to the shoulders with suspenders. A small leather flap is attached inside the mask and held securely by the wearer's teeth. When the size of the mask and the nature of the choreography call for it, the dancer is helped by an assistant. Since in the *ganubire* dance of the great *sirige* mask the Dogon dancer must bend completely backward, one of his comrades stands before him to shield his neck and throat from onlookers. If the dancer's face should be uncovered and visible to the spectators for a single in-

stant, grave consequences would follow. Precautions must be taken to cover the dancer's whole body so as to prevent exposure of an area where a genie might enter. The masked dancers of the Bundu female society of the Mende in Sierra Leone take care that their costumes contain no opening other than a narrow slit for the eyes. This restriction is also common in other areas.

Masks exist to prevent the wearer from being possessed by demons, but they also hold the life-force. This function is so important that possession may be directly caused by the mask or by the infringement of a prohibition concerning it, "by the sight or the touch of a portion of the dance costume, . . . by the too close proximity of a dancer during a ceremony, or by meeting him unexpectedly while he walks about the village" (Marcel Griaule). The mask traps spiritual forces whose unchecked wandering must be prevented. After any contact whatsoever, these forces can invade anyone who has not been trained to endure them. The mask wearer, however, knows what measures to take: while carving his mask and before dressing he must observe prohibitions, mainly of a sexual nature; he also purifies himself and performs sacrifices.

A mask is not in itself the being it represents; it is only a facade intended to deceive the forces it must ensnare. In no way does a dancer identify himself with the spirit whose role he has assumed. Even when a man or a woman is possessed, he or she is not identified with the demon. A person possessed merely remains one of the "horses of the god." It follows, as Griaule claims, that Dogon masks probably do not contain "an essence or an elemental soul that could be revealed through magic." The very fact of wearing the mask "exteriorizes consciousness and discloses the subject to himself through his participation in the continuity of life, through death, and through the tangible renewal of an essence that can become visible in no other way." The dancer does not become one with the vital force he handles, but he feels that he is linked with it and that his own strength is nourished by a presence that allows him to shed his mortal body and to enter the life of the cosmos.

The German ethnologist Leo Frobenius posited two contrasting types of societies. According to him, those whose ceremonies are based on cults of possession grew out of a mystique, whereas societies using masks and statuary were founded on magic. In "possession" societies, the predetermined and permanent ego of the spirit must be transferred to the individual's ego. In a "mask" group, the ego evolves from all the societal elements and from mythical and human ancestors. There do exist several groups who practice nothing but possession cults, but the fact is that numerous others, all over the African continent, combine such cults with masks and statues. Among some peoples and in certain regions—the Ovimbundu and the Tiyvokwé in Angola, several areas of the southern Congo, within the radius of the northern Congo, and the Dogon and the Baule—these possession cults are closely associated, according to Hermann Baumann, with agricultural and matriarchal societies. His linking is, however, arbitrary and ill-founded, for the Songhai in Nigeria have recourse to possession rituals before every fishing or hunting expedition. Frobenius's generalization notwithstanding, possession rituals and sculpted objects can coexist in the same ethnic group. Among Dogon statues I have singled out numerous small figures that literally represent the descent of a genie into the skull of a *hogon* or a totemic priest. According to de Salverte-Marmier, Baule sculptures showing what seems to be a monkey proffering a cup are closely related to possession phenomena. *105* *106*

In short, the mask entraps the power of otherworldly spirits. It is recognizable to these genii who are then easily duped. We must not forget that the mask is not the genie but only its image. A mask has no magical properties. It is neither a statue nor an instrument of witchcraft, but an accessory for a mythic opera or ballet. To really understand a mask one must observe it as a dynamic element of a complicated ensemble in the intricate rhythm of the ritual. The dancer, even when he performs a solo, is rarely alone. To regard the mask merely as a wooden face covering or as a helmet, to consider it static, hung on the wall or placed on a pedestal, would be sheer betrayal. This distorted point of view

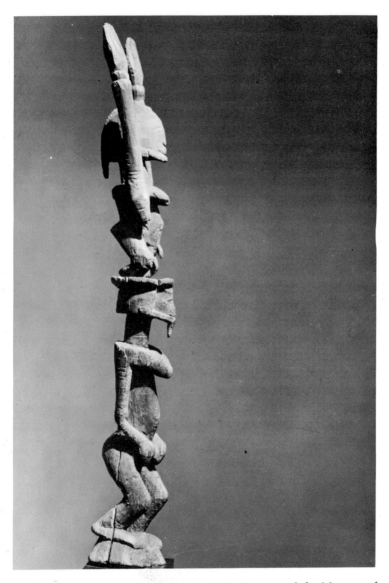

105. Descent of a genie. Wood. Dogon. Mali. Courtesy of the Museum of Primitive Art, New York. Photo by the museum.

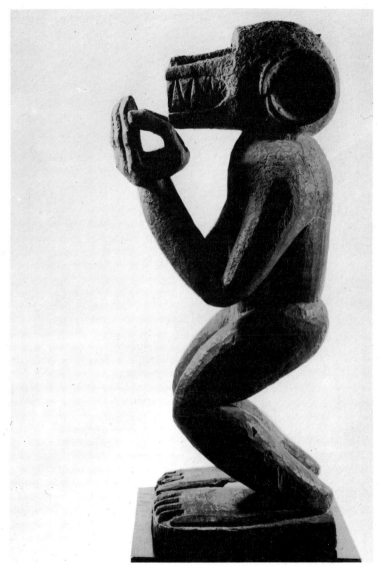

106. Monkey genie. Wood. Baule. Ivory Coast. Charles Ratton Collection, Paris. Photo by Mardyks.

shows the part as the whole and transforms the mask into a completely different object.

Types of Masks

Only the sculpted portion of the mask or the helmet is here discussed, not because the costume worn is devoid of artistic interest but because the masks assembled in public or private collections have been, with few exceptions, reduced to faces or heads. The face or the head may comprise additional elements, such as sparterie, fabric, or plant fibers used to delineate the beard or hair or to shield parts of the dancer's head not covered by the wooden face. Also, from the African point of view, the mask is the most important part of the whole costume, for the head contains the life-force as well as the primary human faculties which the genie carries down to man.

Leaf and Woven Masks

For obvious reasons, information about leaf and grass masks can be obtained only through films or photographs, for they are seldom seen outside the spectacle or the dance. They form part of the costume; we might call them informal masks, seen as vivid whirling patches which melt together or are delineated against an animated multicolored whole. In the extreme southeastern part of Cameroon, the least-known part of the equatorial forest, Maindo rites constitute a true mystery play which recounts the struggle between a powerful magician helped by his warriors and the forest spirit who wears a costume made of fibers, leaves, and grasses. The genie, mortally wounded, is resurrected and then flings himself into a wild dance proving his strength and the extent of his supernatural powers. He finally disappears into the shadowy forest. Other masks, made of cloth (hooded cloaks upon which peoples such as the Toma of Guinea often place a richly ornamented bonnet) or of braided fiber ropes with cowries sewn on them, take on the form of the human body beneath. Made of flexible materials, they are nearly indistinguishable from the rest of the costume.

107

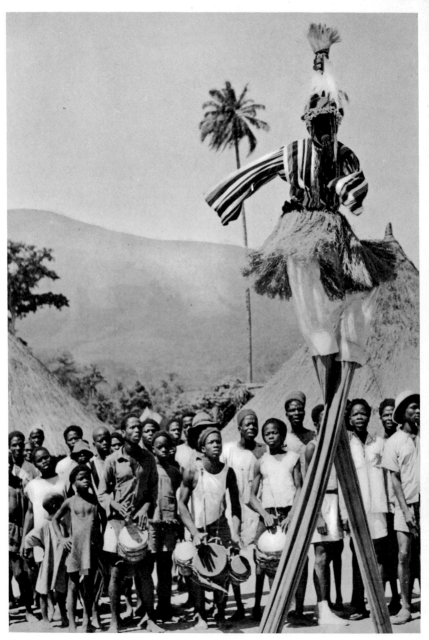

107. Mask with stilts. Fabric. Toma. Guinea. Photo by Hoa-Qui.

The transition between flexible masks and rigid wooden ones can be seen in those that are built on a structure of basketry or reeds. Their style or technique is closer to weaving and sparterie than to sculpture in the strict sense. Such masks are found in the southern Congo, Zambia, and Angola. Artists of the Lunda-Luwale construct a rattan framework on which they stretch bark that has been hammered out and painted. Although of large size, these masks are lightweight; they cover the dancer entirely and

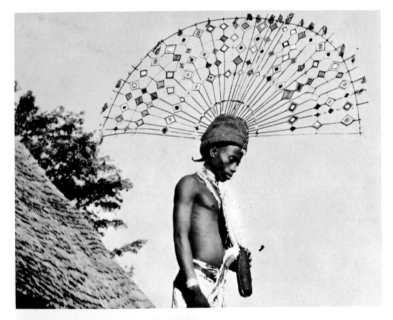

108. Crest. Multicolored wool and basketwork. Coniagui. Youkounkoun, Guinea. Photo by Mission Doctor R. Gessain.

109. Making a mask. Basketwork and painted bark. Makishi. Zambia. Photo by Office du tourisme de Zambie.

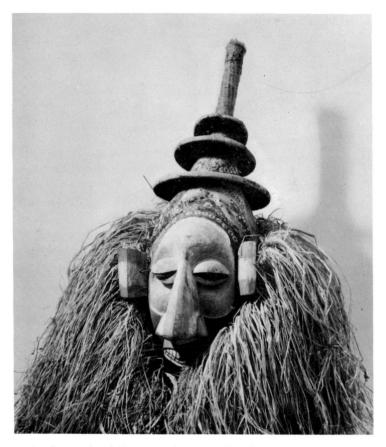

110. Mask. Wood and fibers. Bayaka. Congo/Kinshasa. University of Zurich Collection. Photo by Musée Rietberg.

are used in acrobatic dances accompanying Makishi circumcision rites. The Bayaka of the Kwango region in the Congo sometimes combine the two methods by extending the sculpted face or figure of the mask with a basketwork structure covered with stretched, painted bark. In northern Guinea and the lower Casamance, the Coniagui dancers wear vividly colored woven crests.

The world of the mask is the world of the imaginary. The most astonishing formal inventions go along with an equally re-

110

108

markable spontaneity in the ordering of the subject matter. It is likely that neither the spontaneity nor the formality is felt as such by either dancers or spectators. Even if a ceremony that includes masks is interrupted by interludes or satiric or comic elements, it remains a sacred spectacle carrying out events that are considered real by the persons involved. To these ends, richly varied methods are employed. Realistic observation mingles with the fantastic; idealized facial forms coincide with often rigorously expressive ones.

Facial Masks

The human physiognomy has been the object of particular attention by all African sculptors, who have thus produced a multiplicity of images. These forms seem so new to the uninitiated critic, who lacks precise information on their proper meaning and the artists' intentions, that he often finds himself literally helpless and ends up by borrowing the vocabulary of modern Western art. It is meaningless to say that a Bamoum mask is expressionist or baroque, or that a Bambara, Dogon, or Senufo mask is cubist, or that an Ibo or Ibibio mask is surrealist. Faulty analogies based on superficial resemblances do nothing but rob these totally different works of their personality and their intent. We cannot manufacture universal aesthetic classifications out of art history categories without introducing serious confusion into our analysis. We must therefore resolve first to describe and then to classify the forms and the ways they are handled.

The first distinction can be made between two-dimensional or lightly chiseled figures and the robust, powerful pieces whose "extroverted" volumes expand freely into space. At one extreme are certain Bateke works cut out of a wooden board and painted. Although once believed to be emblazoned decorative panels, they have the unmistakable eye slits of a mask. They are so bare of representative elements as to look like abstract works, but sooner or later a face appears in the lines and colors. The closely related Bakwele masks are more sculptural. The central area of the mask is slightly depressed so that the face stands out. Sometimes Bakwele masks are heart-shaped and are incised with harmonious

111. Mask. Painted wood.
Bateke. Congo/Kinshasa.
Musée de l'Homme, Paris.
Photo by the museum.

112. Mask. Wood. Bakwele. Congo/
Kinshasa. Charles Ratton Collection,
Paris. Photo by Mardyks.

113. Mask. Wood. Pangwe. Gabon.
Musée de l'Homme, Paris. Photo
by the museum.

closed curves outlined by two horns bent around the plane of the
face.

There is no doubt that cubist painters confirmed their own
research by creating analogous works of the same type when they
used the *rabattu*, or "flattening," process. These masks are more
pictorial than sculptural; they can barely be distinguished as bas-
reliefs. In some of their work the Pangwe in Gabon seem to have *113*
arrived at similar solutions. There is a good example in the former
collection of Paul Guillaume. The hollowing out of the face and
the precise, tense lines of the interior contours are reminiscent of *112*

the Bakwele masks as well as of the Fang statues from Gabon, which are completely sculptural.

Without giving an a priori chronological sense to this categorization, we can classify the masks according to the expansion of their forms in space—the nature and the degree of their dimensionality—and also according to the forms themselves and how they have been manipulated. At times the sculptor uses supple curved surfaces drawn firmly over closed convex volumes. The white masks attributed to the Balumbo in the Ogooué region of Gabon and the Baule masks, as well as others, display serenely beautiful, idealized, enigmatic visages, crowned by shell headdresses which are often complex and finely detailed. On the other hand, some artists depend on a construction of articulated planes.

114. Mask. Wood. Balumbo. Congo/ Kinshasa. Vérité Collection, Paris. Photo by Mardyks.

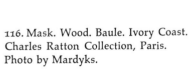

115. Double mask. Wood. Baule. Ivory Coast. H. Kamer Collection, New York. Photo by Edouard Berne, Caravelle Films.

116. Mask. Wood. Baule. Ivory Coast. Charles Ratton Collection, Paris. Photo by Mardyks.

117. Great mask. Wood. Fang. Gabon. P. P. Collection, Paris. Photo by Camille Lachéroy.

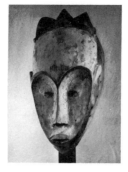

119. Mask. Wood. Dan. Ivory Coast. P. Langlois Collection, Paris. Photo by Edouard Berne, Caravelle Films.

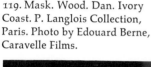

118. Mask. Wood. Senufo. Ivory Coast. P. P. Collection, Paris. Photo by Camille Lachéroy.

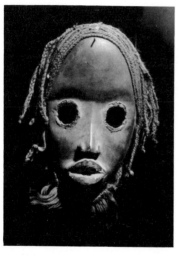

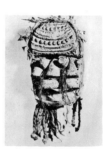

120. Mask. Wood. Guere-Wobe. Ivory Coast. Ch. Tzara Collection, Paris.

The Dan of the Ivory Coast make the plane surfaces of their Dea masks slightly more flexible to round off or soften the sharp edges. The Guere-Wobe manipulate secondary volumes; the sculptural rhythm here is a result of oppositions or juxtapositions of built-up forms and is dominated by discontinuous broken planes. Finally, in Dogon masks the face is cut by straight planes which create their own articulation.

 In all these works the artist maintains the rigid structure of

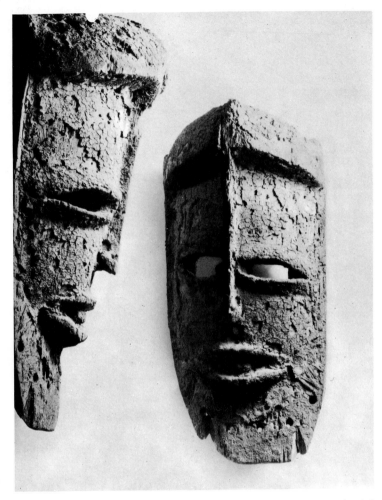

121. Mask, front and profile. Wood. Dogon. Mali. Madame Griaule Collection, Paris. Photo by Mardyks.

a sculptural design whose contours limit the expansion of forms. He achieves this end by the play of tension between curves and straight edges, round surfaces and planes. He adjusts closed areas by indenting arabesque shapes or by limiting the volumes structured by the interior with carefully polished outer layers. Thus

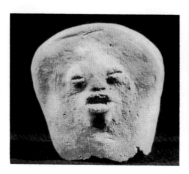

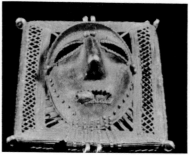

122. Head. Terra-cotta. Sao. Chad. Owner unknown. Photo by Edouard Berne, Caravelle Films.

123. Soul carrier. Gold. Baule. Ivory Coast. Musée I.F.A.N., Dakar. Photo by Edouard Berne, Caravelle Films.

he creates a disciplined harmony that achieves balance and creates a hierarchy among the elements of the figure. When these elements are analyzed and treated separately they appear as autonomous forms whose meanings depend on their positions in the ensemble. When they are subtle or in very low relief they are absorbed as integral parts of the figure's surface.

This method of handling forms is also seen in a series of masks of reduced size which were not made to be worn. As commemorative or funerary symbols they are carried at the belt or placed on an altar or a tomb. Because they must be durable, they are almost never carved in wood but are most often made of gold or bronze or carved in ivory; some are made of iron. Yet certain terra-cotta pieces—small flattened heads from early Sao groups—may have had a commemorative use or may have been worn as pendants. All these works are in very low relief and tend to portray a stylized and quite idealized human face. 122

The Agni, the Ashanti, and the Baule are cultural neighbors who belong to the same Akan group. According to their beliefs, man's soul (*okra*) exists before his birth. "During the entire life of an individual," Pierre Bardon writes, "the *okra* will be divided into two: the soul or spirit of the individual and at the same time a separate being who will protect him." Round gold plaques worn on the chest are the soul carriers. Only the bearer of the king's 123

soul (*okrafo*), who had to belong to the sovereign's family, was entitled to wear them. The commemorative masks probably portray chiefs or kings killed or made prisoners in war. The motif sculpted at the corners of the lips symbolizes the soul (*honhom*) which escapes through the mouth at the moment of death. The Ashanti kings, on the other hand, continue to live in Heaven after death. From that vantage point they watch over their people. Golden masks placed on royal tombs prove the permanence of this invisible royalty. One of the most beautiful examples known is the one that comes from the treasure of King Koffe Kalkalli. William Fagg has associated it with the large polished copper mask that is supposedly the portrait of the third *oni* of Ife, Obalufon II.

Through their stylistic tendencies, the golden masks of the Ashanti and the Baule, the copper and tin ones of Ife, and the bronze and even ivory ones from Benin constitute a relatively homogeneous group. Eva Meyerowitz claims that the very early Ashanti style is more naturalistic than the style of the present-day Baule. The mask of Koffe Kalkalli has an expressive, almost pathetic, intensity which is not found in the usually austere and serene golden objects of the Baule.

Gold and bronze masks are distinguished by a certain richness of form which makes them closely resemble the human face. Their reflecting facets are meticulously curved in a continuous succession, without interruption by plane surfaces. They are more or less successful according to whether or not the goldsmith has corrected their rather facile elegance with more severe tensions of contour and surface, for the material itself is supple, ductile, and easily worked. The human quality that Fagg attributes to the Yoruba and the Baule is often only virtuosity ending in a rather colorless academism and encouraged by weak constraints in technique and raw materials.

124 The pattern of Benin masks made of ivory is like that of bronze masks, except that the former look more solid, the outer layers vigorously resisting the thrust of the internal volumes. The differences result from composition and material rather than

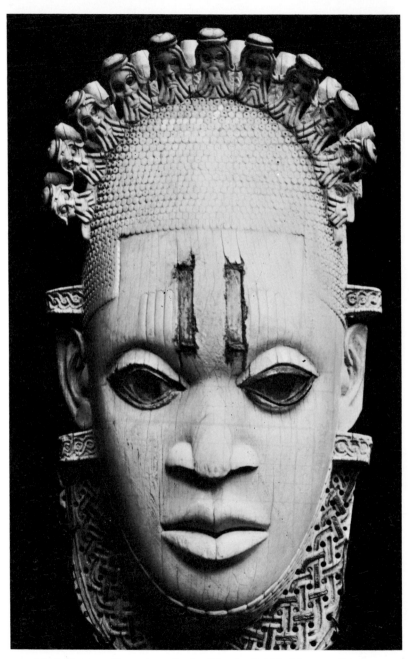

124. Mask. Ivory. 16th century. Benin, Nigeria. British Museum, London.
Photo by the museum.

125. Masked figure. Ivory. Warega. Congo/Kinshasa. Charles Ratton Collection, Paris. Photo by Mardyks.

126. Mask. Wood. Warega. Congo/Kinshasa. Courtesy of the American Museum of Natural History, New York. Photo by the museum.

from style. The artist's genius seems to have been stimulated by the fact that ivory is difficult to work with. When an artist shifts from one material to another without changing his technique, as 125 the Warega do in carving the same models in ivory and wood, 126 there are few qualitative differences. The constraining influence 127 of the material and the carving technique led the artist to surpass himself. In spite of the undisputed successes seen here and there in terra-cotta objects or in a few bronze or gold pieces, a sculptural rather than a modeling point of view predominates in the African genius. When the Dan began to make their little masks worn on the arm from molten metal instead of wood, the change barely affected the style or the technique. The sober and severe lines, the precisely drawn surfaces, prove these masks to be analogous to and of a quality identical with that of the traditional masks modeled on Dea masks.

127. Statuette. Wood. Warega. Congo/ Kinshasa. H. Kamer Collection, New York. Photo by Edouard Berne, Caravelle Films.

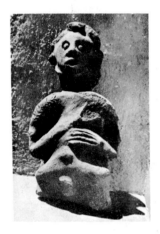

128. Figurine. Terracotta. 14th or 15th century. Djimon, Cameroon.

Masks that are limited to the face are not always in low relief. Masks of the Bamoum and Bamileke, whose successes are rare and not too convincing, are characterized by a proliferation of volumes in space, a taste that may have been encouraged by an early modeling technique. An example found at Djimon in 1948, 128 on the site of the sultans' palace, is a terra-cotta statue which reveals the Bamoum preference for tortured forms and for an often immoderate dynamism, in sharp contrast with the hieratic and rigorous stability of Sudan pieces and with the serene aspect of

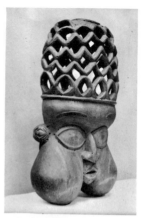

129. Mask. Wood. Bamoum. Cameroon. British Museum, London. Photo by the museum.

130. Helmet mask. Wood. Mende. Sierra Leone. W. Plass Collection, London. Photo by Alec Tiranti. From L. Underwood, *Masks of West Africa* (London: Tiranti).

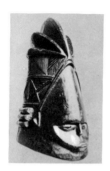

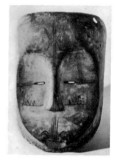

131. Helmet mask. Wood. Pangwe. Gabon. Musée de l'Homme, Paris. Photo by the museum.

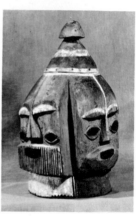

132. Mask. Wood. Keaka. Cameroon. Museum für Völkerkunde, Berlin. Photo by the museum.

129 Guinean art. Bamoum masks expand into space, exaggerating the swollen facial features. Such powerful expressions appear to be trenchant caricatures.

Helmet Masks

A helmet mask, carved out of a single piece of wood into the shape of a human, animal, or mythical head, covers the wearer's head completely. These masks, even though they cannot strictly be called statues, are actually three-dimensional sculptures. They are difficult to classify. Helmets whose exterior surface is barely broken or hollowed out and remains close to its original geometric

form (cone, hemisphere, bullet shape) can be distinguished from those whose wood block has been deeply cut on all sides. Unlike face masks, helmets can be viewed from many angles and do not have a unique facade.

The masks used by the Mende of Sierra Leone for female *130*
initiation ceremonies are chiseled all the way around. The helmets of other groups, principally the Pangwe in Gabon or the Keaka *131*
on the south bank of the Cross River in Cameroon, have up to *132*
four facets, each containing a different face in very low relief. The surfaces of these masks are lightly depressed to mark out the facial form, while the secondary elements, such as the nose, are generally seen as reliefs in the hollows. The work, however, remains a true volume which must be perceived from all angles, even though its facets are juxtaposed and not smoothly joined.

A second series comprises some of the most beautiful masks of Africa, carved for the Baluba male initiation ceremonies. Although not too far removed from the half sphere with which they started, they cannot be grasped as a simple volume; they must be regarded as true sculptures because of the unbroken rhythm of their diverse elements. William Fagg has taken particular note of the development of the horns, which form a strict mathematical curve. Nor can the spherical Baluba initiation masks be appreciated from a single angle, even though the basic volume is only slightly carved out, for they are covered with a polychromatic network of circles whose simultaneous and opposing arcs move in such a way as to fully justify the use of color.

Ekoi masks from southern Nigeria, covered with tanned *133*

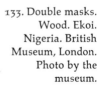

133. Double masks. Wood. Ekoi. Nigeria. British Museum, London. Photo by the museum.

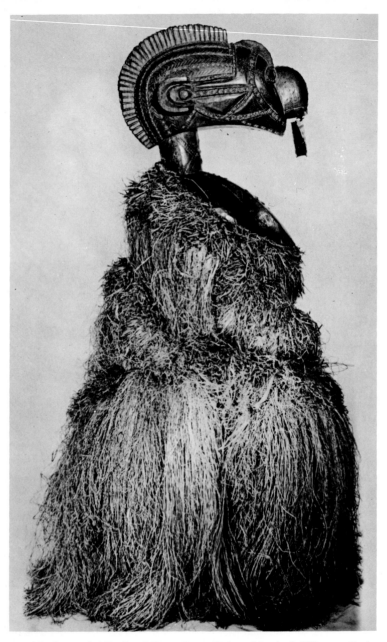

134. *Nimba* mask. Wood and fibers. Baga. Guinea. Musée de l'Homme, Paris. Photo by the museum.

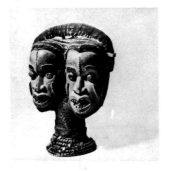

135. Double mask. Wood. Boki.
Nigeria. Charles Ratton Col-
lection, Paris. Photo by
Mardyks.

antelope hide, sometimes have two faces, a woman and a bearded *135*
man. The two heads, powerfully chiseled and hollowed into the *136*
block, are joined together but do not form a homogeneous unit.
This kind of mask is related to another one from the same region
made up of a basketwork helmet crowned by a carved head.

The *nimba* masks used by the Baga of Guinea are not made *134*
from a single block whose surface has been more or less carved.
Rather, they are the counterparts of statuary busts. The sculpted
parts extend farther than the head and the dancer places his own
head inside the carved bust. Thus a *nimba* mask is midway be-
tween mask and statue, possessing elements of both.

Some masks are neither simple facial reliefs nor headdresses.
They may not, properly speaking, be helmets, but there is a round
skullcap covering the dancer's head. The Keaka mask representing *137*
a forest spirit is ambiguous, in a sense. Since it envelops the
dancer's head, it could be described as a piece of sculpture; since
it is also worn vertically in front of the face, it seems to be a re-
lief. The definition of this particular mask, then, depends wholly
on the spectator's point of view. Certain Holli masks from Da-
homey which one might assume to be vertical are worn almost
horizontally on the skull.

The Cameroon mask is conceived within a structure of planes
which branch out from the basic half sphere of the unadorned
skullcap. These planes are so oriented that the observer per-
ceives the mask in three dimensions along a series of varying per-

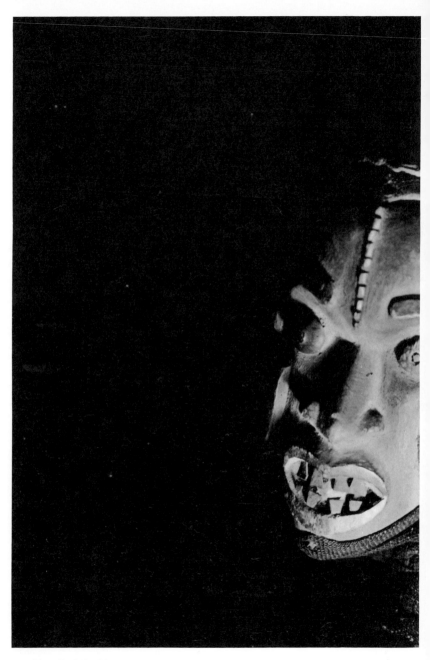

136. Detail of double mask (135). Photo by Mardyks.

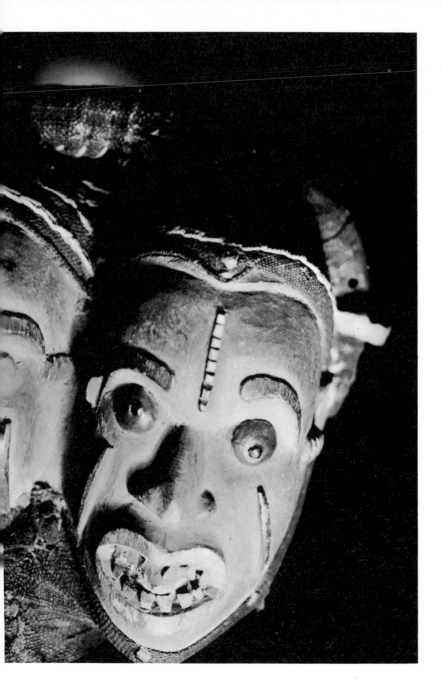

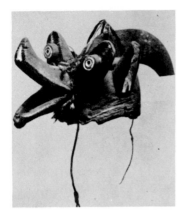

137. Mask. Wood. Keaka.
Cameroon. British Museum,
London.

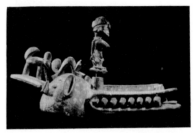

138. Helmet mask. Wood.
Senufo. Ivory Coast. R. Jacob-
sen Collection, Paris. Photo by
Edouard Berne, Caravelle Films.

139. Mask. Wood and fibers.
Chamba. Nigeria. British
Museum, London.

spectives. This kind of mask comes even closer to being sculpture
than do the helmets described above, for it is never enclosed with-
in a limited sphere.

The most extreme models of helmet masks, worn horizon-
tally, have diverse origins: Grunshi or Jaman, northern Ghana,
138 Chamba, northern Nigeria, Senufo and Baule, and the Ivory
139 Coast. They display an interpenetration of interior and exterior
140 space; the mass is broken and carved along different planes so
that the work itself constitutes a space that is both open and
closed where light and air circulate freely. It is the kind of work
that cannot be easily and quickly apprehended. The Baule have
produced the most successful models of this type; a beautiful ex-
ample can be seen at the British Museum.

140. Helmet mask. Wood. Baule. Ivory Coast. British Museum, London. Photo by the museum.

Helmet Peaks

The series of facial masks or helmets showing a single figure includes other works that do not hide the face or the head of the dancer but are supported on a woven cap. These works are of two kinds.

The well-known *sogoni-kun,* representing an antelope and used by the Bambara for the agrarian ceremonies of the Tyiwara, *141* the society of cultivators, are conceived as silhouettes cut out of a single plane. Male antelopes show a latticework mane whose rhythm is created by contrasting straight and curved lines, alternating and growing in three dimensions. Female antelopes are not *143* formed along the same closed-curve shape. Their horns are tall and tapered, almost straight. On their backs they carry a small fawn instead of a mane. These works have been conceived to be viewed in profile. The Kurumba also have helmet peaks that are antelope-shaped, but they are true three-dimensional sculptures, *142* painted on all sides, and not merely one-dimensional cutouts.

Blade-shaped Masks

Some masks are crowned with a wooden blade that may attain a height of 15 feet. As far as is known, blade masks are used *144* only by three culturally similar populations—the Dogon, the Mossi, the Bobo-Oulé—and by a fourth more distant group, the Baga. The Bobo-Oulé are said to have borrowed their model from a Gurunsi group in Upper Volta. This mask series is extremely homogeneous. The face is a relief whose back is attached to a high board that is sometimes pierced and emblazoned with geometric, colored motifs of checkerboard or chevron design. On

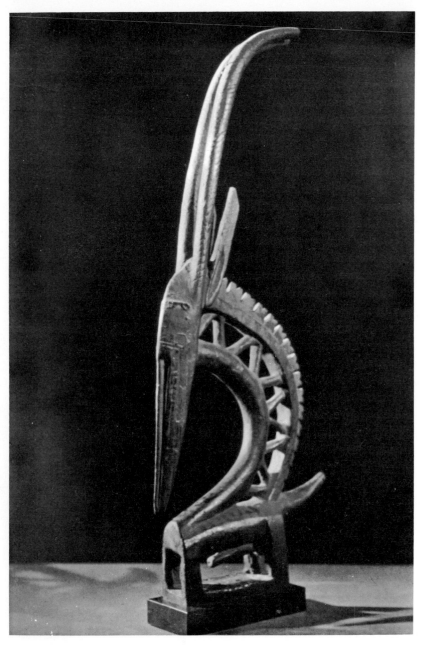

141. Mask representing male antelope. Wood. Bambara. Mali. H. Kamer
Collection, New York. Photo by Edouard Berne, Caravelle Films.

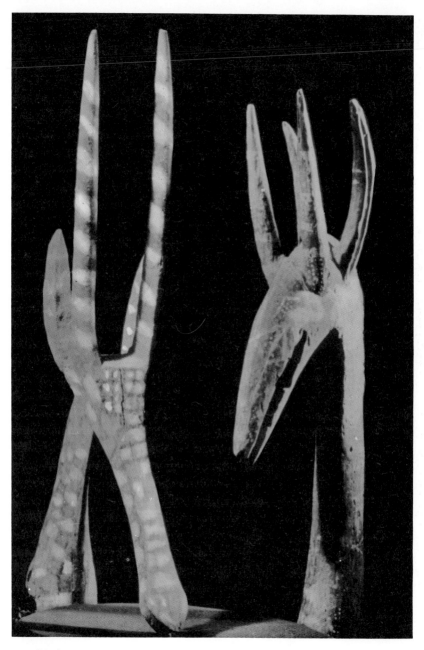

142. Mask representing two antelopes. Wood. Kurumba. Upper Volta. H. Kamer Collection, New York. Photo by Edouard Berne, Caravelle Films.

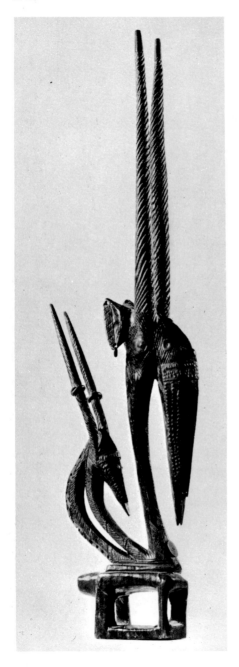

143. Mask representing female antelope carrying fawn on her back. Wood. Bambara. Mali. Vérité Collection, Paris. Photo by Mardyks.

144. Blade-shaped mask. Painted wood. Bobo. Upper Volta. Musée de l'Homme, Paris. Photo by the museum.

the Dogon *kanaga* masks there are, in addition, two horizontal branches, each supporting a smaller vertical board.

According to Marcel Griaule, the Dogon began to carve statuettes only because the great masks they had been using were becoming too bulky and were also endangering the whole community with the excess of life-force impregnating them. A likely and fruitful comparison may be made between the blade masks and the statuettes with raised arms attributed to the Tellem. The same vertical structure characterizes the two series of works. The extension of the uplifted arms forms a background plane behind the head and the bust in numerous Tellem statuettes.

The background plane that supports these statuettes is similar to the blade above the face portion of the great masks. In the *wango* rites the Mossi use a mask on which, in front of the blade, a sculpted female figure stands out from the background. The Tellem-Dogon statuettes may be classified according to a progressively greater distance from the background. The small cutout plank then represents the two raised arms with hands joined. The lower limbs become even more distinct, and the plane itself continues only to the hips. The meaning of the flat plane may already have been forgotten; perhaps it represents the prolongation of the separate arms or additional arms.

Masks Crowned by Sculptures

Some masks are surmounted by one or more sculptures depicting human beings, animals, or objects. Combining facial relief and true sculpture, they are in fact authentic sculptures, especially when they are seen in conjunction with choreography. Certain examples, however, really belong among the reliefs. Some Baule masks are crowned by two birds, perhaps toucans, facing *145* each other and seen in profile. All the symbols to be perceived are grouped on a single facade. The small sculptures over the face are linked to the whole only by their subject matter.

At the other extreme are the enormous helmet masks carved by the Yoruba sculptors for the Epa dance. These works, which at times convey a healthy, popular flavor and are heavily built, may reach a height of 6 feet. They are surmounted by complicated and

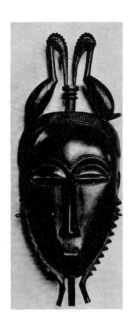

145. Mask. Wood. Baule. Ivory Coast. Courtesy of the Scottish Royal Museum, Edinburgh. Photo by the museum.

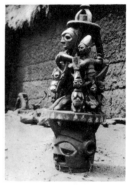

146. Epa mask carved by Ajiguna. Ca. 1900. Yoruba. Nigeria. Photo by William Fagg.

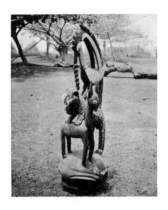

147. Epa mask carved by Bamgboye. Wood. Ca. 1930. Yoruba. Nigeria. Photo by William Fagg.

often confused groupings caused by the proliferation of figures. The mask called Jagunjagun, the warrior, carved by Ajiguna in Iloffa about 1900, and the one that Bamgboye sculpted about 1930, are authentic pieces of sculpture whose helmets serve as pedestals. In spite of their purpose, such works belong to the family of sculptures in the strictest sense—and to group sculpture at that.

146
147

Between the two extremes are found the works in which the sculpture is integrated with the mask as well as those in which it stands out above the wooden head. On a Bayaka mask from

the Congo, representing a woman giving birth, the sculpture is an integral part of the whole. The woman is carved from the same block of wood and is surrounded by the fiber headdress and by a construction of reed and bark attached to the sculpted face portion. Some Dogon masks, like the fine old sample of a woman kneeling over a head, form a transition between the preceding type and the kind whose sculpture stands up clearly above the head, as in *yasigine* masks. *Yasigine* literally means "sister of the 148 masks."

The linkage of masks and statuary is carried out in two distinct ways. At times the plank surmounting the masks is analogous to the background against which the statuettes with raised arms lean. This background gradually diminishes and then disappears altogether, completely freeing the back of the statue. Sometimes, as in the Mossi pieces, the plank persists as such and the sculpture placed before it is not connected. Finally, the sculpture or the sculpted group crowning the mask may be autonomous, whatever its iconographic rapport with the mask might be. The first series of works does not explain the evolution of mask to statue or the progressive replacement of one by the other. This question cannot yet be easily answered. In the second group, the importance of the sculpture above the mask allows the pieces to be legitimately classed as statuary. For the most part, however, these works are of a quality inferior to that of independent statuettes, which suggests that the mask sculptures may have served as models.

Masks and Expressivity

Carl Einstein defined the mask as an immobile ecstasy, perhaps as the means consecrated to the attainment of ecstasy since it has the power to contain the god or the spirit. As noted above, there is in fact a link between masks and the phenomena of possession. According to Ulli Beier, some Yoruba masks show the expression of a living person who has already joined the Bazimu through ecstasy. Certain facial features, particularly the eyes, are prominent and bulging. These rounded and swollen shapes seem

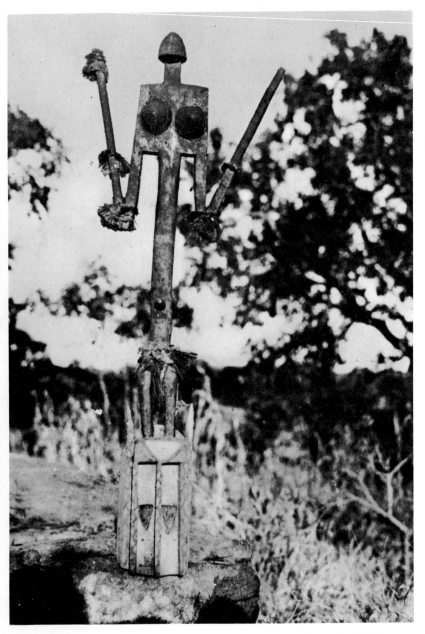

148. Mask. Wood of kapok tree and fibers. Dogon. Mali. Musée de l'Homme, Paris. Photo by the museum.

to jut out because of some internal thrust; they express concentration and receptivity, as does the face of an adoring believer when he prepares to receive his god into his soul or just after the mystical union with his god has been consummated.

Can we pursue these analogies any further? Can we search for the expression of feelings such as anguish, terror, pain, tranquillity, or humor? Here a distinction should be made between the possible aspects of feeling transmitted by the mask and the feeling to be aroused in the spectator. Besides, the code of affective expression often varies from one culture to another. If a mask language exists, it cannot be a universal one. Even within the same population or group it does not speak to everyone, nor does it communicate in the same way with all those who hear it. The entire system to which signs are referred is defined by institutions within the culture. Finally, and above all, the effect is neither uniquely nor necessarily elicited by the carved wooden mask. It comes from the costume, the gestures of the being represented, and the action of the ritual ballet.

Prosper Mérimée once scoffed at Stendhal for having attributed feelings to the virgins of Raphael. Our interpretation of African art could subject us to every kind of mockery. The "terrifying" appearance of certain masks has very often been explained by the insecure atmosphere within the communities that use them. What we have done here is to determine the meaning of a supposed expression by referring to models whose code and system of values are quite different. William Fagg has correctly emphasized that so many masks have usually been described as horrible and frightening, designed to strike terror into the hearts of pagans or novices, when they are really comic and are meant only for amusement. The cosmic anguish that Herbert Read says inspires African artists is often, if not always, only a Western interpretation that owes a great deal to the ideology of the German expressionists. One must carefully refine these judgments and opinions. The art of the Fang from the Republic of Gabon, 149 who live in dark, forested, menacing surroundings, is one of the most peaceful to be found.

Except for Vlaminck and Derain, Parisian painters from Matisse to Picasso have not been trapped into this misunderstanding, nor have those who later discovered black art. Even Paul Guillaume, whose imagination has lent itself to the most fantastic of literary interpretations, remains quite concerned about keeping African art free of exotic or sentimental references. In 1929 he wrote that if the fad for black sculpture was based only on "such adventitious charms," it would not last much longer. Matisse and Picasso became interested in African art in terms of special plastic problems. Matisse was carrying out studies of composition and the expressivity of line. In 1907 Picasso had been working in these same areas, but later he reduced his problem to the object and its integration into the space of the canvas. Clearly, their interpretation of African art is far from being either naturalistic or expressionistic.

Among the widespread misunderstandings created by the European outlook, the interpretation of African art as a type of expressionism is one of the least favorable to its comprehension. There is undoubtedly in these masks an enigmatic violence which we tend to explain as sacred fear or as primitive anguish in the face of a mysterious and aggressive universe. African art does not smile. The mute faces and expressionless eyes convey none of the emotion that classical art lets us share even today. Psychology does not exist in Africa. Being and all its characteristics were granted by one stroke of the Deity. The mask is not a man

149. Mask. Painted wood. Fang.
Gabon. Musée de l'Homme, Paris.
Photo by the museum.

but a spirit, an unchangeable and exemplary model which time cannot touch and into which the individual may not steal. In the words of André Malraux, "The African mask is not the fixation of a human expression, but an apparition. . . . The sculptor does not structure a ghost whom he does not know; he calls forth the ghost by his structure. The more closely his mask resembles man, the less alive it is. Animal masks are not animals: the antelope mask is not an antelope, but the antelope spirit, and it is style that creates the spirit."

This appraisal could not have been better formulated. Still, one might protest: Why the swollen cheeks, the buttocks, the mammary exuberance of the statues? Why the indiscreet sexuality? The spirit certainly works in wondrous ways! True—but here we are not dealing with sexuality in the sad Western sense. If female fecundity is emphasized it is because it guarantees the earth's fertility. Sex is neither horror nor desire, but life. Besides, insistence on sexual functions is an aspect of African art limited to a few groups. Nudity in Africa is perfectly innocent; there is no other art that has been more indifferent to sexuality.

The expressionistic illusion could also be explained by the fixity and the stereotyped character of the forms. It is not the particular appearance of a mouth, an eye, or an ear which the African sculptor wants to represent, but the mouth, the ear, or the eye as the Deity designed it in the beginning. This basic premise explains the simplification and the cubist characteristics of African works of art. The constitutive elements of African sculpture are relatively numerous, stable, and interchangeable; they are always represented by analogous, synthetic signs. The following method of retaining the expression of a face was proposed by da Vinci: "Learn by heart different types of heads, eyes, noses, mouths, chins, throats, necks, and shoulders. Of the nose, for example, there are ten types . . ., and the same diversity is found in the other traits." It is exactly in this manner that the African sculptor proceeds. To represent an eye, a nose, sex organs, or breasts, he has at his disposal a vocabulary that is more or less broad according to his society. But whereas da Vinci prescribed

the life study of the elements of a face, the African sculptor studies them as they have been bequeathed to him by tradition and transmitted by apprenticeship, like the elements of a code.

An African mask or statue appears as a combination of signs that re-create a reality with the aid of a stable vocabulary whose elements are not an imitation of nature but bear a particular intellectual stamp. There was a moment when, in the studios of Parisian artists who were approaching cubism, the question arose as to whether one had to start with a cylinder to achieve a bottle or start with a bottle to achieve a cylinder. To an inquiry in the magazine *Action* in April 1920, Juan Gris replied that African sculptures, as "diverse and precise manifestations of great principles and general ideas," make us accept an art that, unlike Greek art which "based itself on the individual in order to attempt an ideal type," succeeds in "individualizing the general."

This formulation can be accepted only with the reservations that in Africa there is no distinction between the cylinder and the bottle, and that the individual does not exist as such. What counts for the African is not his person, but his participation, his link with the world order. "The Sudanese," says Griaule, "has an unquenchable thirst for the infinite. He became conscious of his cosmic situation at a very early stage, but he has never occupied the central position. Having already projected the ensemble of categories and their functioning upon every phenomenon, he could not arrive at anthropocentrism. On the contrary, he considers man as a cog, neither more nor less essential then a beetle or than rainwater." When he places a mask before his face the dancer seeks neither to disguise, nor to beautify, nor to affirm himself, but to withdraw behind a sufficiently simple image that amply conforms to the injunctions of the myth. The image entraps and mirrors the Deity.

6

Statuary

A mask as perceived by the African always requires human support; it is moving sculpture. Both the wooden mask hiding the face and the helmet entirely covering the dancer's head are only parts of a costume, the costume in turn being part of a dynamic ensemble of choreography and religious spectacle. On the other hand, statuary is rarely exhibited in public. Even though it is closely tied to a network of ritual and exists in terms of religious practices, statuary seems to possess a certain degree of autonomy. In the strongest sense of the word, statuettes are static objects, occupying a defined space. Moreover, they are usually manipulated by private cults; at best they concern the life of the collectivity only indirectly.

Funeral or commemorative masks can be distinguished by their material—wood, gold, or bronze—but statuary is classified by two major techniques: carving and modeling. A brief discussion of these methods is prerequisite to an evaluation of their technical role in the creation of style.

Carving and Modeling

Earthen statuettes have been uncovered in a tumulus near Djenné and in another near Mopti, about 60 miles distant. Made of rough pink clay, these works seem to be related to Sao objects because of the baking process employed. A pink clay male figurine, recently found in the Dogon region, is analogous in technique, style, and method of baking. The clay used for these works is rather coarse-grained and was probably baked over an open *150* fire or dried in the sun. Nok works are varnished, and Mangbetu *151* pieces are blackened with graphite; in the Krinjabo region, the *152* clay used by the Agni is often gray-colored. The latter works are all fine-grained and give evidence of remarkable baking techniques. It might be thought that Djenné, Mopti, Dogon, and Sao terra-cottas, as well as some from Angola or the Congo (particularly the ones found in 1949 at Kingbawa among tools having Neolithic features), represent an archaic stage of ceramics without necessarily implying greater antiquity.

The Dogon figurine wears a round, iron neck ornament which *153* may have been an original feature or may have been added later. *154* The Kissi of Guinea use soapstone statuettes dug up from their *155* fields as rice gods in present-day ceremonies; the Dogon may *156* likewise have adapted something discovered in a tomb. This evidence of technically archaic ceramics is perhaps a survival of an ancient state of African statuary antecedent to the introduction of the iron tools necessary for sculpture in wood. Information about this presumed evolution is too scattered and incomplete to

150. Jar with woman's head. Clay blackened with graphite. Mangbetu. Congo/Kinshasa. Musée de l'Homme, Paris. Photo by the museum.

151. Detail of jar with woman's head (150).

152. Funerary figure. Terra-cotta. Agni. Krinjabo region, Ivory Coast.
Sammlung für Völkerkunde, Zurich. Photo by the museum.

153. Figurine viewed from front. Stone. Kissi. Guinea. Léonce Pierre Guerre Collection, Marseilles. Photo by L. P. Guerre archives.

154. Figurine viewed from back (153). Photo by L. P. Guerre archives.

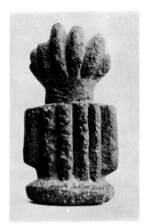

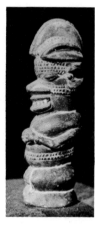

155. Kneeling figure. Stone. Kissi. Guinea. H. Kamer Collection, New York. Photo by Edouard Berne, Caravelle Films.

enable scholars even to establish the problem. It is traditionally the women who do clay modeling; perhaps the hypothesis about archaic ceramics could be joined to the theories concerning the matriarchal bases of Paleo-African civilization. But the existence of a primitive matriarchy is still highly conjectural, and in numerous regions the potter and the blacksmith are as a rule close associates.

Modeling and metallurgy are two essential techniques in village industry. In their mask shelters the Dogon preserve figurines commemorating their predecessors, the Andoumboulou. These pieces, the only modeled works they have today, are dedicated to their nation's past. The art of carving has replaced modeling, at least in societies descended from the Mande, but the two techniques coexist among the Sao. Some of their ceramics por-

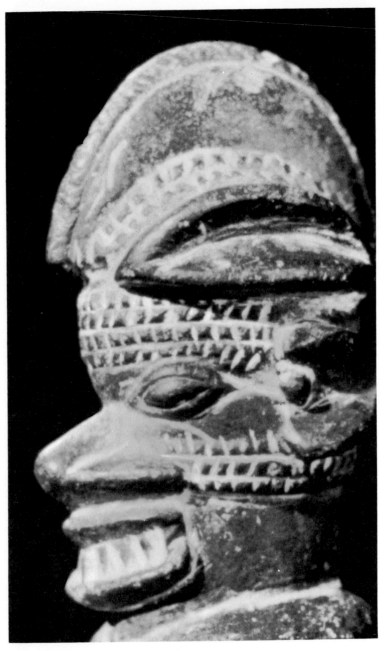

156. Detail of kneeling figure (155).

tray masked dancers. Obviously no priority of modeling over carving, or vice versa, can be established. Even if such a judgment could be made for one community, it could not be extended a priori to others, even to neighbors.

Henri Focillon believed that "raw materials carry their own destiny or a certain formal vocation. They possess consistency, color, and grain. They are form itself . . . and, if only for that reason, they call forth, limit, or develop the life of art forms." There are in Africa wooden sculptures carved to approximate the effects of earthen or bronze pieces, but earthen figurines derived from wooden statuary are far more rare. In both instances the formal vocation of the raw material is hindered by the lack of rapport between the substance and the technique. Rather than actually imposing a style, a technique allows the purest and most suitable forms to appear, fully exploiting the possibilities of the material.

Dogon, Bambara, and Senufo art is dominated by wood sculpture. It is one of the proudest and most austere arts. The artist does not work for a rich aristocracy jealous of its privileges; he does not supply the complicated ritual of a royal court. His creations are not, however, naïvely made to sustain or to express popular fervor. The work is ruled by a rigorous simplicity which is almost never transgressed. The austerity and the rigor are definitely properties of material that is resistant to carving. The sculptor has to be clever enough to deal with knots and the direction and density of the fibers in such a way as to integrate them into his finished product. He recognizes in the wood qualities he can use to realize his own ends. Rigor and austerity are consciously and voluntarily sought. The wooden statuary of the Dogon, the Bambara, and the Senufo arises from the happy conjunction of material, adaptation of technique, and artistic intention. Certain Yoruba works, such as their twin figures (*ibeji*) and the great maternal statue dedicated to Shango, could have been executed in clay without suffering any change in style. On the contrary, a Dogon, Bambara, or Senufo sculpture cannot be con-

158
157

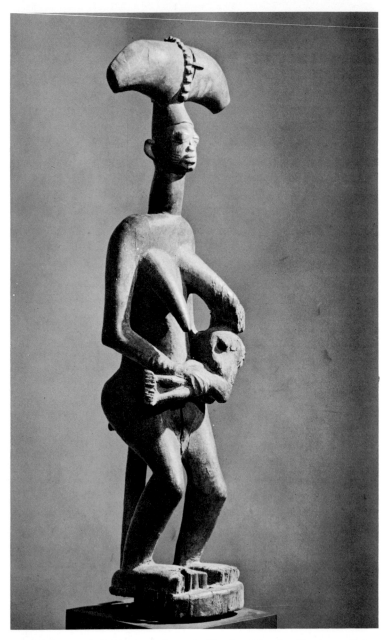

157. Mother and child. Painted wood. Yoruba. Nigeria. Courtesy of the
Museum of Primitive Art, New York. Photo by the museum.

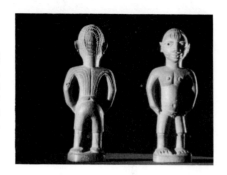

158. Twin figures (acquired in 1854). Wood. Yoruba. Abeokuta, Nigeria. British Museum, London. Photo by Edouard Berne, Caravelle Films.

ceived of in any material other than wood; the entire nature of the work would be altered.

Dogon and Bambara blacksmiths work in both wood and iron. The wooden objects, in spite of their reduced size, have been fashioned into broad architectural rhythms by rich contrasting volumes, which seem to be nourished from the interior and, at the same time, stretched just below their outer surfaces and across the visible contours. Working in iron, the blacksmiths produce slender, flexible objects. Stretching upward like seedlings these slim figures seem on the point of dissolving into space at any moment. The ironwork objects testify to a faultless plastic inventiveness which responds to the suggestiveness of and the possibilities inherent in the material, subjecting them to a central, guiding thought. These works are devoid of expressionism; only the line itself is expressive, sensitive and alive, but intellectually controlled.

Whether he works in iron or in wood, the smith-sculptor is anxious not to betray the formal vocation of his material, which does not, however, impose upon him a single exclusive formula. Compared with Dogon pieces, Bambara ironwork is generally 159 more massive; there are sometimes rounded, lumpy forms whose surface is ornamented. Dogon ironwork is almost exclusively 160 characterized by thin, elongated lines. The same contrasts are 161 apparent in the statuary of these two peoples.

By itself, a material cannot impose a definite style. It is never anything but a more or less well-adapted means by which the

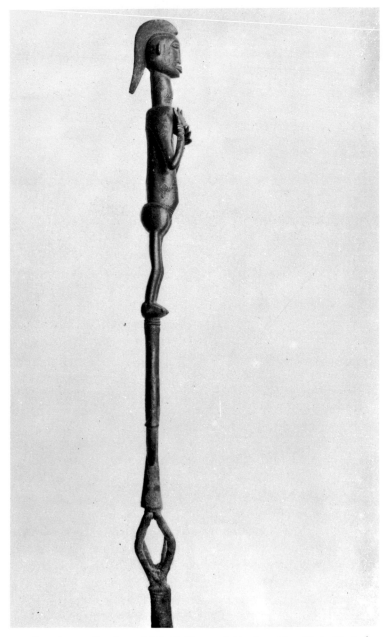

159. Ritual iron. Bambara. Mali. H. Kamer Collection, New York. Photo by Peter A. Juley & Son, Kamer archives.

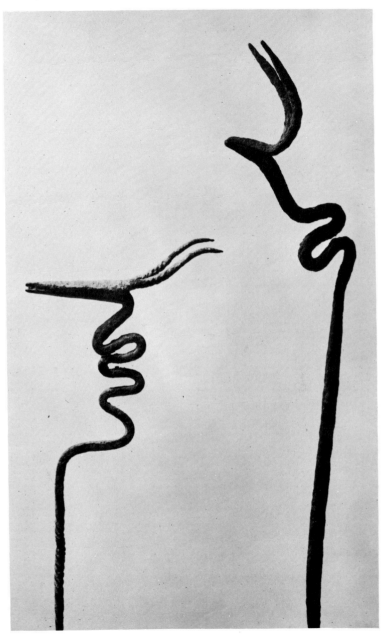

160. Ritual irons representing antelopes. Dogon. Mali. H. Kamer Collection, New York. Photo by O. E. Nelson, Kamer archives.

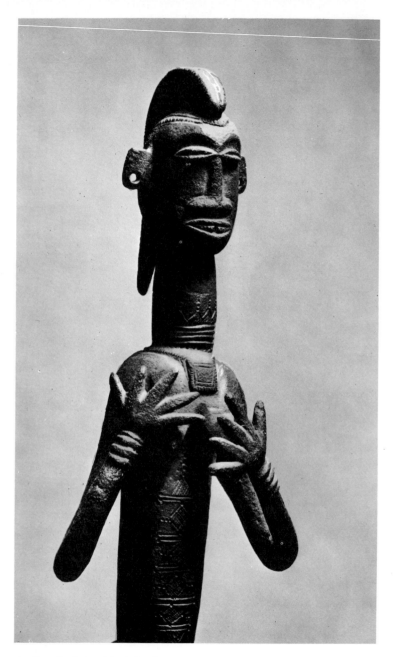

161. Detail of ritual iron (159).

artist realizes his intentions. When certain models seem to have been produced by a technique completely different from the one originally employed, the question arises: Did the change result from the prestige value attached to the new material or merely from contemporaneous influences? The Senufo have made, completely of iron, a magnificent twelve-square game whose extraordinary characters are fashioned in a style quite similar to that of the Baule gold pendant masks. Here a rather limited borrowing of style seems to have taken place, but in other works it is apparently the technique that has been borrowed. The rare examples of small Senufo figurines in bronze which have survived are not essentially different from the sculpted figures in Tristan Tzara's collection or from the forged ones at the Museum of Primitive Art in New York. The Senufo artists seem to have adapted the style of their wood statuary and their ironwork by transposing it 162 into a technique acquired from their Baule neighbors.

Style and Religion

Although the material factors, technique and substance, do not necessarily impose a definite style, is it possible that spiritual factors (religion or philosophy, in a broad sense) influence the formal structure and the sculptural aspect of statuary?

Ever since the discovery of Africa, a suspect terminology has prevailed in references to the black continent; in fact, this terminology masks profound ignorance. The terms "fetish" and "idol" used in travel accounts as early as the sixteenth century created a confusion serious enough to impede a fair appreciation of African religions and their relationship to sculpture. An example is found in the *Relacione del reama di Congo* ("Description of the Kingdom of the Congo") by Filippo Pigafetta and Duarte Lopez, which appeared in 1591 with engravings by the de Bry brothers and was almost immediately translated into several languages: "We saw innumerable objects, for each man worshiped what pleased him most, without order or moderation or reason of any kind. . . . As their gods the people chose snakes, serpents, animals, birds, plants, trees, diverse wood and stone figures and

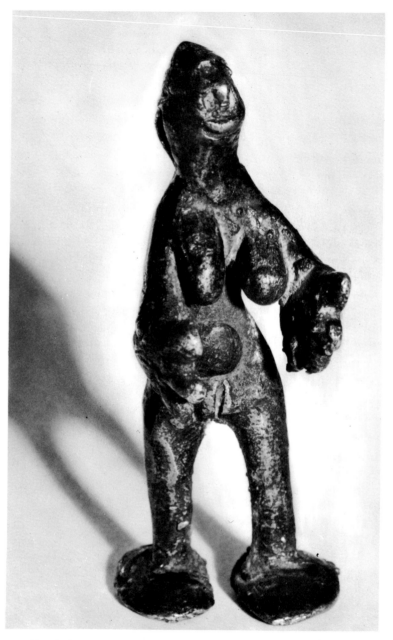

162. Female figurine. Bronze. Senufo. Korhogo, Ivory Coast. J. Verheyleweg-
hen Collection, Brussels. Photo by J. Verheyleweghen archives.

portraits representing the above-named beings, painted or sculpted in stone, in wood, or in some other material. . . . The rituals were varied but all bore the signs of humility: the people kneel, prostrate themselves, smear dust on their faces while chanting to the idol and while offering him the most precious gifts. They also had sorcerers who deceived these stupid people by assuring them that the idols could speak. Whenever someone begged a sorcerer to cure a sickness, he gave credit to the idols if he succeeded and said the idols had been angered if he failed." Théodore de Bry based his engraving, *The Abjuration of the King of the Congo*, on this description.

Present-day writers not only differentiate among traditional African religions, but they are also abandoning the term "animism" which, until recently, served to characterize those religions. According to Amadou Hampatéba, "no matter how real the geographic unity of Africa, it is nevertheless impossible to find a basic African tradition that would be valid for all ethnic groups." As we are unable here to examine in detail African religions, or even the religion of a single group, we will limit ourselves to describing the possible link connecting sculpture to cults, beliefs, and practices. Each African statue has a religious or, in the broad sense, a social purpose. It is an instrument or tool that has at the outset no emotional or aesthetic intent. Very few arts are so unconcerned as African art about the effect produced on viewers. Even the Bini bronze heads and statues, long thought of as products of secular art, were arranged on altars. Some Tellem, Dogon, *163*

163. Ritual object representing hippopotamus. Earth mixed with beeswax and covered with dried blood. Bambara. Mali. Musée de l'Homme, Paris. Photo by the museum.

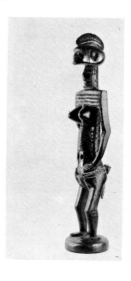

164. Female figurine. Wood; necklace
and belt of pearls; loincloth of fabric.
Bambara. Mali. Musée de l'Homme,
Paris. Photo by the museum.

164 and Bambara statuettes are covered over with a sacrificial coating
of dried blood or millet gruel or with adventitious elements such
as cloth, nails, or shells, which blur or mask the sculpted forms.

Sculpture may be roughly classified according to its relation-
ship to a religion or to magical practices: (1) fetishes; (2) sculp-
tures that incarnate nonmaterial or abstract things (ancestors, the
life-force); and (3) commemorative sculpture recalling a legen-
dary or historical person or event.

Fetishes

The term "fetish" probably comes from *feitiço*, a Portuguese
word meaning "factitious" which, used as a noun, has taken on
the derivative meaning of charm or spell. It first appeared in
France in 1760 in a book written by Charles de Brosses, *Du culte
des dieux fétiches* ("The Cult of Fetish Gods"). Rapidly becoming
pejorative, the word was used for the most part without discern-
ment. Even today people find it difficult to give "fetish" a precise
definition, though it is known to be a translation given by the first
European travelers for the Congolese word *nkisi*.

The word *nkisi* designates not only a statuette but also a horn
or a shell or, as summed up by Denise Paulme, "any receptacle

consecrated by a magician." Nevertheless, not every statuette is a fetish; the pertinent question is how the object is utilized. Albert Maesen says that Mayombe fetishes from the Congo are used "to the same ends and in the same circumstances as many Baluba ancestor statues." The distinction between fetish statuettes and ancestor statuettes is, it seems, independent of their exterior appearance. Certain fetish statuettes can, however, be recognized by their form. Examples are the different kinds of reliquary statuettes in which the abdominal area is occasionally replaced by a mirror and the so-called nail statuettes found among all the Congolese populations, particularly along the coast.

Fetishes such as shells, pebbles, pieces of wood, and excrement owe their magical powers to the natural forces that inhabit them. Impregnated fetishes are pieces of sculpture which have received their strength through an operation carried out by a being gifted with supernatural force, the medicine man (*nganga*). Thus the statuettes seem to be mere props or conductors of magical power.

The *nganga* can use the fetish for pure sorcery: to bewitch and to cause sickness or death from a distance. To these ends he must procure, for example, fingernail or hair clippings belonging to the man he wants to make ill or whose death he desires. A death is almost never considered a natural event. The relatives of the dead man question him to discover whether he was the victim of a magical act, and they expect him to name his murderer. The sorcerer's role in society is auxiliary; he works only on a private basis to reaffirm his own power or in the pay of certain individuals. His antisocial attitude is greatly feared; the community takes numerous precautions, notably that of organizing bands of witch-hunters. It is hardly surprising that these bands, such as the leopard men of the sect Aniota in the Congo, themselves assume occult powers as frightening as those they oppose. The *nganga* does not, however, always use his fetishes for maleficent purposes; the forces he can manipulate remain ambiguous. The same statuettes serve to cure as well as to induce disease, to protect persons from spells as well as to bewitch them.

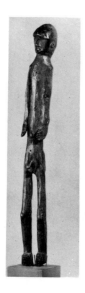

165. Figurine carried by
children to make them grow.
Wood. Bari. Sudan. Musée de
l'Homme, Paris. Photo by
the museum.

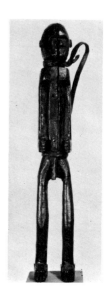

166. Figurine carried to attain
physical strength. Wood.
Bari. Sudan. Musée de
l'Homme, Paris. Photo by
the museum.

It follows that the outward appearance of the statuette, the posture of the personage represented, is not enough to contain the force temporarily housed within. The sculpture (which Henri Lavachery correctly calls the "charm carrier") and its basic or added materials are in themselves inert. The object is susceptible of receiving or of retaining a power for a given time, but it is the *nganga* who, through appropriate rituals and the chanting of certain formulas, quickens the power and orients it. When the Mayombe *nganga* has liberated a force by driving a nail into a statuette, the force still has to be directed and controlled. His next step is to determine whether the operation is to be beneficent or maleficent.

Is it possible to establish, on this basis, a correlation between magical power and the more immediate aspects of sculpture? In 165 the region of the upper Nile, children carry certain statuettes 166 in order to grow or attain physical strength. Although of mediocre quality, these works are interesting in that they clearly state why they were made. Some are extremely elongated; others portray

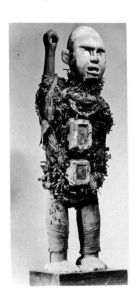

167. Figure with double reliquary and mirror. Wood and mirrors. Bakongo. Congo/ Kinshasa. Vérité Collection, Paris. Photo by Mardyks.

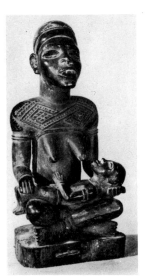

168. Mother and child. Wood. Mayombe. Kasadi, Congo/Kinshasa. Musée Royal de l'Afrique Centrale, Tervueren. Photo by the museum.

individuals whose closed or clenched fists and tensed faces suggest physical effort. Through such an intermediary the child who carries or handles the statue participates in the analogy between the statue's artificial elongation and the body's growth, or between the visible signs of effort and the gaining of strength. The rapport is not always so simple, and it often turns out to be illusory. One Bakongo statuette showing a little man stricken by Pott's disease was just as useful in curing illness as in communicating it.

Even though certain Bakongo fetishes have been considered as "bristling with points and iron blades," it has also been said that "in spite of the dagger some of them brandish in a purely symbolic gesture, their features display the same expression as the mother figures so characteristic of this region." Albert Maesen concludes that "no one ever dreams of attributing a threatening air to maternal figures. A simple comparison establishes the resemblance, even the identicalness, of expression in these two series of figurines whose meanings are profoundly different."

167
169

168

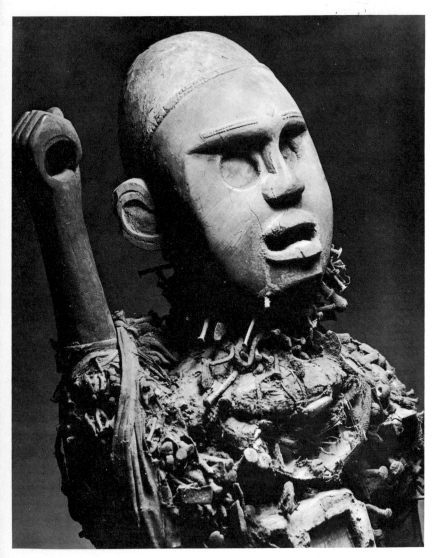

169. Detail of figure with double reliquary and mirror (167).

Used for private aims, fetish statuettes do not concern the group as such, or even a fraction of it. The magical power that impregnates them is only temporary, like electric current passing through a wire. The purpose and the use of other sculptures affect wider groups or larger fractions, perhaps a family or a village. Far from being mere conductors of magical force, these sculptures are true vessels wherein invisible powers are trapped. Whereas a fetish may be only a scrap of cloth, a conglomerate of materials, or any other kind of natural object, the vessels demand a form; they must be sculpted.

Sculpture as Incarnation

Michel Leiris has related the religious function of African statuary to that of ancient Egyptian statuary. Indeed, according to Alexandre Moret, "the knowledge of priests and the art of sculptors must be conjoined to create images that satisfy the 'heart of the gods.' " Above all, the image "must provide each god with his characteristic attributes. . . . Crowns, scepters, and ornaments must be reproduced with the most scrupulous ex- actitude, or the god, not being able to recognize his image, will not enter it." The same words might apply equally well to African artwork were it not for this difference: except for Yoruba objects, African statuary does not represent gods themselves, but is rather a funerary art designed to capture the life-force of mortal or im- mortal ancestors, which is then capitalized and redistributed to the benefit of the interested group. Such sculptures "do not need to reconstruct the features" of ancestors, for they serve as "tan- gible emblems" evoking the features "only symbolically." Leiris adds that many of "these pieces are touched by the officiants who handle them as if they were tools of a particular kind. The link joining man and statue is affective and emotional, a mixture of fear and respect. The statues are anointed with blood or with whatever substance is offered up."

As temporary or permanent dwelling places, African sculp- tures tend to bind the world of the living to that of the dead an- cestors. They situate the world within a temporal continuity and

density which the living man penetrates, as the roots of a tree grow down into nourishing soil. In this peasant philosophy, all values are directed toward the land and its tilling, toward the harmony among man, the earth, and the cosmos. Images and metaphors are borrowed from cultivation of the soil, from germination, and from the cycle of seasons and stars.

The statue is not only the home of an ancestral or spirit life-force, but also the symbol of an individual or of the events through which he has lived. Among the Dogon the life-force of every individual shares in the spirit of one of the mythic ancestors (Nommo, Yeban, etc.), the latter having played a part in the creation or the organization of the world and therefore possessing a history. Dogon statuettes used on private altars are classified according to their immortal lineage. By their thematic matter, the sculpted figures characterize the personality of the genie from which the head of the family is descended. Thus the Nommo is portrayed as a personage with raised arms because he pleaded for life-giving rain, but he was sacrificed to Heaven before having purified the primeval fields. Although the statue incarnates the invisible, it also provides an image, a mythical episode which the believer can immediately decipher. In some populations, particularly the Yoruba, according to William Bascom, the statuette is probably a symbol only and not a concretization.

It has been asked whether the religious purposes of African statuary can, at least in part, explain its plastic characteristics. As early as 1915 the German poet and critic Carl Einstein became interested in this field of research. For him, an African sculpture took on the "appearance of an entity" instead of being perceived "as an artificial creation or as the product of personal choice." Each of its parts "expresses the meaning possessed by the statue, and not the sense the viewer might invent." It is a "hermetically sealed form that confers its own reality upon the ensemble." Whereas European art has "locked itself into a system of varying effects uncovering the spectator's own freedom and his capacity for indifference," African art "is categorical. It conveys the message of being and proscribes evasion." Rather than embody-

ing "formless optical suggestions" (like those of precubist Western sculpture), it aims to display the effective presence of "mythic realities."

Here Einstein is interpreting African statuary in terms of cubism, a movement he was among the first to defend in Germany. It is in this sense that we should understand his interest in an art that "proscribes evasion," as opposed to an art whose viewers passively accept "formless optical suggestions." To say that African art is "categorical" is Einstein's way of affirming that black statuary imposes a vision and that it must never leave the spectator indifferent, that is, free to daydream. To grasp it as a harmony in plastic relationships demands intellectual effort. This statuary transmits "the message of being" because, on the one hand, it refuses, or is too indifferent, merely to transcribe a transitory, anecdotal, or evolving reality, and because, on the other hand, it has the will, confirmed by myth, to represent a stable reality whose deepest nature remains untouched by time.

It is certainly tempting to create a parallel between the necessity of referring to a fixed model based on myth and the African preference for architecturally solid forms securely planted in space. The solidity, the almost brutal simplicity, the plastic rigor of African sculptures can also be explained by the fact that they are cult objects, not intended to be examined in an aesthetic light. As Michel Leiris has said, they are "in large part constructed in the same way tools are made in an economy regulated by precise necessities that hardly permit room for mannerisms." The instrumental and practical character of African statues may also govern their small size. African art is rarely monumental. Another notable trait of African statuary, except for Cameroon posts and lintels, is that it neither integrates with nor derives from architecture. It might even be said that African art, in contrast with Mediterranean art, is ignorant of stone architecture. Houses and royal dwellings are made of clay bricks except for the Zimbabwe buildings, which date from the twelfth to the fifteenth century. Even their layout seems to have a mythical and not an architectural basis. The Dogon patriarchal house, as analyzed by Griaule, *170*

170. Patriarchal house. Dogon. Mali.
Imaginary plan, after Marcel Griaule.

evokes the creation of man. Africans have no temples where they gather, but rather sanctuaries to hide the divine or ancestral powers and retreats to welcome, to sequester, and to imprison the beneficent and yet at the same time formidable energy that pervades the world. There must be a concentration as powerful and closed as the statuettes to capture and retain the strength of the gods and the souls of ancestors. These religious practices may explain why no other people have in this fashion bypassed architecture to devote themselves so intensively and exclusively to sculpture.

The concentration on sculpture may also explain the extreme rarity of painting in Africa. The rock paintings in southern Africa are most likely of Hottentot and Pygmy origin. On the facade of Dogon sanctuaries, and under the overhang of porches where the models of the great masks are kept, are seen colored drawings in red ocher, white, and black. They are so schematic that they never go beyond the level of a sign, and they resemble two-dimensional sculptures. The Tassili frescoes constitute the only notable exception to the absence of painting, but they are not all of black creation. Since we know so little about them, they could in no way serve as a basis for a complete discussion of African paintings, but they do provide the only dynamic images found in African art. They evoke the diverse activity of a pastoral, 171 hunting, or sometimes warlike people, with processions of livestock, hunting scenes, and so on. The reality is taken directly from life at a most favorable moment.

These frescoes are the single exception that confirms the rule. African art is immobile and for the most part ignores everyday

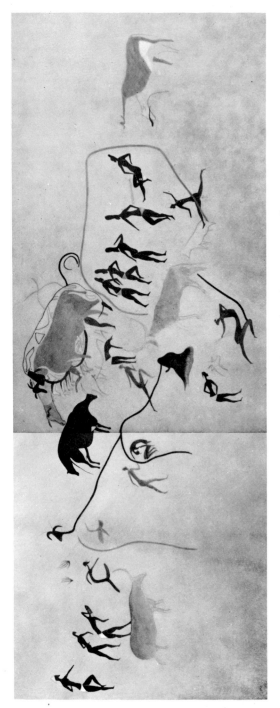

171. Herds and hunters. Detail of fresco. Adjefou. Tassili, Algeria. Photo by Mission H. Lhote.

reality. A people whose art has no other purpose than tirelessly to reaffirm the permanence of the gods' order, and for whom reality is meaningful only insofar as art conforms to this order, remains indifferent to the expression of movement. Nothing that is fluid, transitory, perishable, or irreplaceable in all creation— "the moment of the world which passes," as Cézanne said—can involve the African. He literally lives in eternity, is unaware of the individual, and conceives of himself only in terms of the archetype. He cannot even be said to have descended from the archetypal ancestor; rather, he emanates from the ancestor and exists in an atemporal present.

Climate is not the only reason that African art seems to ignore light and color. When Africans paint their faces or bodies, they are not trying to reproduce a color that is true or beautiful in itself; color is simply a religious symbol, a way to reach the nonmaterial being. In a universe heedless of the individual, of time, and of pomp, there is no room for painting, the representation of the world. The African does not see a horse, a crocodile, an antelope, or a hare as an animal, but as a species in a nearly Platonic sense. There is only one African work of art which depicts the 172 plant world: a Bini plaque showing a hunter aiming at a bird perched in a tree. That tree is unique in African art; blacks live in nature and participate in it intensely and profoundly, but they do not observe it.

Commemorative Sculptures

Works that commemorate feats or mythical or legendary characters are found primarily in regions where the traditional government is in the hands of a king who has attributes of divinity and, at least theoretically, wields both spiritual and temporal power. Examples are the Congolese Bakuba, the peoples of Ife, Benin, Dahomey, and Cameroon, and, to a lesser extent, the populations that call themselves descendants of the Mende.

Such sculptures may commemorate events that occurred at the time of creation, in the beginning of the world. A long series 173 of Dogon statuettes together tell the story of Genesis: the ap-

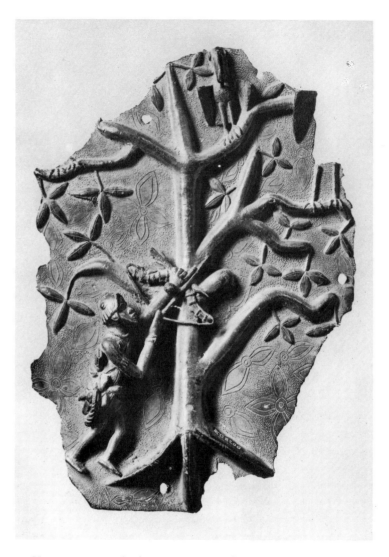

172. Hunter aiming at bird in tree. Bronze plaque. Bini. Nigeria. Museum für Völkerkunde, Berlin. Photo by the museum.

173. Dyougou Serou cover-
ing his face after act of in-
cest. Wood. Dogon. Mali.
Former R. Rasmussen Col-
lection, Paris.

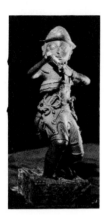

174. Portuguese settler aim-
ing a weapon. Bronze. 16th
century. Benin, Nigeria.
British Museum, London.
Photo by Edouard Berne,
Caravelle Films.

pearance of a first being (Dyougou Serou) who, through an act of
incest, upsets the world order; then the sacrifice of two of the
eight Nommo, after their suppression of the disorder, for the
purpose of purifying the primordial fields; and, finally, the arrival
on earth of the blacksmith-horseman with the ark carrying skills
and crafts as well as the ancestors of men and animals. Other
sculptures recall events taking place or legendary feats accom-
plished after the creation; the statues of Arou on his brother's
shoulders recall not only a myth of migration and the taking of a
country but also the origin of the *hogon's* function. Yet Arou re-
mains a legendary figure, whereas the statues of Bakuba kings
represent definite persons who really lived and whose deeds are
well known. The statue of Mikope Mbula, shown with a small
female figure in front of him, commemorates his freeing of a
slave. The idea presented in this work is ethical, nay, even
political.

From sculptures rooted deeply in myths, we go on to works
that relate legends and to others that concern historical events.
Soon it appears that the statues are only artificially linked to re-
ligious belief. Existing alongside art "in the service of religion"
is art produced "for the sake of religion," in the opinion of André
174 Varagnac. The statues of Portuguese settlers cast by bronzework-
ers in Benin were placed on the altars of the oba's palace, though

the religious link was extremely tenuous. In this way the oba signifies to the court and to the people that he deals with foreigners on an equal footing; he shares in their prestige, thereby reinforcing his own influence. To a certain extent reality intrudes upon art, but it does not continue as "reality." It is immediately absorbed by religion and, in this guise, is utilized for social ends. The European's arrival does not dislocate history, for he at once takes his place in the religious setting but not in chronology or in written records. Nevertheless the foreigner has different features, and his difference must be shown. To portray him is to emphasize this difference, to create an image, and to allow a glimpse of the individual.

The transition, willful or not, from an art that seeks to incarnate abstract ideas to an art that tends to offer images can likewise be observed in works that refer to immortal ancestors (genii, gods) as distinct from those that concern the cult of mortal ancestors. Among the Dogon, the Bambara, and the Senufo the two series are not distinguishable by their themes. Every mortal ancestor who is descended from a spiritual source is depicted with the features of the immortal. Now it happens that, for historical reasons, the cult of certain mortal ancestors—those of the aristocratic class of invaders or of the king—has developed in a peculiar way. Among the Bakuba and in Ife and Benin the king is a direct descendant of the god he incarnates, and the cult devoted to these two is, at least theoretically, solely that of the god. The mythical and fabulous elements, however, dim gradually, to be replaced by strictly religious, even political, aspects, by a pantheon of individually recognizable gods and genii. Like the sovereign who is said to descend from them, the sculptures are no longer instruments, but images. The gods and genii withdraw little by little into the celestial domain, where the human community cannot touch them. They are present in their images only in terms of the event they recall. Only at this level can we glimpse a measure of realism. Indeed, in societies where mythical thought pervades and dominates religion, the world of genii and immortals overlaps and constantly interferes with the world of the

living. Daily life is determined by a model conceived by the Cre-
ator-God; the blacksmith and the weaver reproduce the gestures
of their celestial counterparts. It is this model that must be evoked.

Certain Dogon statuettes of a woman grinding millet show
the woman caught at her routine task as well as the *hogon* whose
life, according to the myth, is identified with the growing of
millet. Passage from the mythical to the everyday aspect, or vice
versa, does not give priority to one over the other. Each terrestrial
gesture has a counterpart in the other world, so that the thematic
realism is only apparent. The statues of several millet grinders
show that the stylistic latitude available to sculptors is infinitely
wider than one might have imagined. The statuette may manifest
a strict hieraticism favoring the mythical side or a realism ac-
centuating the everyday aspect, but in neither instance does it
represent an individual woman or an individual *hogon* in the
guise of a woman grinding. There is no personalization of an in-
dividual; there is only the incarnation of an idea.

The identification of mythical or human ancestors repre-
sented in commemorative sculptures is not impossible, but it has
to be made through intermediate signs defining a type or a func-
tion. The figures of Arou on his brother's shoulders mark a leg-
endary rather than a mythical event, but they do not concern real
people; their function is to recall and exhibit the origin and the
permanence of an institution. In other regions the situation is
totally different. Bakuba statues are not portraits in the Euro-
pean sense, but they are characterized and personalized by the
evocation of traits or happenings belonging to each sovereign's
biography. What is seen is not an immediate portrayal of the
king's role but an incarnation of the function within the person
of a particular king.

It is reasonable to consider the Bini and Ife busts as realizing
analogous intentions. Two broad sculpture groups can easily be
distinguished. In the first, statuary is made to incarnate abstracts
(fetishes, figures of mortal and immortal ancestors); it turns to-
ward the spirit world, toward the domain of genii and the dead.
The second group commemorates beings and events whose mag-

175
176

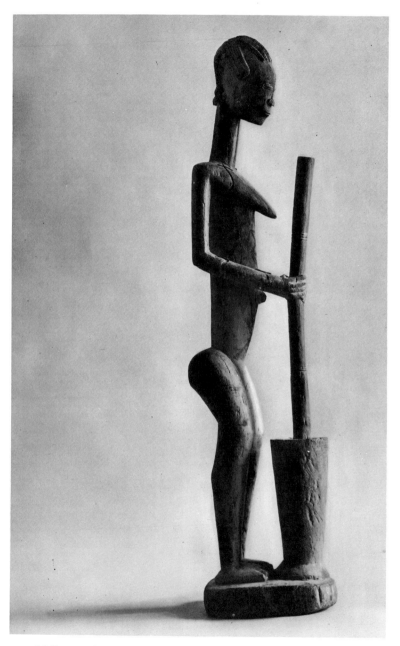

175. Millet grinder. Wood. Dogon. Mali. H. Kamer Collection, New York. Photo by Kamer archives.

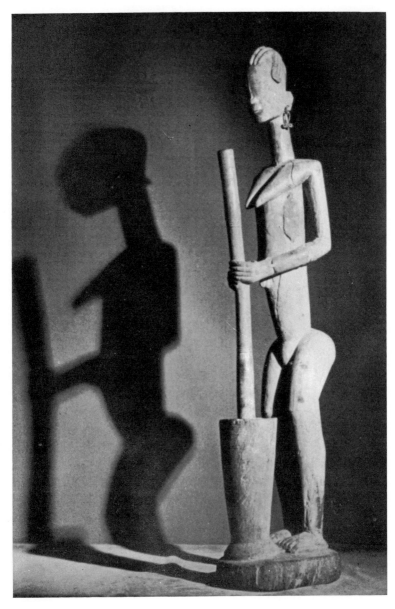

176. Millet grinder. Wood. Dogon. Mali. H. Kamer Collection, New York.
Photo by Edouard Berne, Caravelle Films.

177. Head of queen mother. Bronze. 16th century. Benin, Nigeria. British Museum, London. Photo by Edouard Berne, Caravelle Films.

ical element has already disappeared or has been weakened by the substitution of a relatively historical perspective. Man seems to be conceived and apprehended as a distinct being, even if the terminology used is not that of psychology in the Western sense. The personal features of the sovereign undergo an apotheosis; they are transformed into majesty, strength, and the expression of the perfect physical beauty of an ethnic group. Few statues manifest a more truly royal bearing than certain Ife or Bini heads, 177 which magnificently portray the national pride of a warrior peo- 178 ple sure of its preeminence. It is not a portrayal of the individual but of the royal person; the haughtiness, the dignity, the impassivity of these works reveal all the prestige of a blooded nobility and pride in deeds accomplished.

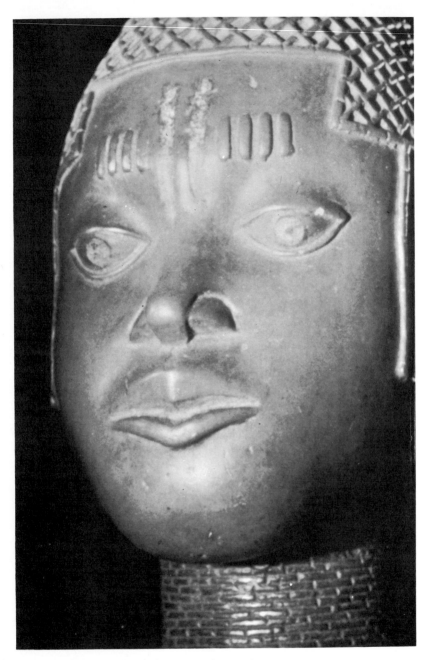

178. Detail of head of queen mother (177).

7

From Myth to History

Alongside statuary, there exist other works that are not cult objects and are relatively autonomous with respect to religious life. In contrast with Benin and Ife busts, they are not altarpieces nor are they sculptures in rounded relief, but sculpted doors and shutters, bas-reliefs, and bronze plaques found among the Dogon, the Senufo, and the Baule, as well as in Dahomey and Benin. These works have no architectural features; they are, however, seen in connection with the royal palace and with sanctuaries, recalling and retelling mythical or historical happenings. The sculptor finds it necessary to make public an account that embraces several episodes, and narrative pieces cannot retain the formal simplicity of sculpture. In order to organize the elements of the story satisfactorily, the artist has been led to select a plane surface, thereby posing a spatial problem. Here, too, solutions differ according to the society envisaged, the depth of its mythical roots, or the way it senses the omens of history.

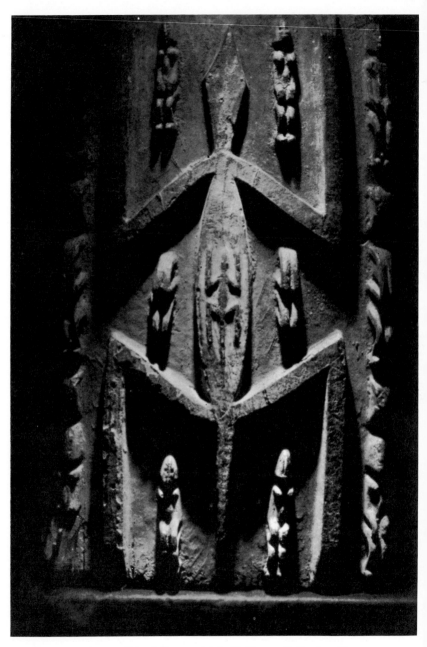

179. Sanctuary shutter. Wood. Dogon. Mali. H. Kamer Collection, New York. Photo by Edouard Berne, Caravelle Films.

Sculptured Doors and Shutters

The first example is a Dogon shutter, a unique object re- *179*
served for a *hogon*'s house or more often for a totemic sanctuary.
The entire surface is sculpted with representations of important
persons and animals constituting the mythical genealogy of the
Dogon and recalling some of the notable occurrences that marked
the creation of the world. The shutter is in a single piece, re-
flecting the construction of the altar. Its upper and lower bands
show eight standing Nommo, arms held close to their sides. In
the central area four kneeling figures cover their faces with both
hands. They allude to the act of incest committed by the first cre-
ated being, Dyougou Serou, the act that caused the serious dis-
order later righted by the Nommo. At the very center is a croc-
odile on whose back a smaller crocodile has been carved. This
figure represents the totem and its companion, whose function is
not well understood.

This shutter summarizes one of the creation myths; it also
reveals that the structure it covers is dedicated to a Nommo. Thus
it places the sanctuary and its caretaker, perhaps a neighborhood
or even a whole village, in the classification of analogies discussed
in chapter 5. The myth is not recited chronologically; the events
are evoked only through the presence of the characters who had
roles to play. To relate the myth, and to ascribe to a lineage the
people who belong to the sanctuary, the sculptor has juxtaposed
figures having no individual meaning, figures that are significant
only in terms of the ensemble and their relative position on the
surface of the shutter.

On a sculpted door of a Senufo sanctuary in the village of *180*
Tawara, two diagonal rays converge toward a sculpted circular
disc at the center. Around the disc have been carved two men on
horseback, a character wearing a horned mask, a bird with a long
beak (or a man with a bird mask), a mask with a human face, a
large crocodile, a tortoise, a serpent, another serpent attached to
a bird (perhaps a serpent eater), and what seems to be a leopard.
Above a bar on the upper edge there are six carved characters,
one of whom is a horseman. On the lower edge are figures of a

man, of animals resembling a leopard and a horse, of a bird unfolding its wings, and of a serpent preparing to attack.

The central disc probably represents the umbilicus of the world, whose meaning may be analogous to the omphalos of ancient Greece. The door separating the sacred place (the sanctuary) from the profane world displays to the living a complete cosmogony, an exposé of creation. The personages depicted are images of the genii, which are also seen in Senufo statuary; they are "intermediaries between the invisible world, with the supreme divinity, Koulou Tyéléo, mother of the universe, at their head. . . . They participate in sacrifices, and especially in divination" (Bohumil Holas). In order to narrate the events that took place in the creation of the universe, the Senufo artist has employed a composition branching out from the umbilicus while reserving the upper and lower bands for a linear account. Perhaps the characters succeed one another temporally, or, most probably, the significance of the story emerges only from their juxtaposition.

The relative scale of beings and things portrayed is not heeded. The *kpélyegué*, or human mask, is larger than the horseman situated above it. Did the artist obey some symbolic hierarchy? Or is the plastic adjustment of his plane surface his most vital concern, in order to avoid the annoyance of empty spaces? It is hard to say. What is clear is that the universe here conceived develops from a central expanding nucleus from which beings and things emanate. This type of universe projected on a plane shows certain characters head downward, since the head, which contains the life-force, must be placed as close as possible to the radiating source. Thus the representation here is not an artifice analogous to a child's drawing of a circle, but what Erwin Panofsky would call "a symbolic form."

181 A third example, a Baule royal door, has on the upper part an elephant, perhaps a female, standing out from a background of striated diamond shapes. The middle part is decorated with black and white triangular motifs, a male elephant with bent tusks, and a black rectangle inscribed in a white rectangle containing nine black dots. The lower area of the panel is covered with diamonds

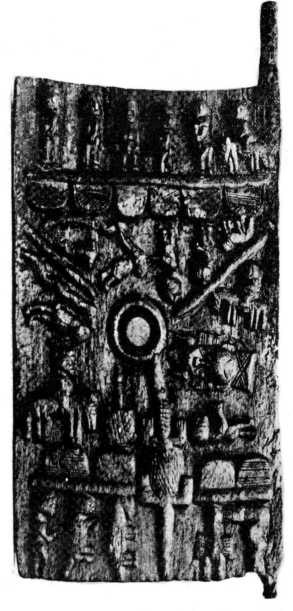

180. Sanctuary door. Wood. Senufo. Ivory Coast. Musée
d'Abidjan.

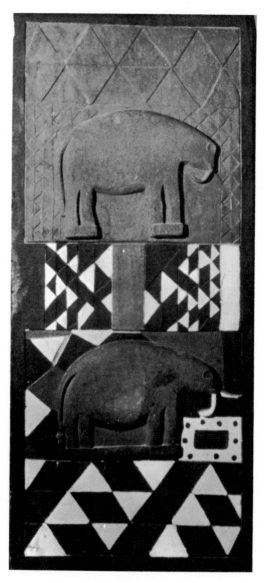

181. Royal door with two elephants. Polychrome;
wood. Baule. Ivory Coast. Musée I.F.A.N., Dakar.
Photo by Edouard Berne, Caravelle Films.

and triangles. This door belonged to Kouakou Anougbélé, traditional chief of the Baule and grandson of the queen Aura Pokou. According to Baule beliefs, the elephant is a symbol of strength, prosperity, and longevity. If the upper animal is a female, these qualities have probably been attributed to the reign of Aura Pokou, the memory of whom is still quite vivid. The two elephants would then refer to the reigns of Aura Pokou and Kouakou Anougbélé. This sculptured door thus represents neither a universal system nor mythical events, but refers back to historical events.

The system of triangles, diamonds, and alternating stripes probably has symbolic value. The triangle is the sign of the divine triad; the diamond shape represents femininity. The way the motifs are arranged may also exhibit a basic system, a map of the clans. But no matter how concrete these values, they are retained and conveyed by abstract signs. They designate fundamental notions and allude only secondarily to occurrences. The figurative elements themselves emphasize characteristics, rather than harkening back to mythical beings. The whole ensemble can be interpreted as the coat of arms of the Ouarébo clan or of the family of Kouakou Anougbélé. The door defines the grandson of the queen in his true genealogy in terms of the values attributed to his reign, placing him in the social fabric of the clan he heads. Historical and mythical space are joined, but in this example there is a clean break between the world of the gods, symbolically recalled by the abstract geometric figures, and the world of the living.

The process that identifies the royal personage with his coat of arms has a formal counterpart in another procedure that substitutes allegory for myth. The Baule door is in very low relief, lightly hollowed. The plane surface is in fact a natural frame for mythical representation. Myths are outside space and time; the artist charged with conveying them is not anxious to find perspective and depth. The discovery of perspective during the Renaissance coincides with the discovery of the mortal and omnipotent human being who watches and organizes a universe of which he

is the nucleus and the ultimate end. Africa has perhaps never made this discovery, but we have already glimpsed a tendency to accentuate the psychic distance separating man from the natural world and to conceive of nature as a spectacle rather than a communion. It is from this point of view that we now look at a double series of works associated with political, social, and religious values supported or incarnated by the sovereign. Earthen bas-reliefs from the palaces of Abomey in Dahomey constitute the first series, and the second is made up of Bini bronze plaques.

Dahomey Bas-Reliefs

Dahomey artists at one time worked under the control of the king and were housed in quarters neighboring the palace. Their mission was to praise the sovereign and his war exploits. Each new king (Gezo, 1818–1858; Gléglé, 1858–1889; and Behanzin, 1889–1894) had his own palace built and had the walls covered with polychromatic reliefs modeled in unbaked clay inscribed in a frame about 2.5 feet square. The background to which the modeled figures are attached is recessed into the wall, in a technique Egyptologists call concave relief.

These bas-reliefs are quite varied, relating historical events such as battles, reproducing coats of arms, or representing allegories or mythical beings. They seem to be mainly concerned with values tied to royalty and to the unity of the kingdom. A *182* container pierced with numerous holes and supported by two hands shows that the Fon must unite for the protection of the kingdom. A shark represents King Behanzin who, at the time of the French invasion, had declared that he was the "shark who deflects the tiller," thereby announcing that he would prevent the *184* disembarkation of the troops. A monkey who holds an ear of corn in one hand while trying to seize a second ear with the other hand recalls the resistance of King Adanzan (1797–1818) to the Nago (Nigerians from Abeokuta) who had come to claim the tribute demanded by their king. Adanzan's reply signifies that Nago pre-*183* tensions were highly exaggerated. A Dahoman warrior cuts off the leg of a Nago who is trying to flee, thus telling the story of

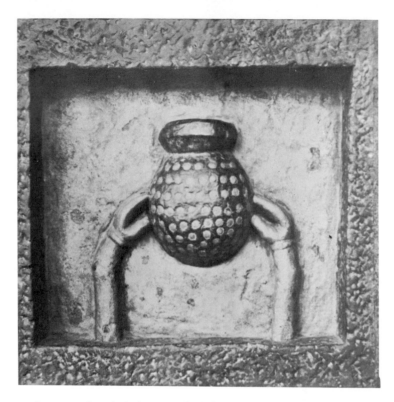

182. Jar pierced with holes. Detail of bas-relief. Polychrome; clay. Fon. Abomey, Dahomey. Musée de l'Homme, Paris. Photo by the museum.

183. Warrior cutting leg of a Nago. Detail of bas-relief. Polychrome; clay. Fon. Abomey, Dahomey. Musée de l'Homme, Paris. Photo by the museum.

184. Monkey with ear of corn. Detail of bas-relief. Polychrome; clay. Fon. Abomey, Dahomey. Musée de Paris. Photo by the museum.

the battle. The representation of the Nago in the guise of an ape evokes Adanzan's reply to the emissaries of the king of Abeokuta.

This emblematic and allegorical art is essentially directed toward nationalistic and political values as incarnated in the sovereign. The bas-reliefs identify every royal person by his words, his acts, and his exploits. Without doubt, the phenomenon here is similar to what was observed in Bakuba statues, with an important difference. Bakuba statues, more or less associated with funerary rites, were probably never created during the lifetime of the subject, whereas Dahoman kings had themselves celebrated and exalted before death.

Since the royal person possesses sacred value, these bas-reliefs are neither profane nor secular. They are, however, rooted in chronology, referring to declarations, situations, and events that were dated, influential, real. All epical qualities seem to have been obliterated. The marvelous is only outward appearance: a king represented as a lion or a shark is not a fantastic being, but merely a metaphor. The wide, black cloths to which appliqués are sewn with brightly colored thread are part of the same mode of thought. They establish the text of chants composed in honor of a dead man by his closest friend; the patterns illustrate the words of the text, at times with the aid of a rebus. For example, the proper name "Huha" is represented by a butcher's hook, *hu*, and a razor, *ha*.

In this art an effort has been made to characterize scenes or emblems in historical order. The concern for temporality corresponds nicely to the ambitions and political aspects of the king-

185

186

185. Cloth establishing theme of funerary chant. Polychrome. Fon. Dahomey. Musée I.F.A.N., Dakar. Photo by Edouard Berne, Caravelle Films.

186. Cloth establishing theme of funerary chant. Polychrome. Fon. Dahomey. Musée I.F.A.N., Dakar. Photo by Edouard Berne, Caravelle Films.

dom, especially to the strong individualization of the royal person. The phenomenon appears most clearly in Benin.

Bini Plaques

Dogon, Senufo, and Baule wood-carvers, in treating their shutter and door surfaces, never raise their work above the plane surface and do not attempt to give the quality of depth to their figurative elements, which they arrange on horizontal or vertical bands or in a radiating composition. Dahomey bas-reliefs are more complicated. Because the background is recessed into the wall, scenes and patterns emerge as if in a box. The background, lacking character of its own, simply limits and supports the single important plane. The artists have not tried to present their figurative elements in a third dimension, but then the nature of the work did not call for such a refinement. The synthetic and emblematic character of the motifs (for instance, describing a bat-

tle by showing the confrontation of two men) is in harmony with the way the artists chose to represent their subjects.

The plaques made in Benin belong to differentiated systems of figuration. Some writers claim that the higher the relief in these works, the more recent the date. In fact, the tendency to heighten the relief has increased with the expansion of European trade. Furthermore, the degree of accentuation coincides with a growing complexity in the representations: a multiplication of figures, the search for and the introduction of movement, and the presence of an architectural decor and of landscape details. At the same time there were varying efforts to express different degrees of depth.

One series of plaques represents a single character, standing immobile and facing outward, or an animal head viewed from above, or a wild animal in profile. The relief is very low and the

187
188

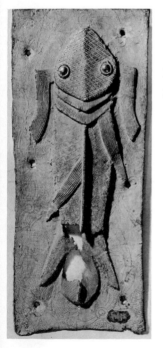

187. Fish. Bronze plaque. Benin, Nigeria. Museum für Völkerkunde, Vienna. Photo by the museum.

188. Ibis. Bronze plaque. Benin, Nigeria. Museum für Völkerkunde, Vienna. Photo by the museum.

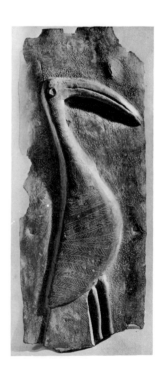

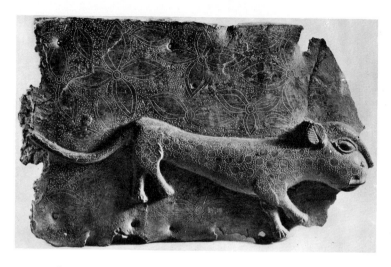

189. Panther. Bronze plaque. Benin, Nigeria. Museum für Völkerkunde, Vienna. Photo by the museum.

background is finely etched with rosettes, flowers, and leaves. *189*
Such a background motif may be an artist's signature or the
trademark of a workshop. The emblematic character of the an-
imals is clear, but the problem of the human figures is more com-
plex. The *Naked Boy* at the Vienna museum alludes to the ritual *191*
that initiates the adolescent into a new age-group, a ritual anal- *192*

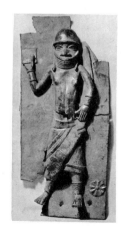

190. Messenger. Bronze plaque.
Benin, Nigeria. Museum für
Volkerkunde, Vienna. Photo by
the museum.

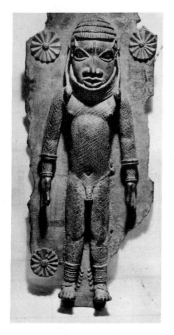

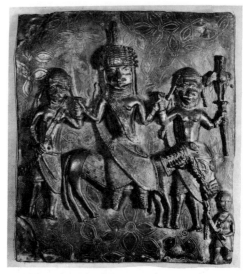

193. Oba on horseback between two vassals.
Bronze plaque. 17th century. Benin, Nigeria.
British Museum, London. Photo by the
museum.

191. Naked boy. Bronze plaque. Benin,
Nigeria. Museum für Völkerkunde, Vienna.
Photo by the museum.

190 ogous to the one undergone by a young Roman candidate for a
toga. On the other hand, the *Messenger* (also in Vienna) is as-
sociated with courtly life and protocol. A gesture suggesting an
anecdote is expressed by the man displaying his message. The
strict verticality is broken by the oblique lines of the loincloth
and the forearm. On plaques that show several characters with
differing gestures, such as musicians and lance bearers, the fig-
ures stand out from the background. They form the entire fore-
ground and there is no feeling of depth.

 The same is true of the plaques owned by the British Museum
which show the oba standing between what appear to be two
vassals who hold his hand and his elbow. There exist several

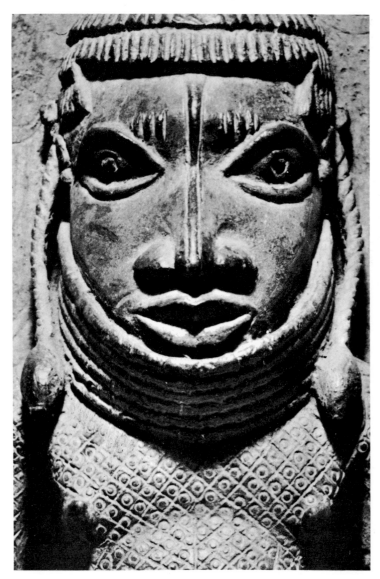

192. Detail of naked boy (191).

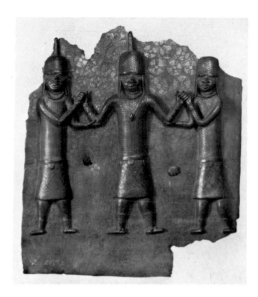

194. Oba between
two vassals. Bronze
plaque. 17th century.
Benin, Nigeria.
British Museum,
London. Photo by
the museum.

194 versions of this tableau. In the one that William Fagg has as-
signed to the sixteenth century the oba and his vassals are stand-
195 ing. In a second version, perhaps from the seventeenth century,
the oba is seated and his assistants kneel. In the sixteenth-century
example the figures are arranged in one plane, with only the
suggestion of a third dimension in the slight distortion of the
shoulder of one vassal, who is shown in almost a three-quarter
view. The play of crossed lines on the arms and forearms creates
a type of counterpoint which lends a horizontal rhythm to the
plane and tempers the dry monotony of the characters' vertical
posture. The later version is marked by technical prowess and
virtuosity, achieved at the expense of the hieratic aspect. The
gesture of allegiance is developed in all three dimensions, where-
as in the earlier plaque the artist analyzed the movement and the
gesture, then synthesized them and put them into two dimensions
by a process similar to cubist flattening.

Another plaque at the British Museum poses the problem
193 more succinctly. The oba is on horseback, mounted sidesaddle,
with two dignitaries supporting his hands and under his feet a

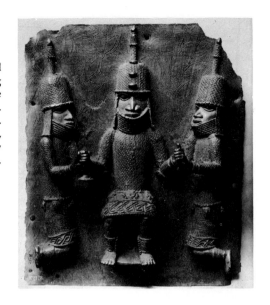

195. Oba seated between two kneeling vassals. Bronze plaque. 17th century. Benin, Nigeria. British Museum, London. Photo by the museum.

small page holding the horse's reins. The four characters are seen fullface. The dignitaries are the same size as the oba, but the page's dimensions are reduced. Probably the play of symbolic hierarchical proportions has here determined the height of the figures, or perhaps the founder, lacking space after treating the central motif, was constrained to reduce the figure of the page. Finally, the solution may be suggested by an analogy with Oriental perspective, where the elements become larger the farther they are from a vanishing point situated at the front. The page in this plaque, however, is not in the foreground.

In fact, only a few characters are always on a small scale: pages, musicians, the priest's aides. They are men who belong to a subordinate class, perhaps slaves, but never warriors. The difference in size, depending on social level, is made very clear in a seventeenth-century British Museum plaque where the oba, holding his insignia of office, the scepter and the sword, is flanked by two shield bearers who are exactly the same size as he is. Two characters, reduced to one-third size, are in front of the oba at his feet, and two other small ones behind him frame his head.

196
198

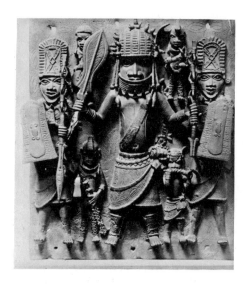

196. Oba with two shield
bearers. Bronze plaque.
17th century. Benin,
Nigeria. British Museum,
London. Photo by
the museum.

All four subsidiary figures are of the same size, excluding the
representation of distance or proximity through relative pro-
portions. They include a man carrying what seems to be a bell
and a sword in its scabbard, a trumpet player, another musician,
and a fan bearer.

 The same method of indicating relative importance by size
197 has been used in a work depicting the ritual sacrifice of a bull
during the funeral ceremony of an oba. Each of four small char-
acters holds one hoof of the quartered animal, which is seen from
above. The priest slashes the fleshy part of the neck of the bull
whose head, supported by an aide shown in three-quarter view,
masks part of the sacrificer's loincloth. The proportions of two
pages seen on the upper edge of the plaque are also symbolically
regulated. In trying to show the complete scene, including the
figures that normally would have been hidden by the body of
the bull, the artist has quartered the animal and supplied a bird's-
eye view. It was necessary to retain every detail in order not to
risk altering the meaning of the ritual. Here we see an illusion-
istic space joined to a symbolic space, with respect to dimension
and perspective. The flattened cubist forms can be thought of

as variants of this procedure, where elements situated in three-dimensional space are staggered on vertical axes. A final example of the Bini plaques is one showing a tambourine player with all his instruments, seen from above, placed around him in a semicircle. *199*

The modes of spatial arrangement are therefore more complicated than at first appeared. The artist must form his composition out of diverse and sometimes conflicting elements. The unmistakable desire to render the third dimension was largely ignored by Dogon, Senufo, and Baule sculptors and by Abomey modelers. Diverse solutions have been offered to this problem. Once in a while the artist purposely strives for illusionism; he presents his figures fullface and accentuates the relief of the elements (a horse, for example) whose largest dimension is perpendicular to the plane. Sometimes the artist defines his planes of distance or proximity by placing his characters, not in an artificial depth, but on a vertical axis of the surface; the upper figures form the background and the lower ones compose the foreground.

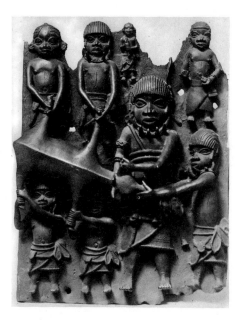

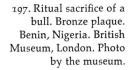

197. Ritual sacrifice of a bull. Bronze plaque. Benin, Nigeria. British Museum, London. Photo by the museum.

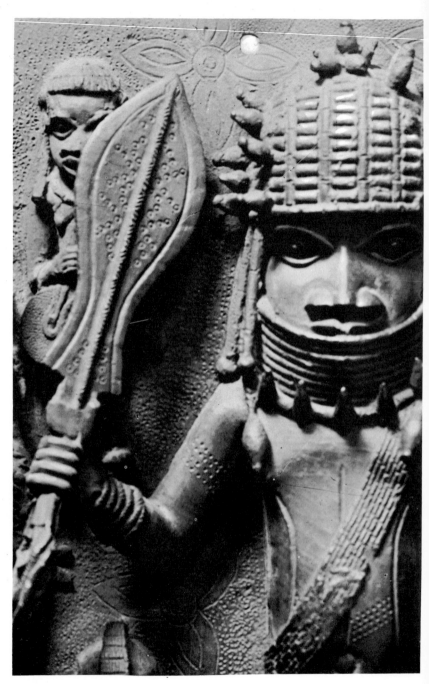

198. Detail of oba with two shield bearers (196).

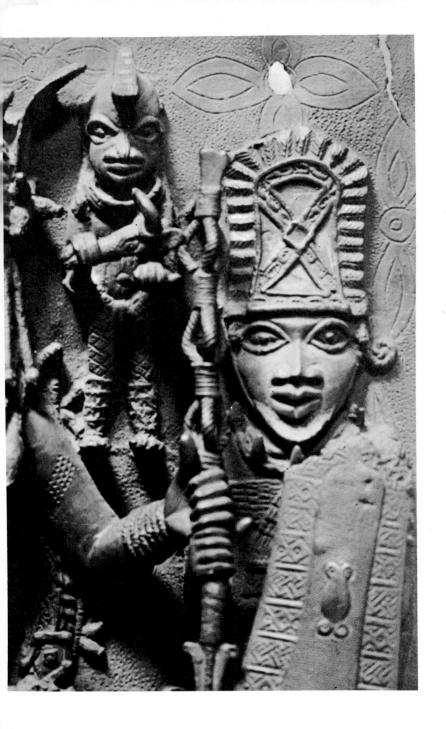

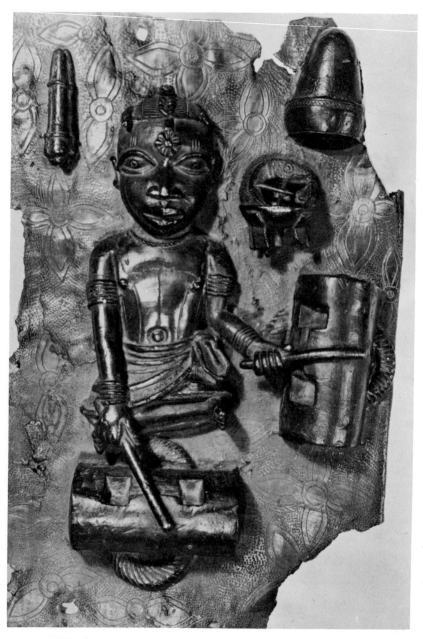

199. Tambourine player. Bronze plaque. Benin, Nigeria. British Museum, London. Photo by the museum.

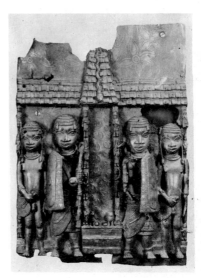

200. Entrance to oba's
palace. Bronze plaque.
Benin, Nigeria. British
Museum, London. Photo
by the museum.

In this type of work the height of the characters is determined
by symbolic proportions which may not be transgressed without
threatening the entire system of values and belief forming the
social order. Even when art veers toward this relative illusionism,
there is no absolute visual priority. It is when the artist is no
longer constrained by social symbolism, when the elements of
the work are not structured by a hierarchy, that the illusionistic
effects are most extreme. Decorative details may appear: another
British Museum plaque shows the entrance to the oba's palace 200
flanked by shield bearers and a page with a round fan. The steps,
the pillars of the porch roof (covered with bronze plaques), and
the roof tiles with their supporting nails are depicted with pre-
cision. The palace itself is of course the repository of beliefs and
nonmaterial representations, whether mythical or religious. Pre-
sented in this minutely realistic fashion, however, it can also be
perceived as a representative element, not only as a symbolic
object.

Bini plaques cover the faces of the columns in the palace
courtyards. The order in which they are arranged is probably
highly significant. Since they are dedicated to recounting and

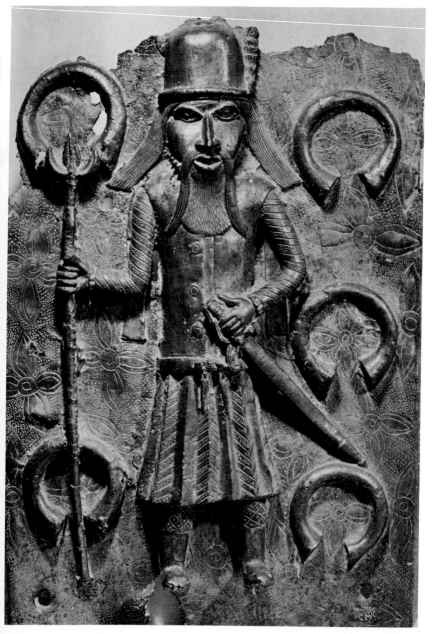

201. Portuguese soldier surrounded by manillas. Bronze plaque. Berlin, Nigeria. Museum für Völkerkunde, Vienna. Photo by the museum.

praising the oba's feats, his everyday life, and happenings in his court, they form a chronicle of ritual, protocol, and memorable events. As permanent exhibits, they are additions to architecture; their existence is visual. These characteristics could be the result of the search for illusionistic effects. Here space is perceived as the theater of a spectacle rather than as the shape of mythical expression.

All the Bini plaques were cast in the sixteenth and seventeenth centuries. The Portuguese arrived in the capital of Benin in 1472, and trade between Africa and Europe began in the early part of the sixteenth century. Any influential contact between Bini and Western art remains conjectural. Some writers claim that the format and the composition of the plaques were suggested to black artists by illustrated books introduced by missionaries or merchants, but such hypothetical statements are hard to authenticate. Nevertheless, an indirect Western influence cannot be ruled out entirely. Clearly, the population that manifested the most sophisticated sense of space and time was the one that enjoyed the most direct and most enduring contact with Europe.

The arrival of the Europeans truly marked the intervention of history among populations that, like the Ife, were disposed to accept it only insofar as they had already sensed individual autonomy at the level of the royal person. The artist who portrayed a Portuguese soldier surrounded by his manillas (copper bracelets used as slave currency) had, at least provisionally, banished all mythical thought. It was no longer a question of allegory, for that was the moment when Africa entered history.

8

Conclusion

The foregoing is merely a sketch of African art history. Black art, vanishing into a past as distant as that of European art, has at different moments offered clear signs of vitality and renewal. It withered when colonization began; it died at the beginning of the twentieth century, but Africa herself remained. Sociologists have attributed the disappearance of African art to its strict subordination to the social institutions it expressed. When traditional African societies began to disintegrate, owing to their colonial status and to a prolonged contact with certain aspects of Western civilization, the arts entered a period of irreversible decadence. Georges Balandier and Jacques Maquet especially have used this argument to show how artistic production was determined by society and traditional religions. If art disappears when society dissolves, society has entirely ruled creativity, and art is the reflection or the expression of society.

In this supposition there is an optical illusion, although the rapport between art and society cannot be denied. It is not, however, a direct causal link. It is, to borrow a formula from Roger

Bastide, a situational link. The dissolution of traditional society and religion often seems to be merely external. The example of the Congo shows that, in places where group structures were preserved by the colonizers, art has nonetheless decayed. Present-day statues of Bakuba kings retain no more than a vague and distant relationship to those discovered by the Europeans in 1910. As far as religion is concerned, the Dogon experience is just as convincing. The celebration of seasonal cycles continues and mythology is still vividly present. The masks produced, however, appear to be makeshift copies, like the ones exhibited at the Théâtre des Nations in 1964. If, then, social and religious values outlive artistic values, the causes of decadence must be sought by direct reference to the sculptor and his working conditions.

After colonization the artisan, like all other members of the community, found himself subject to duties from which he had traditionally remained more or less exempt. The necessity of paying taxes in currency constrained him to work for the new settlers, for he had to fulfill military and work obligations. It logically followed that his professional activity suffered, while the quantity of work orders increased. The period of apprenticeship grew shorter and more difficult as traditional models disappeared, owing to their destruction during the missionaries' autos-da-fé and to the massive purchases made by the Europeans in the early 1900's. From then on, limited to a short apprenticeship and working time, no longer living with the venerable models that had sustained his efforts and formed his taste, the artist fashioned crude and hasty rough drafts. A totally different kind of demand had arisen. The artisan now became a supply source for Western tourists who, eager to own exotic souvenirs, commissioned objects (ashtrays, elephants) suited to their taste. The artist filled urban marketplaces and airport shops with such mementos.

Since social and religious needs continued to be fulfilled, at least in the more remote regions, it seems correct to say that purpose and function basically determine neither the quality nor the outward aspect of masks, statuettes, and routine objects, and that the artist's values surpass the exterior determinants of society,

myth, and cults. In the words of Marcel Mauss, these values are not mere adjuncts. Even though the Dogon, the Bambara, and the Senufo adhere to the same metaphysical concepts, their arts are clearly differentiated. The artistic and stylistic traits of created works must be considered in any analysis of the culture as a whole.

It is not proper to describe African art as a monolithic whole or to ascribe to it a single style, copied from one model and subject only to minor variations. Archaeological research has supplied abundant proof of the diversity of black art. A double motif, or rather a double contemplative theme, pervades the African continent. It is from two basic notions, person and vitalism, that cultures seem to have developed and become diversified.

Emile Durkheim has shown that the consciousness of the body is at the origin of the notion of person. African art is neither fantastic nor imaginary. The human body sustains it; the prime value attached to physical existence gives it solidity and internal force. This art is the expression of a peasant culture, founded on a settled existence and the seasonal cycles, as evidenced by the fact that pastoral peoples and nomads are ignorant of sculpture. It is interesting to contrast this farmers' art, whose plastic formalism and material solidity fascinated the cubists, with Oceanic art, the art of the great navigators, a fabulous creation that enchanted the surrealist imagination. For André Breton, Oceanic art expresses "the greatest effort of all time to expose the interpenetration of the physical and the mental, to triumph over the dualism of perception and representation, to dig through the outer bark to the sap," whereas in African art he finds only "sempiternal variations of the external appearance of men and animals, . . . heavy material themes, the structure proper to the physical being—face and body—fecundity, domestic labor, horned beasts." We must pause here for a moment to offer our profound sympathy to Breton for the suffering that the thought of all these horned beasts has caused him. But what can one expect? Racine's Pyrrhus had not read the seventeenth-century salon novels, nor are the Africans aware of Breton's *Discours sur le Peu de Réalité*.

The African does not place himself at the center of the cosmos, nor does he tend to mingle his characteristics with those of other species in order to create composite images. The arts of black Africa contain very few monsters. To create the diabolical and demonic images that Théodore de Bry engraved at the direction of Duarte Lopez and Filippo Pigafetta would require the fiery and religious imagination of a fifteenth- or sixteenth-century believer. The African individual rarely conspires with the obscure forces that shape the universe. Moreover, his conception of self changes with time and place.

For the Dogon and the Bambara, man is "the seed of the universe"; he is part of the network of relationships woven among all beings by the Creator. His bonds with the organization of all forms are not symbolically but actually present. For Ife and Bini artists, man is represented by a king of divine essence, the haughty dignitary whose mouth seems to curve scornfully and skeptically. This royal personage is so sure of his preeminence that he does not ask to be represented through his own features. He is the god he incarnates, the god who incarnates himself within a temporary human shell whose personal appearance matters not at all. Earthly possessions belong to him by right; through his ancestry he holds the monopoly of blood, of barter, and of commercial trade. To obtain from the Portuguese the bronze he requires to exalt his authority, he can dispose of the life and liberty of his faithful subjects. Through the benefits flowing from all these advantages his vital energy is further increased.

Ife heads, and to a lesser extent Bini heads, truly seem to be Apollonian, but they too share in the sombre, rhythmically expressed energy that all African art critics have considered fundamental. The black essayists Anta Diop and Léopold Senghor have partly confirmed this intuitive conclusion, describing the rhythm more subtly and perceiving it in terms of African reality.

Following Gobineau, Elie Faure has emphasized the cosmic and biological aspects of African rhythm. In black sculpture, he writes, "the rhythm alone constitutes the subject matter . . . and reflects cosmic order without even discussing it." From Senghor's

point of view rhythm for an African is "the architecture of being, the internal dynamism that shapes him, the system of life waves, waves he emits directly toward others, the expression of vital force. . . . Rhythm illuminates the spirit to the extent that it transforms itself into sensuality." Dionysus is the hidden god of Africa: the god who dances, who possesses and inspires the voice and the poetic word, the god of intemperance who provisionally annihilates individual will in order better to strengthen life. These qualities appear over and over again in mythology and in cults. African civilizations are civilizations of the dance and the word, it being understood that vocal or instrumental music is always associated with recitatives and choreography. Nonsculptural forms all express highly complex poetry and music. Herbert Pepper has recorded five-part fugues from the Pygmies of the equatorial forests, constructed according to a "tiled counterpoint."

The essential features of African life and thought relate very well to rhythm. Upon analysis, rhythmic aspects are revealed as well in the scansion of poetry, the position of rhetorical figures in a poem, choreographical and musical patterns, and finally in the arrangement of sculptural volumes. Here it is necessary to shade the purely biological interpretations of Gobineau and Faure, who exaggerate the importance of instinct. William Fagg, after careful consideration of this problem, has cautiously proposed an explanation for rhythm in the importance attached to the germination and the growing of grain and to the vital force of the person. It is not a question of denying the existence of an African philosophy governed by dynamic vitalism, a fact confirmed by the acquisition of detailed knowledge about different ethnic groups. African philosophy, however, must not be interpreted in the light of modern Western metaphysical systems, such as that of Pierre Teilhard de Chardin. In spite of their attractiveness to modern African intellectuals, these systems do not necessarily provide a sound basis for comparison.

The most striking feature of black African masks and statuettes is their ambiguity. They all aim to trap nonmaterial forces, but only in order to augment the group's reserves of life-force,

whether the group is a family, a village, or the nation. Their second mission is to control the force which, if allowed to wander freely and indiscriminately, would pose a serious threat to the collectivity. Masks and statuettes also shield man from genii and spirits and from the liberated and scattered energies in nature. In other words, they are designed to take possession of nature through cultivation. It is a simultaneous process of recapturing the burning and dangerous blood that flows through nature and of mastering, through agriculture, the spirited forces by trapping and irrigating them. This theory runs counter to other theories that evaluate, or simply express, a rhythmically transmitted and instinctively perceived present. The traditional African would never abandon himself to the dark forces that obsess the world or let himself be carried away by the vital flux. African emotivity is quicker and more sharply alerted than that of Western man, but perhaps these qualities are simply a function of milieu. Abstracted from the community where it developed, this emotivity is deprived of its natural, tempering, and meaningful framework.

The traditional milieu is changing. Africa is becoming urbanized, and roads crisscross the continent. In the villages transistor radios open people's minds to the vastness of space and to the rest of humanity, and thus to new problems. Large cities absorb men who have stretched and broken the bond with their peasant ancestry. Although still at an embryonic stage, industrial growth is beginning to provide a new black proletariat with a different kind of civilization. These are the visible changes; there are other, deeper ones which are harder to assess. The training of qualified technicians, the establishment of universities, the education of younger generations—all these are altering modes of thought, breaking traditional ties, and creating new scientific and rational relationships. Once in a while someone glances back at the vanishing traditions and nostalgically describes the past as a golden age. But the backward look is a sign that the break with the past is indeed complete and that the present momentum will not slow down. Africa is not so much surviving as inventing herself anew.

Comparative Survey of
World History and Art

Date	Western Africa	Central and equatorial Africa	Eastern and southern Africa
5000–4000 B.C.	Blacks take possession of Africa, then probably inhabited by ancestors of Pygmies.		
4000–3000 B.C.			
3000–2000 B.C.			
Ca. 2720–2560 B.C.			
Ca. 2400 B.C.			
2000–1000 B.C.			
18th century B.C.			
1558–1530 B.C.			
1530–1520 B.C.			
1504–1483 B.C.			
15th and 14th centuries B.C.			

African arts	Discovery of Africa	Egypt and Mediterranean Basin
		Beginning of Early Minoan.
Sudan: Pottery with wavy patterns. *Nubia*: Cut or hammered rock reliefs with animal design.		Copper (from Asia) in Lower Egypt. Perfecting of copper tools in all Egypt. Animal sculpture in Upper Egypt.
Nubia: The triumph of Djer (on rock).		In Upper Egypt, first great royal necropolises. Stela of king-serpent.
	Egyptian raids into Nubia.	Middle Minoan. First palaces built.
	Exploitation of Nubian mines. Exploitation of lower Nubia by rulers of Elephantine. Pepi I has granite obelisks cut in Nubia for Heliopolis.	
	Pacification of Nubia. Establishment of Kerma. Colonization of Nubia.	
		Middle Minoan III. The snake-goddess. Cnossus frescoes: Sudanese landscape with blue monkey; white chief leading army of blacks.
	Egyptian expansion toward Sudan.	Egypt: Amenophis I.
		Introduction of horse into Egypt by Hyksos.
	Founding of province of Kouch. Voyage to country of Punt.	Tuthmosis I. Queen Hatshepsut. Temple at Deir el-Bahri.
	Domination of Egypt to 3d cataract. Resumption of Egyptian expansion to 4th cataract. Temples of Amada and of Semneh.	Mycenaean style. Cretan decadence.

Date	Western Africa	Central and equatorial Africa	Eastern and southern Africa
13th century B.C.			
12th century B.C.			
10th century B.C.			
9th and 8th centuries B.C.			Beginning of Kouch expansion toward north. 1st dynasty of Napata. *Ca.* 760: Napata necropolis. Triumphal stela of Napata. *Ca.* 730: Piankhy, king of Sudan and of Nubians, master of Upper Egypt.

African arts	Discovery of Africa	Egypt and Mediterranean Basin
		Amenophis II.
	Foundation of Gem-Aton in Nubia. Temple of Amon at Soleb.	
	Temples at Faras and Kawa in Nubia. Temple at Abu Simbel. Battle of Kadesh (carved decoration). The four giants. Temple at Amara. Temple of Re at Dehr. Temple of Ptah at Gherf-Hussein. Temple at Wadi es-Sebou. Identical Pharaonic temples in delta, in Upper Egypt, and in Nubia.	Amenophis IV (1372). Tutankhamen (1354–1346). Restoration of cult of Amon. Ramses II (1301–1235).
Engravings of chariots in Sahara. Rock paintings (age unknown) in Tassili and Ennedi.	Introduction of horse into Libya by People of the Sea who cultivate the region bounded by Fezzan, Maroc, and Niger Bend.	
	Reestablishment of relations with country of Kouch.	Appearance in Egypt of official metal statuary, divine or royal. Renewal of stylization of bodies. Height of bronze period in Middle and Upper Egypt.
	Extension of Pharaonic culture to 6th cataract. *Ca.* 600: Periplus of Phoenicians by Necho.	In 753, legendary foundation of Rome. 609–595: Necho II pharaoh of Egypt.

Date	Western Africa	Central and equatorial Africa	Eastern and southern Africa
7th century B.C.			
6th–4th centuries B.C.		Nok civilization (northern Nigeria).	

African arts	Discovery of Africa	Egypt and Mediterranean Basin
		605: Defeat of Necho II by Nebuchadnezzar. Failure of Ethiopian attempt against Egypt. Growing importance of Meroë.
Nok terra-cottas (up to 1st century A.D.).	Ca. 500: Periplus of Hanno, suffete of Carthage, as far as Mount Cameroon (controversial).	525: Conquest of Egypt by Persians.
Meroë as artistic center. Diffusion of Hellenistic arts into Meroë.	Ca. 450: Travels of the Nasamons across Sahara.	332: Conquest of Egypt by Alexander. 146: Destruction of Carthage by Romans.

Date	Western Africa	Central and equatorial Africa	Eastern and southern Africa
1st millennium A.D.			Introduction of agriculture and metallurgy, from Nubia to the south.
A.D. 66			Until 4th century, height of kingdom of Axum.
A.D. 70			
A.D. 86 A.D. 106			
2d century A.D. 3d and 4th centuries A.D.			Kingdom of Axum. End of kingdom of Meroë. Beginning of pre-Monomotapa period.
Ca. 350	*Ghana:* To 8th century, first dynasty in Ghana (44 kings). People inhabiting Hohd, Aoukar, and Ouagadou are subdued by Berbers (?).		
392 5th century A.D. *Ca.* 400			
Ca. 429			
6th century			

African arts	Discovery of Africa	Europe and Islam
	Suetonius Paulinus goes beyond Atlas Mountains.	Palmyra under suzerainty of Rome. Strengthening of Arab agreements with cultural centers in ports and on caravan routes.
	Septimus Flaccus in Fezzan.	
	Julius Maternus reaches Agisymba.	
		Trajan annexes Nabatene. Province of Arabia.
	Ptolemy's maps.	
		State Christianity in Rome. Christianity spreads into southern Arabia.
		Establishment of Mecca, which becomes large commercial city. Vandals in North Africa. Coptic Christianity introduced into Meroë.
	Ca. 550: Legendary voyage of Irish monk, St. Brendan, to Madeira and Canaries.	

Date	Western Africa	Central and equatorial Africa	Eastern and southern Africa
7th century	First Songhai dynasty in Sudan.	Massacre of group of Sao in oasis of Bilma (*ca.* 310 miles from Lake Chad).	
622			
654			
666			
8th century	Exploitation of gold mines of Bambuk (Upper Senegal) begins. First kingdom of the Nupe.		End of kingdom of Axum. Until 12th century, trade between eastern Africa and India. Indian pearls on coast. Africa sells ivory and iron, demanded by India.
732			
790	After assassination of reigning prince, Ghana passes under rule of Kaya Maghan, king of Ouagadou and chief of line of Sissé Tounkara.		

African arts	Discovery of Africa	Europe and Islam
		Until 11th century, Arab conquests in Egypt. Arabs collect booty and then introduce into money market precious metals accumulated in church treasuries, finally bringing to light buried riches in Pharaonic tombs. Nubian gold no longer reaches Byzantium because nomads (Blemmyes) who roam the desert bounded by Nile, Red Sea, and Ethiopian mountains have cut the road.
		Hegira
	Until 11th century, Arabs travel road from Honain, near Tlemcen, through Tuat to Timbuktu.	Arabs take possession of Dongola, chief entrepôt of Nubian gold. Treaty with Nubians. Founding of Kairouan. In Europe, slaves traded to Arabs for gold and ivory of Zandj country. Enrichment of Verdun and Meuse Basin.
		Charles Martel defeats Arabs at Poitiers.

Date	Western Africa	Central and equatorial Africa	Eastern and southern Africa
9th century 800 852–853			
890	Djerma take Gao.		Arab geographer Yakubi describes feverish activity in goldfields of upper Nile. Islamization of eastern Africa. Arabs introduce cowries as money, which prevails in interior of Africa. Muslim settlement in Mozambique.
10th century			
Ca. 950		Migration of Bantu from central to southern Africa begins. Settlement of Sao in Chari Delta.	
990	Capture of Aoudaghost (Tegdaoust?) by reigning sovereign of Ghana.		
11th century	Beginning of empire of Sosso. Ruler of Gambaga extends his influence over right bank of White Volta.		
1010	Djerma move Songhai capital to Gao. Sovereign converted to Islam.		
1050	Chief of province of Mande converted to Islam.	First mention, by al-Bekri, of empire of Kanem-Bornu.	
1061–1075	Almoravid chief mounts war against Ghana, which falls apart.		

African arts	Discovery of Africa	Europe and Islam
Until 13th century, stone towers and tombs in Angola of same style as those in Zimbabwe.		Charlemagne crowned. Shrine of St. Vaast, decorated with Arabian gold.
Until 16th century, development of Sao art, ceramic and bronze. Until 16th century (?), development of Ife art and civilization (ceramic, bronze, quartz).	Masudi writes *Meadows of Gold*.	At beginning of 10th century Fatimites seize Ifrikia, Djerid, and Tripoli, destroy principality of Tiaret, and occupy Sijilmassa, thus becoming masters of all gold routes.
	Spread of Almoravid conquest along western gold route, from Sudan to Maroc and then to Spain.	Invasion of Ga'aliin Arabs into Ifrikia (Tunisia) interrupts route that, through eastern Sahara, Djerid, and Tripoli, supplied Fatimite domain with Sudanese gold.
	In his description of Africa (1068), Arab geographer al-Bekri describes capital of Ghana.	

Date	Western Africa	Central and equatorial Africa	Eastern and southern Africa
1083			Mission of blacks from Zandj country to China, close to Emperor Cheun-Tsoung (?).
1086		Conversion of ruler of Kanem-Bornu to Islam.	
1095–1099			
12th century	Preponderance of Dyaresso in Sahel. Formation of Mossi kingdoms south of Niger Bend.	Forming of Hausa cities. Muslim dynasty at Kanem-Bornu.	In eastern Africa, beginning of migration from north. Monomotapa period, known as Chona I, ends ca. 1450.
13th century	Dogon settle at Bandiagara cliff.	Kingdom of the Congo formed. Kings of Kanem-Bornu try to enlarge their realm at expense of Sao. Foundation of Wadai.	
	Emperor of Sosso has prince of Mande and eleven of his sons assassinated. Twelfth son, Soundiata, is spared, reassembles army, and reestablishes his authority.		
Ca. 1234	Soundiata raids Tinkisso, attacks eastern Bambara, and penetrates Diériba, the capital. He defeats Sosso emperor in 1235. Economic development of Mali under Soundiata.		
1255	Death of Soundiata.		

African arts	Discovery of Africa	Europe and Islam
Ceramic figurines at Djenné and Mopti. Building of Zimbabwe.		Gregory VII prepares First Crusade. Arabs trade between east coast of Africa and China. Chinese currencies and porcelains on east coast.

Date	Western Africa	Central and equatorial Africa	Eastern and southern Africa
1255–1270	Reign of Mansa Oulé who expands inheritance from his father, Soundiata.		
1275	Ife being at its height, Yoruba dominate Nupe.		
1285–1300	In Mali, after troubled period, emancipated slave takes power and reestablishes order.		
1291			
14th century	Raoua, younger son of Ouedrago (founder of Mossi empire), builds settlement of Sangha and leaves there one of his sons whose descendants mix with the Dogon.	Until 16th century, Baluba kingdom. Conversion of Hausa princes to Islam.	Kitara states around lakes.
1300–1307	In Mali, Keita regain power.		
1307–1322	Rule of Kankan (or Gongo) Moussa. Mali at its height. Gold market at Gao active. Fields of West Africa feed Berber and Egypt.		
1324	Kankan Moussa in Cairo causes devaluation by expenditure of gold.		
1325	Mali dominates Songhai. Capture of Gao.		
1332–1336	Weakening of Mali.		
1333	Mossi of Yatenga loot Timbuktu.		

African arts	Discovery of Africa	Europe and Islam
Organization of Benin bronze workers by artist from Ife.		1270: Death of St. Louis in Tunis.
	The Genoese Vivaldo on west coast.	
Beginning of sculptural art in wood among Baluba. In West Africa, jewelry, ornaments, and masks of gold.		
	Before 1312: Cherbourg sailors in Canaries. 1320: Map drawn according to indications of a Genoese living in Sijilmassa in 1306 shows crossing from Tafilalet to Oualata.	
	1336: The Genoese Lanzarote Malocello in Canaries.	

Date	Western Africa	Central and equatorial Africa	Eastern and southern Africa
1336–1359	Recovery of Mali under rule of Suleiman.		
1359–1390	In Mali, fratricidal struggles and troubles.		
End of 14th century	Active trade in copper from Maghreb.		
15th century	Mossi, Tuareg, and Songhai attack Mali.	Metal mines (copper and orichalc) in Kano or Takkedda occupied by Arabs (?).	Hottentots in Zambezi. Empire of Bechuana. 1450(?): In East Africa, Mambo period called Chona II.
1402–1405			
1405–1413			
1415 1417			
1434			
1437			
1439			
1441			
1442			

African arts	Discovery of Africa	Europe and Islam
1346: Death of Andalusian architect Es-Sahéli in Timbuktu.	1346: Jacmé Ferrer in Canaries. 1352: Ibn Batuta visits Mali. 1364: Hypothetical voyage of Dieppe seamen to Guinea. 1375: Abraham Cresques, Jew of Majorca, finishes *Catalan Atlas* which shows image of Kankan Moussa, emperor of Mandingo (Mali).	
Zimbabwe: Stone cups with carved edges; birds with folded wings; stone figurines. Benin: Lasting until arrival of Portuguese, first bronze period.		
	Conquest of Canaries by the Norman, Jean de Béthencourt.	
	Sojourn of Anthelme d'Ysalguier, of merchant family from Toulouse, at Gao, where he marries Songhai princess. Conquest of Ceuta. Henry the Navigator at Sagres. Gilianes rounds Cape Bojador.	Under pressure from Bruges, half payments for commercial transactions in devalued money.
	Rediscovery of Azores. Nuno Tristam at Cape Blanc.	Ecumenical council tries to merge Greek and Roman churches with that of Prester John (?). In painting, first representations of the Wise Man, Gaspar, with features of a black. Pope gives Portuguese trading privileges in Africa.

Date	Western Africa	Central and equatorial Africa	Eastern and southern Africa
1480–1483	Mossi loot Oualata but are defeated at		
1482	Gao by Sunni Ali.	Power of Loango weakened.	
1481–1485			
1484	John II of Portugal, believing Mali is still powerful, sends ambassadors.		
1487			
1490		King of the Congo	
1491		baptized as João I.	
1492	Mamadou Touré (1492–1529) overthrows son of Sunni Ali and founds Askia dynasty.		
1493			
1495			
1497–1499			Companions of Vasco da Gama learn of empire of Monomotapa.
16th century	Chieftaincies of Adansi, Dyenkera, and Akwamu develop in southern part of present-day Ghana.	Sao disappear from chronicles.	
		In the Congo, reaction against Christianity, drowned in blood by son of Nzinga Nkuwu (1506–1541).	
	In Benin, the oba Eséguié institutes title of queen mother.		
1529–1549	Songhai emperor Mamadou abdicates; ensuing troubled period ends with accession of Askia Daud (1549–1582).		

African arts	Discovery of Africa	Europe and Islam
	Diogo Cão reaches Angola.	
	G. Dantas travels up Senegal as far as Felu falls.	
	Bartholomew Diaz rounds Cape of Good Hope.	
	Portuguese penetrate to Mbali, capital of the Congo.	Fall of Granada. Christopher Columbus discovers America. Pope divides New World between Spain and Portugal. Beginning of traffic in blacks.
	The Portuguese Pedro de Corvilhan in kingdom of Prester John (Ethiopia).	
	Voyage of Vasco da Gama.	
In Angola, until 17th century, Christian figurines in wood, ivory, and copper. In Benin, heads of queen mother. Work in ivory.		April 1520: A. Dürer notes in journal his admiration for exotic works which probably come from "treasure of Montezuma." Leonardo da Vinci becomes interested in arts of East Indies (in paintings in caves of Ajanta). Francis I visits "La Pensée," villa of Ango brothers, Dieppe shipowners who collect objects from newly discovered lands. At Dieppe, bas-relief in church of Saint-Jacques shows three known continents.

Date	Western Africa	Central and equatorial Africa	Eastern and southern Africa
1534	Emperor of Mali asks in vain for help of Portuguese settled near Gulf of Guinea.		
1548		John II of Portugal sends Jesuits to the Congo.	
1550		Mbali, capital of the Congo, becomes San Salvador. Portuguese buildings.	
1570–1603		Height of Kanem-Bornu in reign of Idriss III.	
1580		Philip II of Portugal sends Carmelites to the Congo. Decline of kingdom of the Congo.	
Ca. 1590	Adansi dominate Akan group which includes Agni and Dyenkera. They are subject in turn to Dyenkera.		
1591	(12 March) Songhai army defeated at Tondibi by mercenaries of Moroccan sultan, who occupy Songhai country until 1780. Period of anarchy.		
17th century	Founding of Bambara kingdom of Kaarta.	1600–1620: Reign of Shamba Bolongongo, king of Bakuba.	Decline of Monomotapa.
1625–1650	Reign of Deko, first king of Dahomey.		Dutch in South Africa in 1651. Establishment of Capetown.
1650–1680	Ouegbadja, and then Akaba, complete conquest of plateaus of Abomey and subdue countries of the East.		
1680–1708			

African arts	Discovery of Africa	Europe and Islam
		Papal bull of Paul III (Alessandro Farnese) grants status of men to natives of newly discovered countries.
Second period of Benin art. Plaques and bronzes on pillars of palace courtyards.		Vigorous impetus given Flemish metallurgy (braziery) by trade with West Coast of Africa. Bronze is exchanged for slaves.
	Publication of *Relatione del reame di Congo,* owing to collaboration of Duarte Lopez, Portuguese agent, and Italian humanist Filippo Pigafetta. Illustrated with engravings by de Bry brothers. Translated into several languages.	
Creation of decorative art among Bakuba. Goblets shaped like drums. Michael Praetorius, musician and musicologist at court of Brunswick, reproduces African ivory horns in *Theatrum Instrumentorum* (1619).	During 17th century, French cartographers, no longer understanding tracings of their predecessors, obliterate interior of Africa.	

Date	Western Africa	Central and equatorial Africa	Eastern and southern Africa
1670	Disappearance of empire of Mali. Formation of Bambara kingdom of Segu under impetus of Fotigué, known as Biton Kouloubali (1660–1710).		
1680	Ashanti uprising against Dyenkera. Foundation of Ashanti kingdom.		
18th and 19th centuries	First half of 18th century: Settlement of Fangs in northeastern Gabon.		
		São Paulo de Loanda competes with and ruins San Salvador.	
1727	Dahomey: Occupation of kingdom of Allada by Agadja, successor to and brother of Akaba. By 1729 Agadja controls coast cities.		
1720 or 1730	Death of founder of Ashanti kingdom. Quarrels over succession.		
1730	Migration of Ashanti group led by Dakon's sister Aura Pokou who founds Baule kingdom in Ivory Coast.		
1730–1749	Reign of Apokou Ouaré who develops Ashanti kingdom militarily and economically.		
1738	Yoruba seize Abomey under reign of Tegbessou and exact annual tribute until 1850.		
1749–1753	Michel Adanson in Senegal.		

African arts	Discovery of Africa	Europe and Islam
Benin art begins to de-cline.		1713: Treaty of Utrecht controls slave trade.
Golden mask of Ashanti king Koffe Kalkalli.		

Date	Western Africa	Central and equatorial Africa	Eastern and southern Africa
1775–1789	King Kpengla tries to break Yoruba yoke over Dahomey.		1779: Beginning of Kaffir wars between Dutch and Bantu. End of Bantu migration to South Africa.
1789–1797	Weakening of royal authority in Dahomey.		
1800–1810		Reign of Kata-Mbula, 109th king of Bakuba.	
1804	Usman founds Muslim empire in Nigeria from Hausa states, Nupe kingdom, and Northern Cameroon; dies in 1810 or 1815. Period of anarchy until 1900.		
1818–1858	Gezo reestablishes authority over Dahomey, defeats Yoruba, and stops paying them tribute.	1849: French found Libreville in Gabon. 1853: Empire of Kanem-Bornu disappears.	1814: England purchases Cape Colony. 1835: Boer exodus: the great trek.
1854–1864	Hajj Omar (1797–1864) preaches holy war, defeats some of Bambara in 1854, and strikes against Faidherbe. In 1861 he enters Segu; in 1862 he seizes Massina. Dies at Bandiagara in 1864.		
1851	Gezo signs commercial treaty with France.		
1854	Death of Adama who had founded Muslim empire in northern Nigeria.		
1858–1889	Reign of Gléglé in Dahomey.		
1859–1862	Struggles of Bambara kingdom of Segu against Hajj Omar.		1867: Discovery of diamonds in Orange Free State.
1874	English raid against Ashanti.		

African arts	Discovery of Africa	Europe and Islam

Engraved calabash important, especially in Dahomey.

Ca. 1850: *Les Annales Maritimes* takes note of goldsmith's craft in Grand Bassam (Lt. Besson).

From 1840 on, rediscovery of African interior. Scientific missions (geographic and ethnographic). Large European cities establish museums of ethnography.

Second half of 19th century: great European powers compete for markets and banks and then to colonize Africa.
1848: Abolition of slavery.

First missionaries and settlers in Dahomey in Glégl é's reign.

Ca. 1860: Bas-reliefs in palaces of Abomey.
Since 1872: Destruction by missionaries of ancient works in northern Angola. Kyoka religious movement.

1867: Discovery of mines in Monomotapa.

Date	Western Africa	Central and equatorial Africa	Eastern and southern Africa
1879–1894	By his intransigence, Behanzin brings about annexation of Dahomey by France in 1894.	1881: Establishment of Leopoldville. 1883: Germans in Cameroon.	1877: England colonizes Transvaal.
1884	Germans in Togo.	1885: Independent state of the Congo.	1884: Discovery of gold in Transvaal.
1890	End of Bambara kingdom of Segu. Colonel Archinard enters Segu.		
1897	Punitive expedition of English to Benin. Annexation of country. Bronzes discovered in a shed are distributed to European museums.	End of 19th century: Fangs (or Pahouin) reach Gabon estuary.	
1900	Last Ashanti uprising.		1899–1902: Boer War. 1910: Union of South Africa formed. 1914: Boer uprising.
1944	Conference of Brazzaville.		
1958	Most of the former colonies achieve independence.		

African arts	Discovery of Africa	Europe and Islam
1880: Use of sculpture forbidden to Bena-Lulua and replaced by hashish cults. Beginning in second half of 19th century, massive destruction of carved works by European missionaries and by adherents of African syncretist movements.		
A sculptor, Herbert T. Ward, praises Congolese art in book that is not translated into French until 1910. 1906–1907: Discovery of black art by Matisse, Braque, and Picasso. 1915: Carl Einstein publishes *Negerplastik*. 1917: Paul Guillaume and Guillaume Apollinaire bring out first French album devoted to African sculpture. 1919: Blaise Cendrars, *L'Anthologie nègre*. *Ca.* 1930: Yoruba sculptor Bamgboye. 1920–1935: Great exhibits of Negro and Oceanic art: Marseille (1923); Paris, Pavillon de Marsan (1925); Galerie Pigalle (1931); colonial exhibit in Vincennes (1931); New York, Museum of Modern Art (1935). *Ca.* 1934: Fangs no longer practice sculpture.	1931: Dakar-Djibouti Mission	1914–1918: African battalions recruited in European colonies fight in World War I. Allies divide up former German colonies.
	1937: Former Musée d'Ethnographie in Trocadéro becomes Musée de l'Homme.	

BIBLIOGRAPHY

GENERAL WORKS

L'Art Nègre. Special issue of *Présence Africaine,* nos. 10–11. Paris: Editions du Seuil, 1951.

Einstein, Carl. *Negerplastik.* Leipzig, 1915. Trans. into French by J. Matthey-Doret in *Médiations* (Paris), no. 3 (1961).

Fagg, William. *La Sculpture africaine.* Paris: Hazan, 1963.

Gerbrands, Adrian A. *Art as an Element of Culture, Especially in Negro-Africa.* Mededelingen van het Rijksmuseum voor Volkenkunde, XII. Leiden, 1957.

Griaule, Marcel. *Arts de l'Afrique Noire.* Paris: Editions du Chêne, 1947.

Hardy, Georges. *L'Art nègre.* Paris: H. Laurens, 1927.

Kjersmeier, Carl. *Centres de style de la sculpture nègre africaine.* Paris: A. Morancé, 1935–1938. 4 vols.

Laude, Jean. *Les Arts de l'Afrique noire.* Collection of 100 transparencies. Paris: Ministère de la Coopération, 1964.

Lavachery, Henri. *La Statuaire de l'Afrique noire.* Neuchâtel: La Baconnière, 1954.

Leiris, Michel. "Les Nègres d'Afrique et les Arts sculpturaux." In *Originalité des cultures.* Paris: Unesco, 1954.

———. "Réflexions sur la statuaire religieuse de l'Afrique noire." In *Les Religions traditionelles africaines.* Paris: Editions du Seuil, 1965.

Lem, F. H. *Sculptures soudanaises.* Paris: Arts et Métiers graphiques, 1947.

Level, André, and Henri Clouzot. *Sculptures africaines et océaniennes.* Paris: Librairie de Médicis, 1925.

Paulme, Denise. *Les Sculptures de l'Afrique noire.* Paris: Presses Universitaires de France, 1956.

Radin, Paul, ed. *African Folktales and Sculpture.* Introduction by James J. Sweeney. New York: Pantheon Books, 1952.

RELATIONS OF EUROPE AND AFRICA

Coquery, C. *La Découverte de l'Afrique.* Paris: Julliard, 1965.
Denucé, J. *L'Afrique de XVIᵉ siècle et le Commerce anversois.* Antwerp: De Sikkel, 1937.
Labouret, H. "L'Echange et le Commerce dans les archipels du Pacifique et en Afrique équatoriale." In *Histoire du Commerce.* Vol. III. Paris: S.P.I.D., 1953.
Lombard, M. "L'or musulman de VIIᵉ au XIᵉ siècle," *Annales E. S. C.,* 2 (April–June 1947).
————. "La Route de la Meuse et les relations lointaines des pays mosans entre le VIIIᵉ et le XIᵉ siècle." In *L'Art mosan.* Paris: A. Colin, 1953.
Roncière, Ch. de la. *La Découverte de l'Afrique au Moyen Age.* Cairo, 1929. 3 vols.

WORKS OF AFRICAN ART IN EUROPEAN COLLECTIONS (15TH–19TH CENTURY)

Besson, M. *L'Influence coloniale sur le décor de la vie française.* Paris: Agence économique des colonies, 1944.
Bonnaffé, E. *Les Collectionneurs de l'Ancienne France.* Paris: Aubry, 1873.
Fagg, William. *Afro-Portuguese Art.* London, 1959.
Hamy, E. T. *Les Origines du Musée d'ethnographie.* Paris: Leroux, 1890.
Olbrechts, F. M. *Bidjdrage tot de Kennis van de Chronologie der afrikaanse Plastiek.* Mémoire, Vol. X, fasc. 2. Brussels: Institut Royal Colonial Belge, 1941.
Van Gennep, A. *Religions, Mœurs et Légendes.* 5th ser. Paris: Mercure de France, 1914.
Von Schlosser, J. *Die Kunst- und Wunderkammer der Spätrenaissance.* Leipzig, 1908.

EVOLUTION OF EUROPEAN APPRECIATION OF BLACK ART

Goldwater, R. J. *Primitivism in Modern Painting.* New York and London, 1938.
Hermann, F. "Die afrikanische Negerplastik als Forschungsgegenstand." In *Beiträge zur afrikanischen Kunst.* Berlin, 1958.
————. *Die Bildnerei der Naturvölker als Forschungsgegenstand, Studium generale.* Heidelberg, 1951.

HISTORY OF BLACK AFRICA

Labouret, H. *Histoire des Noirs d'Afrique.* Paris: Presses Universitaires de France, 1946.
Moniot, H. "Pour une histoire de l'Afrique noire," *Annales E. S. C.* (Jan.–Feb. 1962).
Murdock, G. P. *Africa: Its Peoples and Their Culture History.* New York, 1959.

RELATIONS OF AFRICAN ART WITH MEDITERRANEAN CIVILIZATIONS

Laude, Jean. "En Afrique noire: art et histoire," *Annales E. S. C.,* 4 (Oct.–Dec. 1959).
Paulme, D. "Un problème de l'histoire de l'art en Afrique noire: les bronzes du Benin," *C. R. Institut français d'anthropologie* (Paris), Fasc. II (Jan. 1944–Dec. 1946).

Schweger-Hefel, A. M. "Der afrikanische Gelbgusse und seine Beziehungen zu den Mittelmeerländern," *Wiener Beiträge zur Kulturgeschichte und Linguistik*, 5th year (1943).
Segy, L. "The Symbolism of the Snake in Africa," *Archiv für Völkerkunde* (Vienna), IX (1954).

ARCHAEOLOGY

Fagg, William. "L'Art nigérien avant Jésus-Christ." In *L'Art Nègre*. Special issue of *Présence africaine*, nos. 10–11. Paris: Editions du Seuil, 1951.
———. *Merveilles de l'Art nigérien*. Paris: Editions du Chêne, 1963.
Hamelin, P. "Les Bronzes du Tchad," *Tribus* (1952–53).
Lebeuf, J. P. "L'Art ancien du Tchad," *Cahiers d'art* (1951).
Lebeuf, J. P., and A. M. Masson-Detourbet. *La Civilisation du Tchad*. Paris: Payot, 1950.
Wieschhoff, H. A. *The Zimbabwé-Monomotapa Culture in South-East Africa*. Menasha, Wis., 1941.

AFRICAN SCULPTURE

Fagg, William. "De l'art des Yoruba." In *L'Art Nègre*. Special issue of *Présence Africaine*, nos. 10–11. Paris: Editions du Seuil, 1951.
Fagg, William, K. C. Murray, et al. *The Artist in the Tribal Society*. London: Kegan, 1959.
Fischer, E. "Künstler der Dan," *Baessler-Archiv*, n.s., X (1962).
Himmelheber, H. *Negerkünstler*. Stuttgart, 1935.

METALWORK

Clément, P. "Le Forgeron en Afrique noire," *Revue de Géographie Humaine et d'Ethnologie*, 2 (April–June 1946).
Davidson, B. *L'Afrique noire avant les Blancs*. Paris: Presses Universitaires de France, 1962.
Laclant, J. *Le Fer dans l'Egypte ancienne, le Soudan et l'Afrique*. Actes du colloque international: *Le Fer à travers les âges*. In *Annales de l'Est*, Memoir no. 16. Nancy, 1956.
Mauny, R. "Essai sur l'histoire des métaux en Afrique occidentale," *Bulletin de l'Institut Français d'Afrique Noire*, XIV (1952).

REGIONAL ART

Dahomey
Herskovits, M. J. "The Art of Dahomey," *American Magazine of Art* (1934).
Mercier, P. *Les Asè du Musée d'Abomey*. Dakar: Institut Français d'Afrique Noire, 1952.
———. "Evolution de l'Art dahoméen." In *L'Art Nègre*. Special issue of *Présence Africaine*, nos. 10–11. Paris: Editions du Seuil, 1951.
———. "Images de l'Art animalier au 'Dahomey," *Etudes Dahoméenes* (1951).
Waterlot, E. *Les Bas-Reliefs des Bâtiments royaux d'Abomey*. Paris: Institut d'Ethnologie, 1926.

Ghana
Kjersmeier, Carl. *Ashanti Vaegtloeder.* Copenhagen, 1948.
Paulme, D. "Les Kuduo ashanti." In *L'Art Nègre.* Special issue of *Présence Africaine*, nos. 10–11. Paris: Editions du Seuil, 1951.
Ratton, Ch. "L'Or fétiche." In *ibid.*

Nigeria
Bradbury, M. R. *The Benin Kingdom and the Edo-speaking Peoples of South-Western Nigeria.* London: International African Institute, 1957.
Egharevba, J. U. *A Short History of Benin.* 2d ed. Lagos, 1953.
Fagg, William. "The Antiquities of Ife," *Magazine of Art*, XLIII (1950).
———. *The Art of Ifé.* Lagos: Nigerian Museum, 1955.
———. "De l'art des Yoruba." In *L'Art Nègre.* Special issue of *Présence Africaine*, nos. 10–11. Paris: Editions du Seuil, 1951.
———. *Merveilles de l'Art nigérien.* Paris: Editions du Chêne, 1963.
Pitt Rivers Museum. *Antique Works of Art from Benin.* London, 1900.
Read, C. H., and O. M. Dalton. *Antiquities from the City of Benin.* London, 1899.
Schweger-Hefel, A. M. *Afrikanische Bronzen.* Vienna, 1948.
Underwood, L. *Bronzes of West Africa.* London: Tiranti, 1949.
Von Luschan, F. *Die Altertümer von Benin.* Berlin, 1919.

Cameroon
Frobenius, L. *Der Kameruner Schiffschnabel unde seine Motive.* Halle, 1897.
Germann, P. *Das plastichefigürliche Kunstgewerbe im Grasland von Kamerun.* Leipzig, 1910.
Jauze, J. B. "L'Art inconnu d'une culture primitive africaine dans la région de Yaoundé," *Bulletin de la Société d'Etudes Camerounaises* (1948).
———. "Contribution à l'étude de l'archéologie du Cameroun," *Bulletin de la Société d'Etudes Camerounaises* (1944).
Lebeuf, J.-P. *L'Habitation des Fali du Nord Cameroun.* Paris: Hachette, 1961.
Lecoq, R. *Les Bamiléké: une civilisation africaine.* Paris: Présence Africaine, 1953.
Truitard, S., and E. Buisson. *Arts du Cameroun à l'Exposition coloniale de Naples.* Naples, 1934.

Congo/Brazzaville and Congo/Kinshasa
Bittremieux, L. *Symbolisme in de Negerkunst.* Brussels, 1937.
Les Arts au Congo belge et au Ruanda-Urundi. Brussels, 1950.
Himmelheber, I. H. *Art et Artistes Bakuba.* Broussa, 1940.
———. *Art et Artistes Batshiok.* Broussa, 1939.
———. *Les Masques bayaka et leurs Sculpteurs.* Broussa, 1939.
Hottot, R. "Teke Fetishes," *Journal of the Royal Anthropological Institute*, LXXXVI (1956).
Maës, J. *Aniota Kifwebe.* Antwerp: De Sikkel, 1924.
Olbrechts, F. M. *Plastiek van Kongo.* Antwerp, 1946.
Torday, I. E., and T. A. Joyce. *Les Bushongo.* Brussels, 1911.
Van Wing, J. *Etudes Bakongo.* Vol. II: *Religion et Magie.* Brussels, 1938.
Verly, R. "Les Mintadi," *Zaïre* (1955).

Gabon

Andersson, E. *Contribution à l'étude des Kuta.* Vol. I. Uppsala, 1953.

Chauvet, S. "L'Art funéraire au Gabon," *Bulletin des Sœurs Bleues* (1933).

Grébert, F. "Arts en voie de disparition au Gabon," *Africa* (1934).

Peissi, P. "Les Masques blancs des Tribus de l'Ogooué." In *L'Art Nègre.* Special issue of *Présence Africaine,* nos. 10–11. Paris: Editions du Seuil, 1951.

Segy, L. "Figures funéraires ba-kota." *Zaïre* (1952).

Tessmann, G. *Die Pangwé.* Berlin, 1913.

Guinea

Appia, B. "Masques de Guinée française et de Casamance," *Journal de la Société des Africanistes* (1943).

Fagg, William. "Two Wood-Carvings from the Baga of French Guinea," *Man* (1947).

Neel, H. "Statuettes en pierre et en argile de l'Afrique occidentale," *Revue Ethnologique et Sociologique* (1914).

Paulme, D. "Deux statuettes en pierre de Guinée française," *Bulletin de la Société Française d'Anthropologie* (1943).

Rütimeyer, L. "Über westafrikanische Steinidole," *Globus* (1901).

Ivory Coast

Bardon, P. *Catalogue des masques d'or baoulé de l'I.F.A.N.* Dakar: Institut Français d'Afrique Noire, 1954.

Goldwater, R. J. *Senufo Sculpture from West Africa.* New York: Museum of Primitive Art, 1964.

Holas, B. *Cultures matérielles de la Côte-d'Ivoire.* Paris: Presses Universitaires de France, 1960.

———. *Portes sculptées du musée d'Abidjan.* Dakar: Institut Français d'Afrique Noire, 1952.

Olbrechts, F. M. *Maskers en Dansers in de Ivoorkurst.* Louvain, 1938.

Salverte-Marmier, M. de. Work on Baule art in preparation.

Vandenhoute, P. J. *Classification stylistique du Masque Dan et Guéré de la Côte d'Ivoire Occidentale.* Mededelingen van het Rijksmuseum voor Volkenkunde, IV. Leiden, 1948.

Mali

Goldwater, R. J. *Bambara Sculpture from the Western Sudan.* New York: Museum of Primitive Art, 1960.

Griaule, Marcel. *Masques dogon.* Paris: Institut d'Ethnologie, 1938.

Kjersmeier, Carl. *Bambara Kunst.* Copenhagen: Ymer, 1927.

Langlois, P. *Art soudanais: tribus dogon.* Lille: M. Evrard, 1954.

———. "La Statuaire du Pays dogon," *Revue d'Esthétique,* XVII, fasc. 1–2 (Jan.–July 1964).

Laude, Jean. *Irons of the Dogon.* New York: H. Kamer, 1964.

Leiris, Michel, and J. Damase. *The Sculpture of the Tellem and the Dogon.* London: Hanover Gallery, 1959.

STUDIES OF GENERAL INTEREST

Brosses, Charles de. *Du culte des Dieux fétiches.* Paris, 1760.

Césaire, A. "Culture et Colonisation," *Présence Africaine* (1956).
———. *Discours sur le colonialisme*. Paris, 1955.
Francastel, P. *Peinture et Société*. Lyon: M. Audin, 1950.
Focillon, H. *La Vie des Formes*. 2d ed. Paris: Presses Universitaires de France, 1948.
Jahn, J. *Muntu*. Paris: Editions du Seuil, 1961.
Lévi-Strauss, Claude. *La Pensée sauvage*. Paris: Plon, 1963.
Moret, A. *Le Nil et la Civilisation égyptienne*. Paris: Renaissance du Livre, 1926.
Panofsky, E. *Die Perspektive als symbolische Form*. 1927.
Les Religions traditionnelles africaines. Paris: Editions du Seuil, 1965.
Senghor, L. S. "L'esprit de civilisation ou les Lois de le culture négro-africaine," *Présence Africaine* (1956).
Tradition et Modernisme en Afrique noire. Paris: Editions du Seuil, 1965.

INDEX